Butterflies and Moths

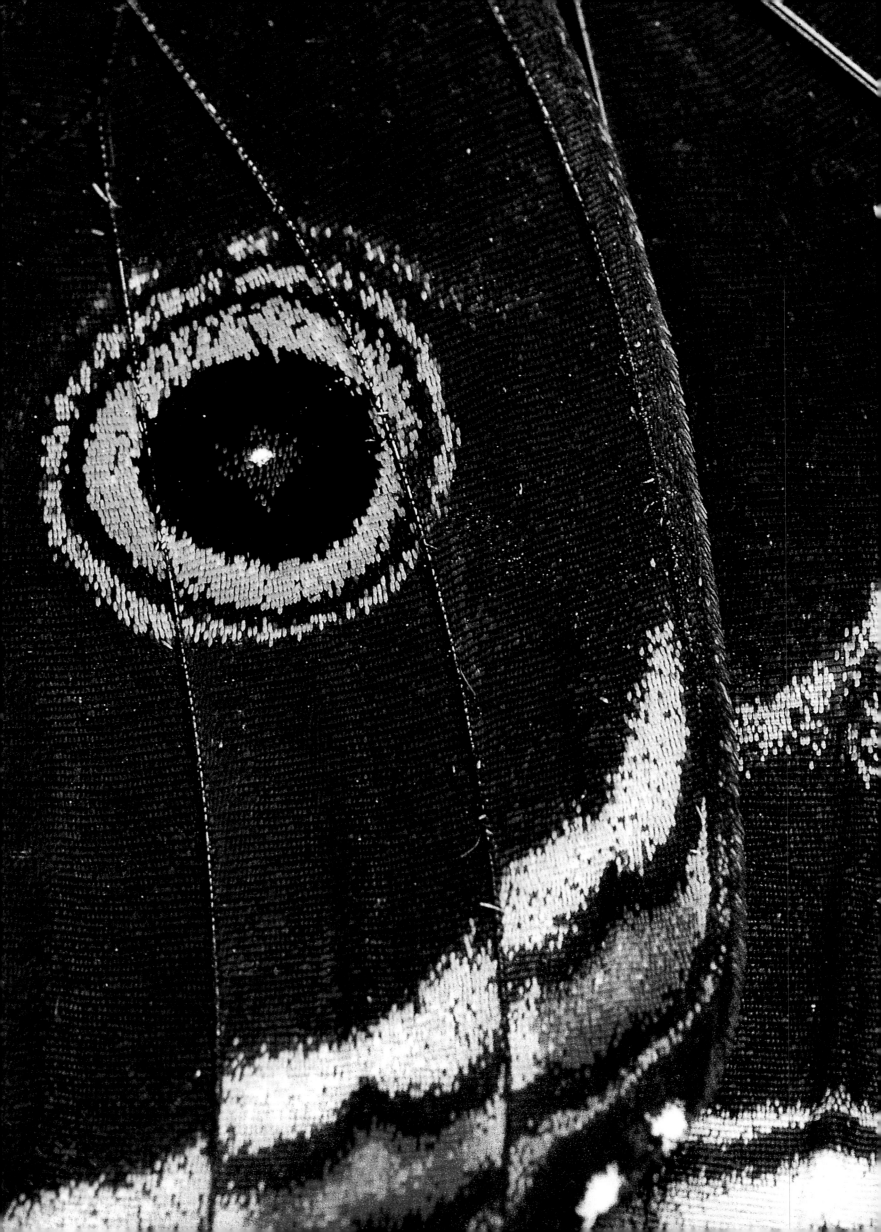

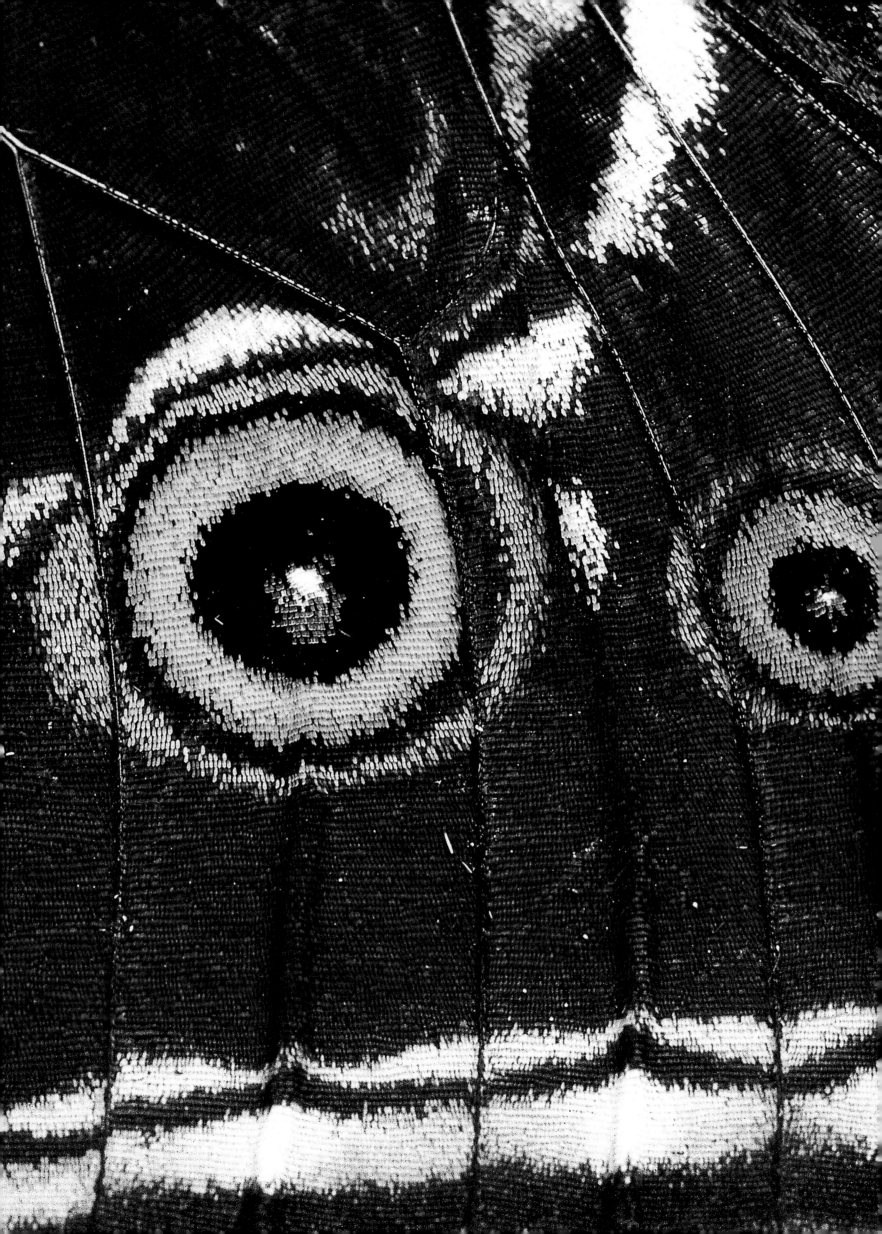

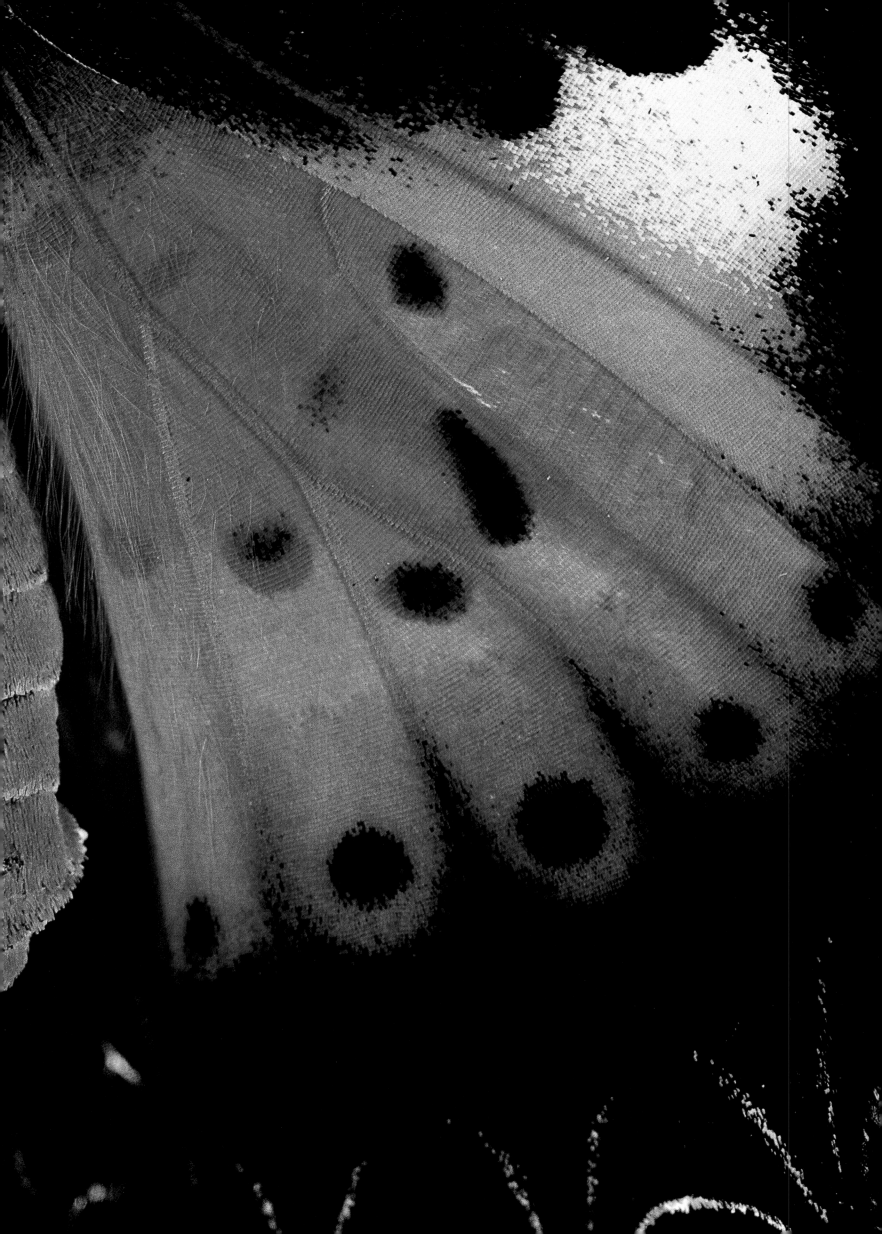

Butterflies and Moths

TEXT BY Jean-Pierre Vesco

PHOTOGRAPHY Paul Starosta

TRANSLATED FROM THE FRENCH BY Florence Brutton

Viking Studio

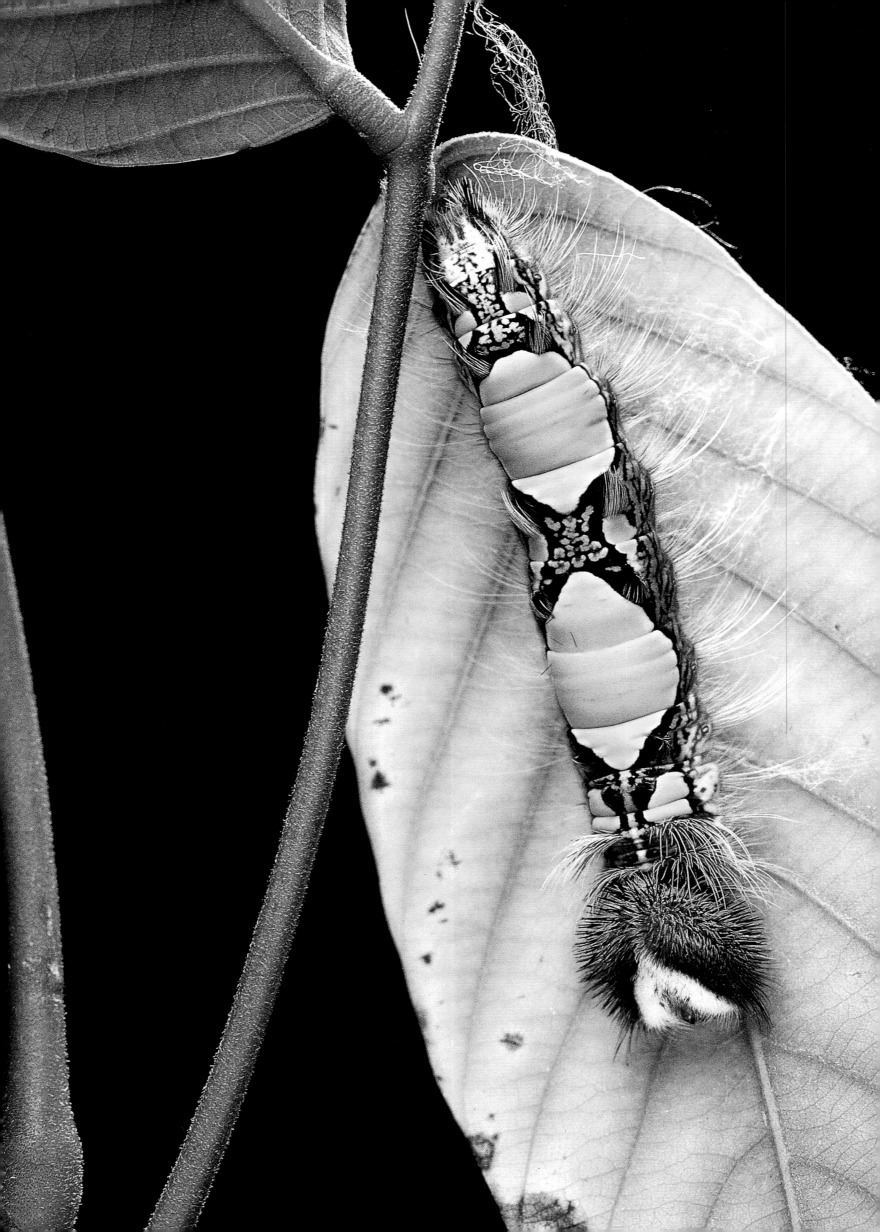

Contents

LEFT
Morpho menelaus (x 5.6),
Morphidae. Larva.

PAGES 2-3
Morpho helenor (x 14.6),
Morphidae. Detail on wing.

PAGE 4
Cethosia hypsea (x 17.5)
Nymphalidae. Detail on
hindwing

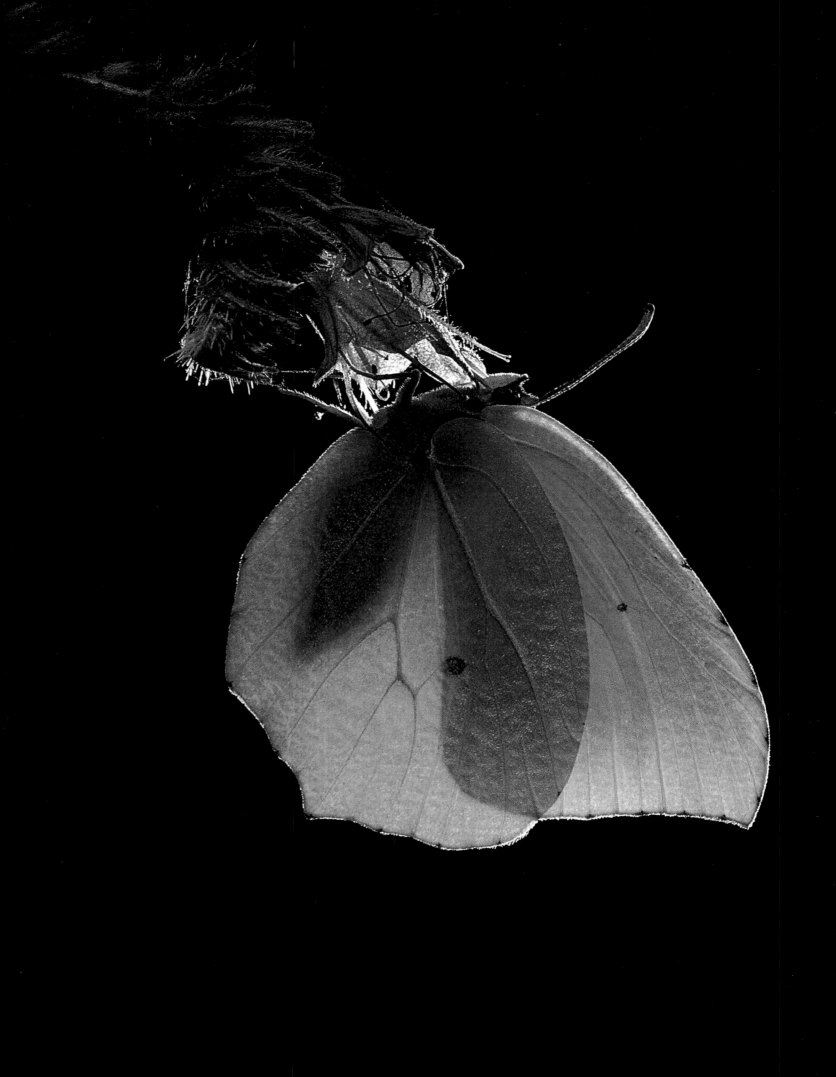

Preface

Dear Reader,

Yet another book on butterflies and moths, you may say, and so it is, of course. But take a closer look and you will see that this book considers Lepidoptera (the insect order that comprises butterflies and moths) from a very different perspective. The author made it a point of honor to show only living specimens; even the finest details on the wings are pictures of living insects. Finding dead specimens pinned on pages in collectors' albums is easy, but obtaining living butterflies and moths is quite a different matter. Our research put us in contact with professional breeders far and wide who were raising species we did not have access to in France. This book does not attempt to be a course in entomology, but it will provide amateurs and professionals alike with illustrations of Lepidoptera never shown before. Principally, however, this book is addressed to a general readership drawn to the discovery of a fascinating world by a wealth of detail and astonishing anecdotes.

LEFT
Gonepteryx cleopatra,
"Cleopatra" (x 4),
Pieridae.

Note:
The numerals within parentheses preceded by "x" indicate the amount that the insect has been magnified.

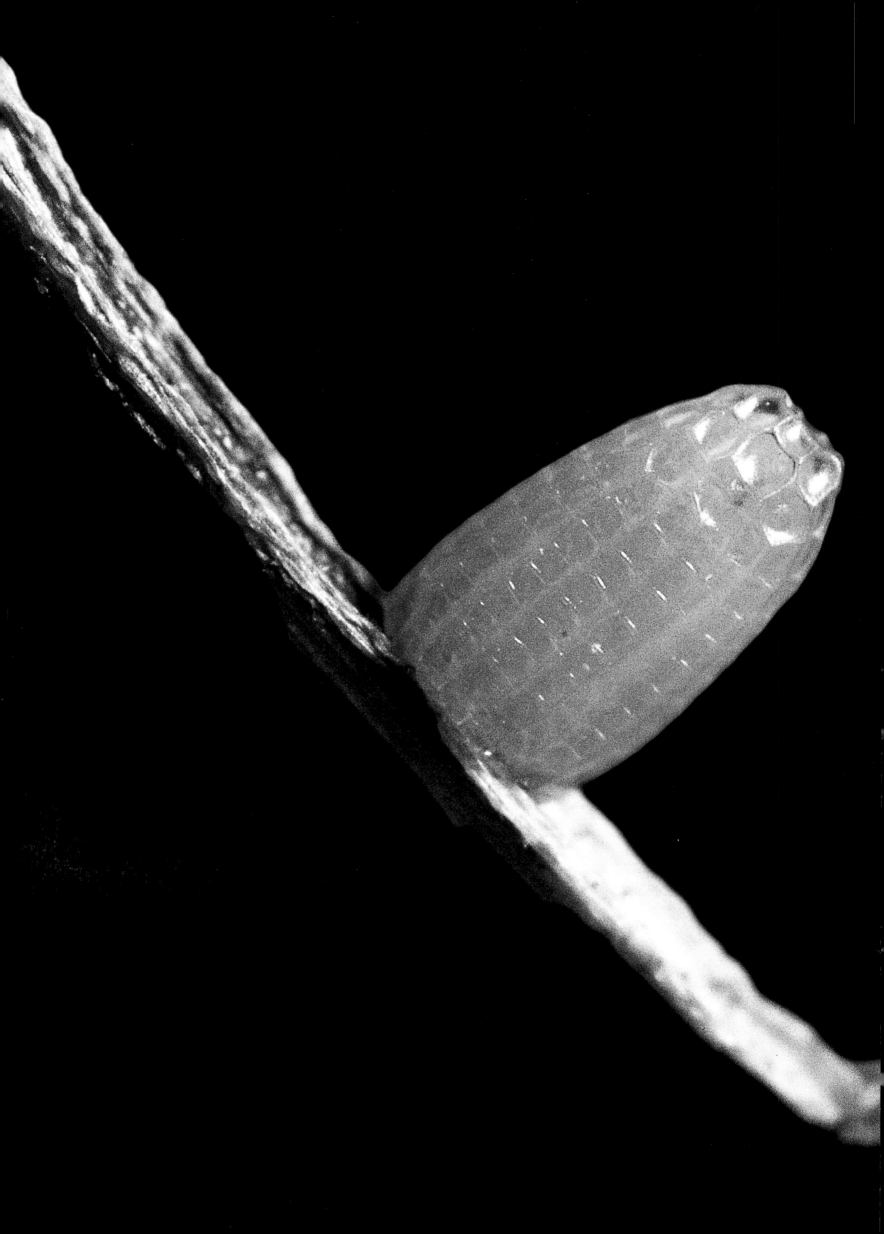

The story of butterflies and moths

REINCARNATION—THAT DREAM OF A MYTHICAL ETERNITY
BEYOND THE REACH OF MORTAL MAN—IS PART OF LIFE FOR
LEPIDOPTERA. THE PAGES OF THIS BOOK
PRESENT THESE FASCINATING CREATURES AS THE STARS IN
A THREE-ACT PLAY: FIRST AS INSATIABLE GLUTTONS IN A
"CAREFREE CHILDHOOD"; THEN SHY AND INVISIBLE DURING
THEIR "MYSTERIOUS RETREAT"; FINALLY, ELEGANT
AND REFINED IN THEIR "EPHEMERAL LIFE."

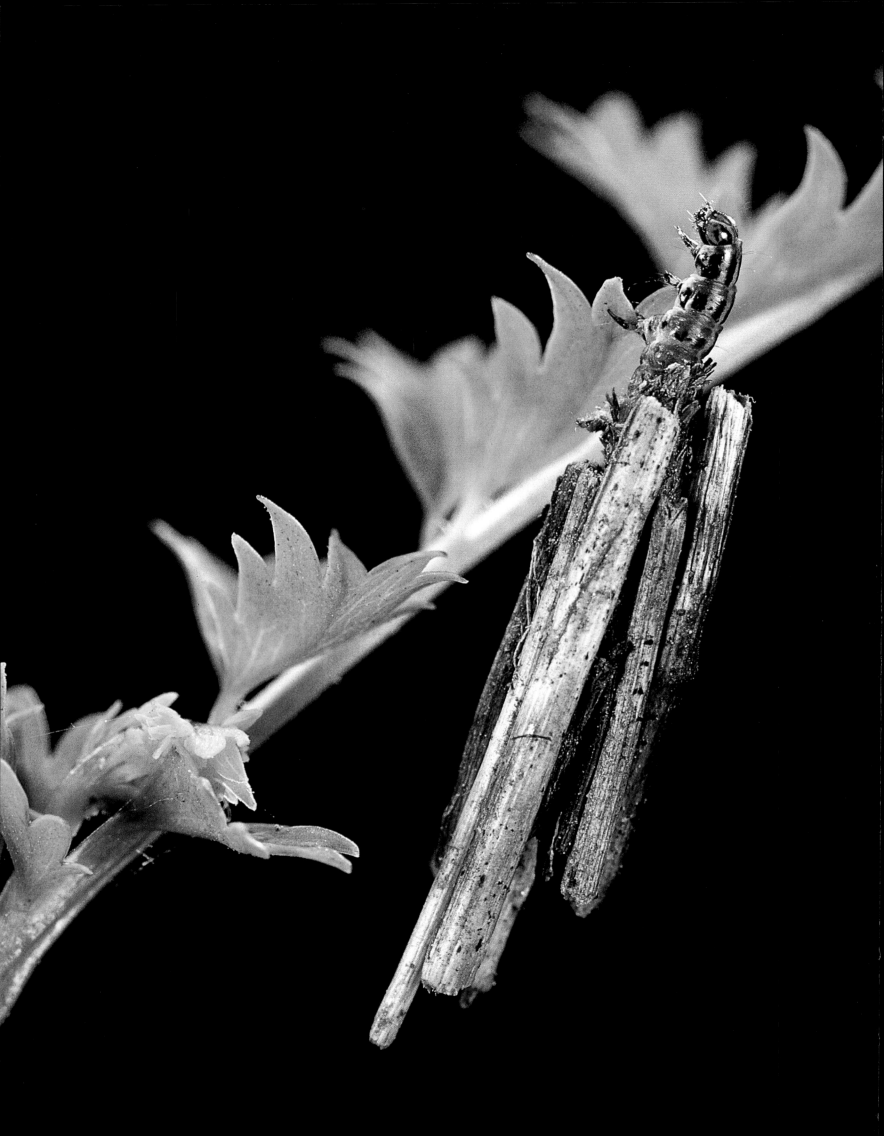

Butterflies and moths, with their bright colors and harmless, friendly appearance, are so popular with human beings that many of us forget that these creatures form part of the insect world. There is nothing new in this. Butterflies have fascinated man since as far back as the ancient Greeks, who held them in particular esteem and regarded them as symbols of the soul's immortality because of their transformation from pupa to butterfly.

This metamorphosis from the base, humble larva into the diaphanous, richly colored butterfly was something that fired the imagination of the ancient Greeks to whom it signified the fulfillment of man's destiny and the transition from earthly life to the hereafter. So strongly did the Greeks identify with this notion that they used a single word to describe both the butterfly and the soul: *psyche.*

Twenty-five centuries later, entomologists intent on classifying all insects revived the word and applied it to a small group of butterflies that became known as the *Psychidae* family. They are the only trace remaining of this unassuming insect's fabulous importance in the metaphysic of an entire civilization.

What we have lost in poetry, however, we have gained in objective knowledge; over the past three hundred years, our knowledge of Lepidoptera has been steadily growing. Today, thanks to countless collections and a continuous process of research and classification, nearly two hundred thousand species have been identified, making butterflies and moths the largest group of insects after the Coleoptera, which are three times as numerous.

It is not only scientists who are interested in butterflies and moths. For the general public too these insects offer a privileged, beautiful, but relatively easy means of exploring nature and all its wonders. Think only of the many entomological exhibitions, grants, and events that give pride of place to Lepidoptera. Each of us in our own way can become an amateur entomologist, if only for a day, and make new discoveries. This kind of work is vital and in many cases offsets the lack of professional resources, particularly when it comes to research "in the field."

LEFT
Psyche or "bagworm"
(x 11.7), Psychidae. These
larvae shelter inside
protective casings made of
various materials.

PREVIOUS DOUBLE-PAGE SPREAD
Dryas julia (x 84),
Heliconidae, egg.

DEVELOPMENT

reproduction

As with the majority of animals, butterflies and moths are unisexual, so the two sexes must meet up to mate. Again, as is usually the case, it is the female who waits and the male who seeks her out. In fact, that is his sole occupation; some males even go without food so as to hunt for a mate with greater perseverance. They know they have no time to waste. To help them in their search, Nature has equipped them

for instance, have eyes that make up for their relatively poor sense of smell. Watch butterflies in a field of flowers; see how they flutter around, gather nectar and pollen, and follow each other. Look more closely and you will see that the butterflies they follow most closely are the ones that

they resemble. Their eyes have identified the colors and designs of their own species. That, however, is not enough. They also need to sex their fellow butterflies and this they do with their antennae. If the pursuer, invariably male, finds himself following a female, he may have a chance. If his beloved is recently hatched, she is probably still a virgin and will willingly allow herself to be seduced. At worst, she will expect him to woo her briefly, and the male will perform a dainty airborne dance, when he will take the opportunity to release pheromones of his own that are sure to win her over. If a male finds himself in pursuit of another male, he will probably abandon the chase —why bother, after all? Not all males think that way, however, and some will not give up until they have chased the intruder off their patch. These species are highly territorial: males will perch at the tip of a branch endlessly watching over their domain, and pounce on anything that comes too close. Some launch into fierce battle, furiously beating their wings; some have even been known to chase after birds!

with a powerful means of detection: antennae that are in effect the nose of Lepidoptera. But this is no ordinary nose. Compared to the truly awe-inspiring olfactory powers of the antennae, even the nose of the most delicate perfumer seems permanently blocked by a heavy cold. Thanks to the antennae, the male of the giant peacock moth, the largest moth in Europe, can find his companion at a distance of seven miles simply by following her perfumed emissions. This scent that she sends out, which scientists call the pheromones, allows animals to signal to each other over distances and make their presence known to other members of the same species. Using his antennae, the male picks up the pheromone molecules emitted by the female, analyses the signal and heads off in the direction where the concentration of smell is at its strongest. He arrives without fail at the source of the scent where the two lovers, together at last, can set about perpetuating the species. Not all Lepidoptera possess such remarkable olfactory powers, however. Many are far less well endowed in this particular area. Butterflies that fly by day,

the egg

The female, meanwhile, has more serious things on her mind. She is already thinking of tomorrow and, like every other mother in the world, her only goal is to fulfil the task that she has been given by Nature. The survival of the species is now all up to her. Over the coming days, the eggs will slowly develop within her abdomen, and soon it will be time to find a nutritive plant on which to deposit them. This is much easier said than done. Plants, or in some

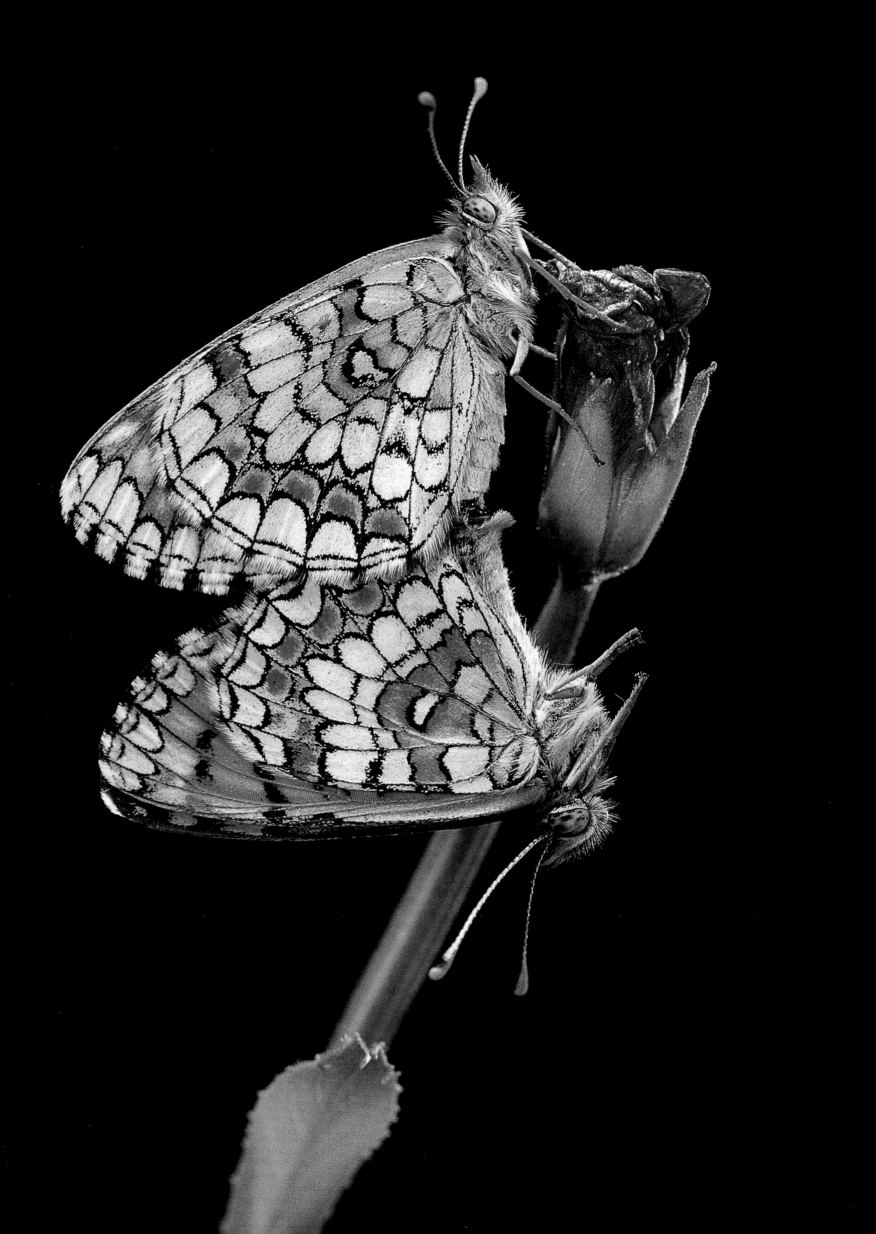

cases a single plant, are specific to different species. The female must therefore select the right plant from among thousands upon thousands of alternatives. What she is looking for is a plant that can provide her offspring with enough food to finish growing. Actually, however, she is not "looking" at all but feeling. She alights at random on a plant and, instead of using her eyes, gathers and analyzes information about the leaf by tapping it lightly with her front legs. Everything she needs to know about the nutritive plant is right there at her fingertips. If, and only if, she finds the right plant, she can then deposit her precious cargo, which depending on her species might be a single egg at a time, or many eggs, or even hundreds of eggs. The butterfly then abandons her offspring to their fate. In the world of Lepidoptera, parents never see their offspring, who are orphans from birth and must fend for themselves. If they survive,

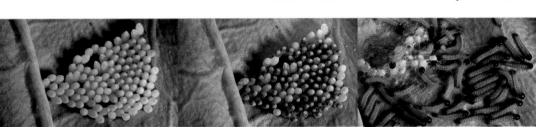

it is thanks to their mother, who made sure that they had everything they needed.

the larva

As soon as it emerges from its shell, the newly hatched larva is ready to take on the world. Nothing daunted by the immensity of the vegetation on all sides, it sets about organizing its life. The first priority is food. It begins by devouring the eggshell from which it has hatched: first it eats its way out and, once hatched, when it finally has room to move, it continues the meal from the outside. Usually it devours the whole thing. Having eaten its fill, the larva cannot afford to fall asleep. There, perched precariously on the slippery leaf, its situation is not an enviable one. One false move and it could plummet to the ground. The larva is well aware of this and knows it has to act fast to save itself. What it needs is some sort of rope or safety barrier to hold onto and that is precisely what it starts to construct. Moving cautiously, it creeps forward, nodding its head from side to side.

With each imperceptible movement, it drops a fine but tough thread of silk onto the smooth surface of the leaf. Eventually it forms a pathway that it clings to and reinforces each time it moves along the leaf. With safety and food taken care of, the next thing the larva needs is a place to find shelter and sleep. The question is: where? Once again, the larva cannot depend on Nature, but must look after itself. Some larvae join the two edges of the leaf with a few threads of silk to form a sort of little cone in which to hide from prying eyes, especially predators. The only time the larva leaves this snug little nest is to feed, mainly at night. Another tactic is to build a house or protective casing made of twigs that the larva enlarges as it grows. These, however, are relatively luxurious living conditions, and most larvae make do with much more basic accommodation. Often they simply cover themselves with a silk sheet woven directly onto the leaf, emerging at regular intervals to feed just one or two inches away on the edge of the leaf, which they devour greedily.

And so the larva lives out its peaceful, relatively uneventful life. Inevitably, of course, eating as much as it does, it starts to put on weight, and soon its skin no longer fits properly. As with all insects, it can only grow through molting or shedding its skin. For the larva, this is a great moment in life that requires careful preparation. Knowing that it will have to remain motionless for several days, the larva takes every precaution and makes sure that everything is in readiness for its period of enforced retreat. It weaves new threads into the silk sheet to make it thicker and checks that it is firmly anchored to the leaf. When it has completed its preparations, it settles neatly in the center, clings on tightly and waits, motionless. Hours and days go by and then, finally, the larva seems to come back to life. Its body quivers and the skin grows increasingly taught until it is on the point

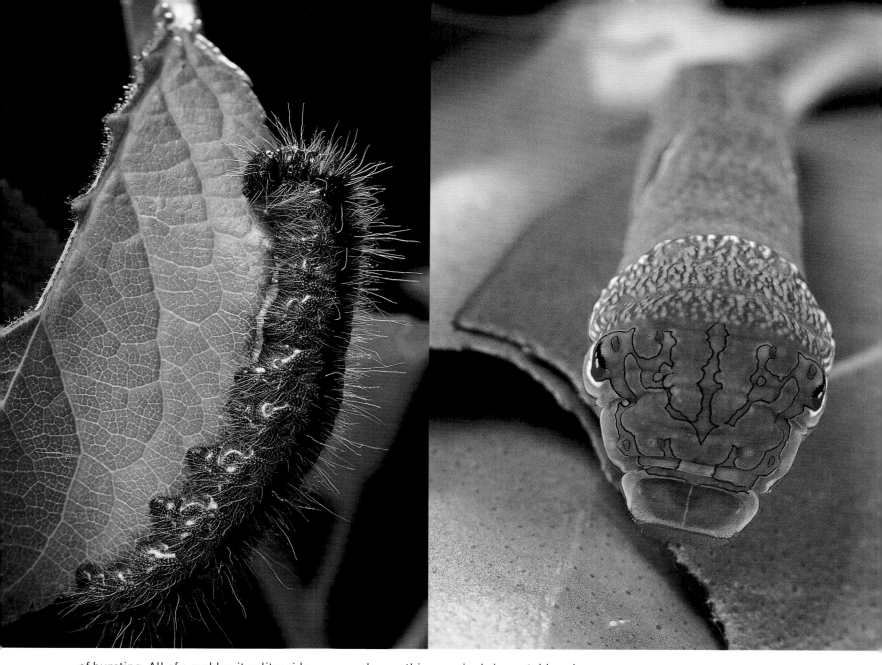

of bursting. All of a sudden it splits wide open just behind the head, and from this gaping hole the larva slowly wriggles out of its old skin that it pushes away behind it. Soon it has completely shed its old skin and within just a few hours, now dressed in far more ample clothing, the larva is ready to resume the business of being a larva, which means eating. Several days of fasting have put an edge on its appetite and energy reserves are running low. The larva is in luck, however, because a favorite source of protein is within easy reach: its old skin, which it devours without a moment's hesitation. For the vegetarian larva, this is effectively cannibalism, but nothing is wasted in Nature.

The same scenario will be repeated several times as the larva eats, grows fatter, and molts. Some larvae go so far as to shed their skin fifteen times, but these are extreme cases. Most settle for four times.

the pupa

One day, however, something happens to change this seemingly immutable scheme of things, something with such far-reaching consequences that the larva's life will never be the same again. Suddenly, this starving creature with a voracious appetite stops feeding. Its stools, that have always been dry, hard little pellets, grow profusely runny. The larva becomes quite literally drained and loses a third of its size. It changes color: the whites turn gray and the yellows turn green. It grows very agitated and, for the first time ever, abandons its beloved plant that has so generously fed it for weeks. The larva will never need it again: childhood has just come to a brutal end in a bout of diarrhea.

Drastic purging is an inevitable part of life for the larva at this stage in its development. It is like a process of vital purification in preparation for the transition to superior life, when it metamorphoses into a pupa.

We human beings may find it difficult to grasp such a radical change, but for the larva it is perfectly normal. From now on,

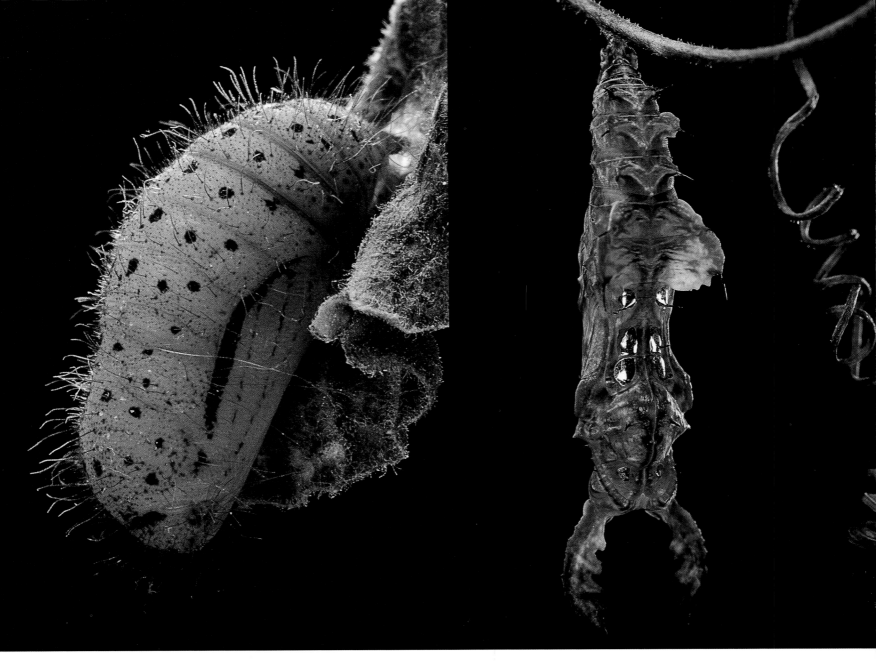

1. *Hamearis lucina* (x
11.2), Nemeobiidae.
This pupa is pubescent,
whereas most species
are hairless.
2. *Heliconius charito-
nia* (x 5.5), Heliconidae,
Pupa.

things will change very quickly indeed.
Suddenly, it abandons its former indolent
existence of eating and sleeping and pours
its energies into a new set of tasks that
have to be carried out in a very precise
order. The larva knows that it has to move
fast because it only has a few hours in
which to complete Nature's schedule. If it
fails to meet the deadline, there is no sec-
ond chance. If it misses out a stage, it can-
not complete the next one and faces
certain death.

Its first task is to find a quiet, sheltered,
and above all discreet place to undergo
this transformation. Larvae are not accus-
tomed to getting changed in public. Some
species choose to bury themselves, others
wrap themselves in a silk cocoon. Ours,
like nearly all butterflies, stays in the
open. As soon as it finds a suitable place, it
becomes motionless and starts to weave a
silken cloth, not on the leaf this time, but
underneath it. It makes the fibers thicker
in the center so as to create a little cush-
ion. Then it turns over, clings on with its

last pair of hindlegs, and hangs upside
down.

After two days in this awkward position,
the larva sheds its skin once again, but the
creature that emerges bears no resem-
blance to its former self. Without head and
legs, it is no longer a larva and, although
still the same being, has taken on a differ-
ent form with a different name: the larva
has turned into a pupa. Before our aston-
ished eyes, the future gradually emerges
from the past, as the young pupa sloughs
off its old, and now useless, skin. Actually,
the skin is not entirely useless just yet
because it allows the pupa to remain sus-
pended in mid-air. But this blind, infirm
creature, with no visible means of holding
on to anything, must now find its own way
of attaching to the leaf. It must extricate
the tip of its body that is covered with tiny,
curved spines, called the cremaster, and
plant it in the silken cushion that it wove
as a larva. This is a very dangerous
maneuver because for a few seconds the
pupa is attached to the old skin only by a

tiny part of the abdomen. Yet with its life literally hanging by a thread, it never, or hardly ever, slips up. As soon as the cremaster is free of the old skin, the pupa plants it in the silk with surprising agility, wriggles around to drive it in further and lies back motionless with exhaustion. This marks the beginning of a period of austerity that will last for weeks or months. The pupa can neither move nor eat and barely breathes. Yet within that apparently lifeless shell the most extraordinary process of transformation is at work, as the little larva that was born, grew, shed its skin and pupated, now changes for the last time. What it will become will look and behave so unlike what it was before that it will hardly seem to be the same creature.

Nevertheless, the imago (adult insect) that emerges one fine day from the pupa will be the selfsame larva that changed its skin for the last time and turned into the

Then it pulls itself up quite abruptly, clings onto the cocoon, and extracts itself completely.

Its wings seem so small and its body so fat that it is hard to believe this butterfly will ever fly. Patience. A miracle is about to take place before your very eyes. The wings start to grow. They are a bit crumpled, admittedly, but there is no doubt that they are growing, and quickly too. In just a few minutes, they have reached full size, but remain as floppy and soft as gossamer. To be on the safe side, the imago examines its wings before taking flight. It furls and unfurls them, tests their strength, makes sure that they can support its bodyweight. Now the wings are almost ready, and the butterfly spreads them in the sunlight. They are brand new and in perfect condition.

And yet, moments from birth, this newborn butterfly is already old. However beautiful and young it may seem, its birth

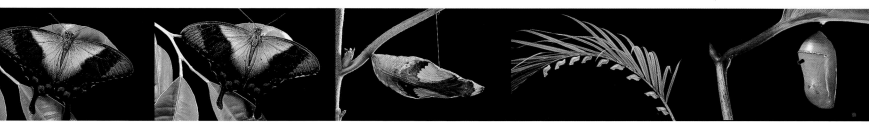

pupa that released the imago.

As human beings, we will always be astonished by this triple transformation, where a single creature goes through distinct stages of development quite unlike our own. It is like entering a magical world, where fairies turn pumpkins into gilded carriages.

the imago

Before this final birth, there are certain warning signs. One or two days before the imago emerges, the pupa gradually changes color. On the sides, the designs and colors of the wings grow visible through the now transparent casing. A few more hours and everything will be in place for the final scene. The long-awaited event is about to happen. Once again, the skin of the pupa bursts near the head revealing the first glimpses of the imago: the nape of the neck, the back, and the base of the wings. Moving very carefully, it extracts its legs, antennae, and proboscis. So far, it is only half way out and still upside down.

has driven it closer to death. From this point forward, trapped in its adult shell, it can grow no more. In hatching, butterflies and moths fulfill their destiny and embark on a fleeting but vital future whose purpose is common to all living beings: the perpetuation of the species.

Once it has warmed itself in the sun, the imago is ready to leave. All of a sudden, it takes flight, headed for wide-open spaces, love, and the honeyed nectar of flowers.

DEFENCE MECHANISMS

They may look vulnerable, but butterflies are not as helpless against their enemies as they look. They know how to defend themselves, but since they are equipped with no means of aggression, their defense tactics are essentially passive. The simplest strategy is to go unnoticed: a happy life is a hidden life. Some butterflies have therefore become masters of camouflage. At each stage in their life, they blend with their surroundings by imitating the shape and color of the things around

| 1 | 2 | 3 | 4 | 5 |

1 and 2. *Papilio peranthus* (x 0.3), Papilionidae. These metallic colors are due to the manner in which light is reflected by the striated structure of the scales. The reflected color varies depending on the angle of incidence of the light.
3. *Papilio dardanus meriones* (x 1), Papilionidae. Pupa ready to hatch.
4. *Parides photinus* (x 0.1), Papilionidae. Pupa under a palm leaf. Amazingly, between each pupa there is just enough room for the butterfly to hatch.
5. *Daneus plexippus*, "monarch" (x 1), Danaidae, Pupa.

them: a piece of wood, a leaf, bark, stone. A covering of irritant setae (bristly hairs) is a traditional but equally efficient means of defense used by a great many hairy larvae. The most widely known are the processionary larvae that live in their hundreds in communal nests on pine and oak trees. Anyone foolish enough to handle these larvae or touch their nest will break out in a violent rash that may cause temporary discomfort or even permanent damage if the processionary larvae are present in large enough numbers. There are examples of such cases in the literature. In 1865, the Bois de Boulogne near Paris suffered an infestation of oak processionary larvae. There were so many that their hairs blew about in the wind and made the area uninhabitable, chasing away all the wildlife. Tragically, the men who were sent in to find and destroy the nests died in the process. Such incidents are fortunately very rare, and contact with these larvae is usually more unpleasant than dangerous. Actually, their irritant properties have not always been considered a nuisance. The Romans, for instance, came up with a very unexpected use for them, to say the least: knowing that the hairs caused reddening and blistering, they used to rub them over their genitalia and the swelling produced was supposed to heighten pleasure in love-making. Processionary larvae became known as "voluptuous larvae" as a result of this unusual custom, which has apparently now gone out of fashion ... Butterflies and moths with irritant spines are rarer, but one such species, the moth *Hylesis metabus,* is a notorious nuisance in Guyana. At certain times of the year, these moths hatch en masse and swarm round the streetlights at night. As they flutter about, they spread large quantities of scales and very fine irritant hairs that combine to form an aerosol. This attacks the mucous membrane and skin in particular, triggering allergic reactions and leading the authorities to declare a curfew during the hatching season, forbidding all outdoor lighting.

Poisonous spines are a variation on the same theme. Unlike irritant hairs that can have a long-distance effect when they are airborne, such spines are only dangerous on direct contact and are therefore potentially less of a risk. Still, although the larva itself is never aggressive, merely touching these spines can be enough to trigger a violent allergic reaction or even more serious problems requiring hospital treatment. Once again, however, such incidents are few and far between, and most larvae are harmless.

It is also worth pointing out that the larvae of moths and butterflies, unlike domestic animals, cannot transmit disease to humans. They belong to a group that is too far removed physiologically from our own. Another less predictable but equally effective means of warding off the enemy is by a vivid display of so-called "warning" colors. This is a protective mechanism common to all butterflies, moths, and larvae that are naturally inedible, either because they taste horrible or because they are poisonous. In hot countries where entire groups of butterfly and moth larvae live off poisonous plants, this type of protection is particularly common. The plant's toxins pass into the bloodstream of first the larva then the imago, making them inedible and less vulnerable to attack from birds and lizards, their main enemies. Predators soon come to associate a vile taste with vivid colors and learn to leave these butterflies and moths alone.

A more refined version of the same approach is to fool the enemy by pretending to be something else, often by mimicking a wasp or other harmful insect. This a technique that the Sesiidae (wasp or clearwing moths) practice to such an extent that they cease to look like moths at all. With their short antennae and narrow, fully transparent wings folded down onto their striped yellow and black bodies, they

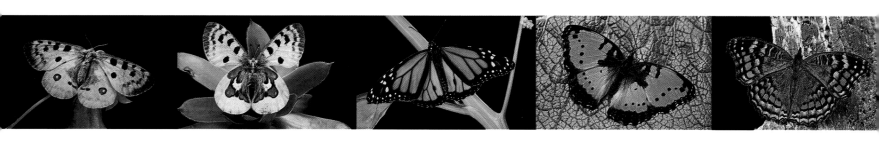

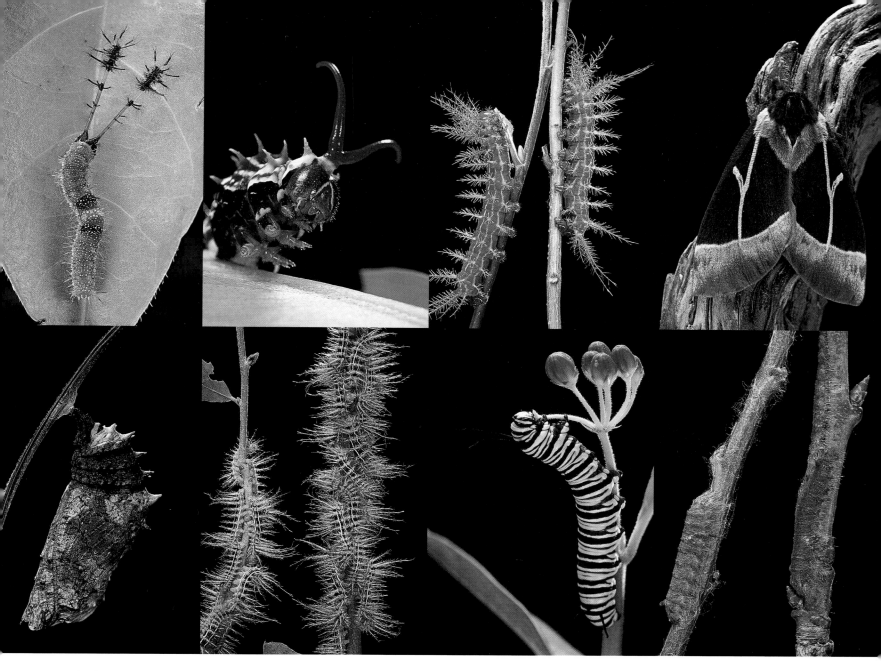

look and behave exactly like wasps. In fact, all that's missing is the sting, and since the trick works perfectly well without it, who cares? Cleverer still is to mimic another butterfly; not just any butterfly, but preferably one whose bright warning colors discourage predators. As a result, the harmless butterfly is taken for an inedible species and benefits from the same defense mechanism. This mimicking of a poisonous species by an edible species is known as Batesian mimicry, after the nineteenth-century naturalist H.W. Bates, who first drew attention to it. But things do not stop here. It has been observed that the dozens of poisonous and therefore "protected" species found in any one place all look alike and may be classified by color and design in just two or three categories. Why so few? Because it makes their defense mechanism even more effective. The fewer patterns a predator has to memorize, the sooner it learns to associate a particular design or color with a disagreeable taste. If, on the other hand,

it were faced with a multitude of inedible butterflies and moths of different shapes, it would have a job remembering them all. As a result it would prey on them regularly, depleting numbers for the species as a whole. This type of mimicry in which "protected" species "copy" each other is called Müllerian mimicry, after another nineteenth-century naturalist, Fritz Müller, who first discovered it.

BUTTERFLIES AND MOTHS AND THEIR NATURAL HABITAT

The quantity and diversity of butterflies and moths in the natural world makes them important in the maintenance of the earth's ecosystems. First and foremost, butterflies and moths in their adult state are vital pollinators. The majority of cultivated plants do not depend on them to reproduce, but many wild plants would cease to exist without Lepidoptera, impoverishing the Earth's natural flora. The animals that depended on these plants for food would also perish. The second

1	2	3	4
5	6	7	8

1. *Callicore cynosura amazona* (x 2.8), Nymphalidae. Larva.
2. *Papillio aegeus* (x 3), Papilionidae. When the larva feels threatened, it gives off bad-smelling substances from an extrusible scent organ that is characteristic of the Papilionidae.
3. *Dirphia tarquinia* (x 1), Attacidae. Larvae with poisonous spines.
4. *Dirphia tarquinia* (x 0.8), Attacidae. Imago.
5. *Kallima inachus*, "Dead-leaf butterfly" (x 2.3), Nymphalidae. Pupa with cryptic coloring.

6. *Automeri egeus* (x 0.7). Attacidae. Group of young larvae with poisonous spines.
7. *Danaus plexippus*, "monarch" (x 1.75), Danaidae. Toxic larvae with warning colors.
8. *Gastropacha quercifolia* "tent caterpillar" (x 1.5), Lasiocampidae. These larvae may grow to 8cm (3in) long but they are hard to spot. When pressed against bark on a branch, clumps of hair on their sides conform to the shape of the wood, thus eliminating the shadow that would otherwise give them away.

equally major, but less poetic function of Lepidoptera mainly concerns the larvae. Sad as it might be, the principle raison d'être of the larvae is to serve as food for other species. Most batrachians, lizards, and insectivorous birds depend on larvae for their survival, as do vast numbers of meat-eating insects and parasites. Admittedly, in areas where larvae thrive, their collective weight is measurable in many hundreds of pounds per hectare.

France), which can fairly claim to be the first "butterfly garden" in France. This type of initiative provides real opportunities for fieldwork and helps to further the understanding of butterflies, moths, and their

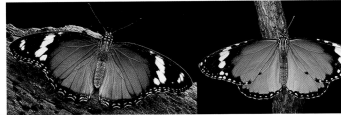

ecosystem. The studies produced will play a key role in determining how best to protect these creatures and may be extrapolated to other areas of research.

	4	5
1	2	3

1. *Catocala elocata*, (x 0.5), Noctuidae (owlet moths). At rest, this moth's folded wings blend into the background. If startled by a predator, it suddenly flies off and the bright color on its hindwings takes the predator by surprise as the moth makes its getaway.
2. *Pyropteron chrysidiformis* (x 2), Sesiidae. Imago mimicking a stinging wasp.
3. *Graellsia isabellae*, (x 0.4), Attacidae. Protected by law, this moth is found in the southern French Alps.
4. *Hypolimnas misippus* (x 0.6), Nymphalidae. Harmless female mimicking a *Danaus chrysippus* (example of Batesian mimicry).
5. *Danaus chrysippus* (x 0.5), Danaidae. Poisonous species serving as a model for the female *Hypolimnas misippus*.

RIGHT
Dryas julia (x 31.5), Heliconidae. The eyes have 360° vision and can see ultraviolet light.

Imagine what that means in terms of a forest, a country or indeed the entire planet. The figure is staggering and helps to explain why larvae play such an important role.

In their natural environment, butterflies and moths are at the mercy of numerous predators, but none of these is as formidable and dangerous as man. Over the centuries, Lepidoptera have successfully evolved survival techniques to protect themselves against their natural enemies, but not against man. The more we expand into new areas, the more the environment suffers as a result, and butterflies and moths, along with the rest of Nature, are gradually being wiped out. For any living being, there can be no greater catastrophe than the loss of its natural habitat, as this inevitably leads to death. Butterflies and moths are especially vulnerable in this respect, and there is no more influential factor in their disappearance. Thanks to a growing awareness of the problem, we see an increasing number of new measures designed to protect species and preserve biotypes. These measures include:
• The protection of "sensitive" species by making it illegal to capture them.
• The preservation of traditional forms of agriculture that actively encourage wildlife.
• The establishment of specific butterfly-friendly zones such as the region of Digne (in the Alpes-de-Haute-Provence in

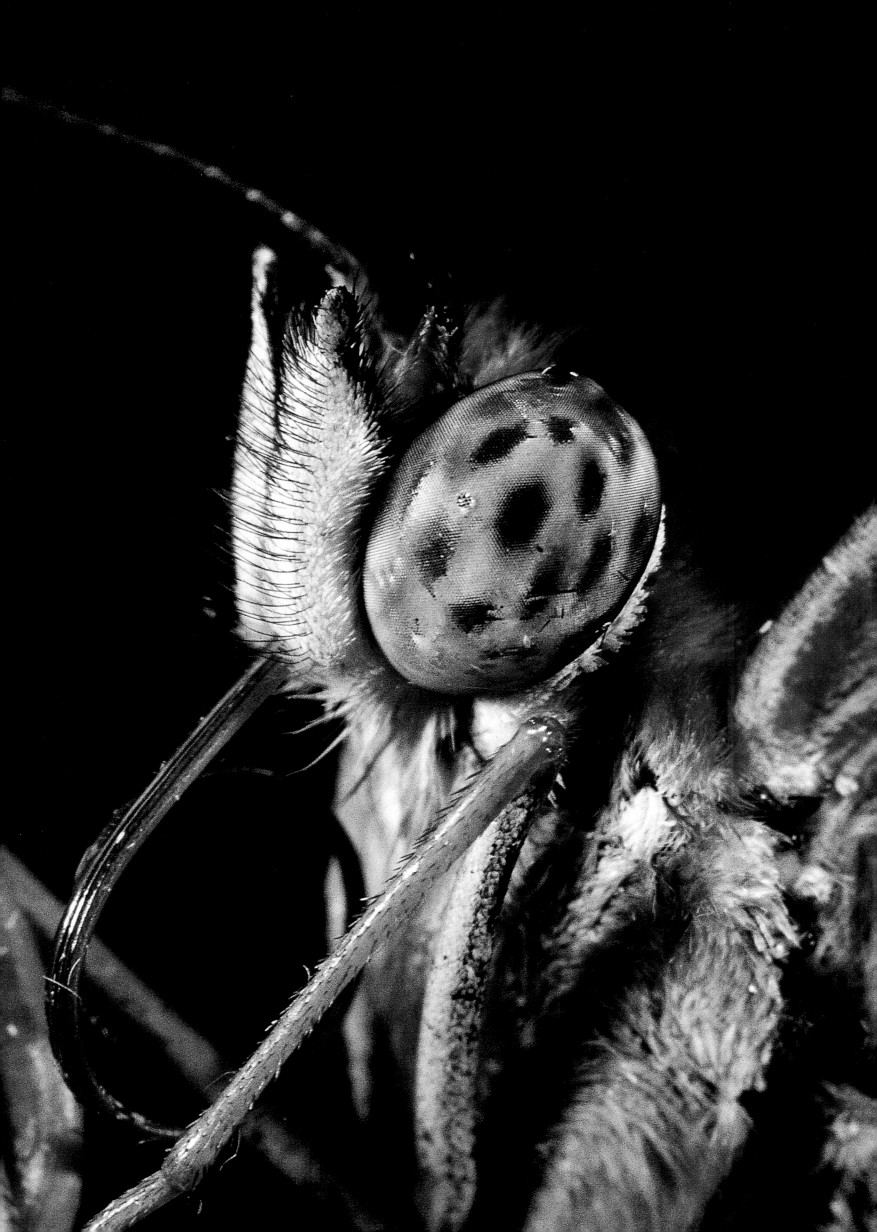

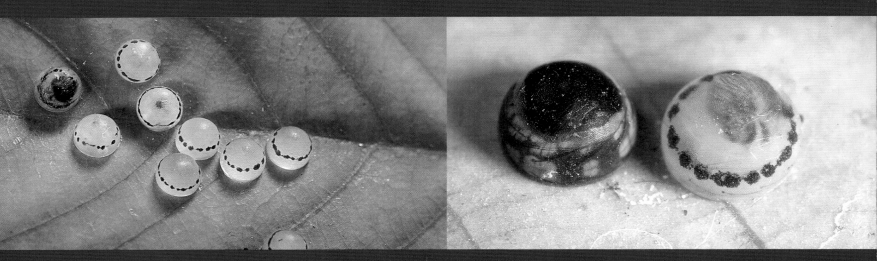

thirty-two pictures of butterfly development

ABOVE AND OVERLEAF
The development of *Morpho peleides*, Morphidae.

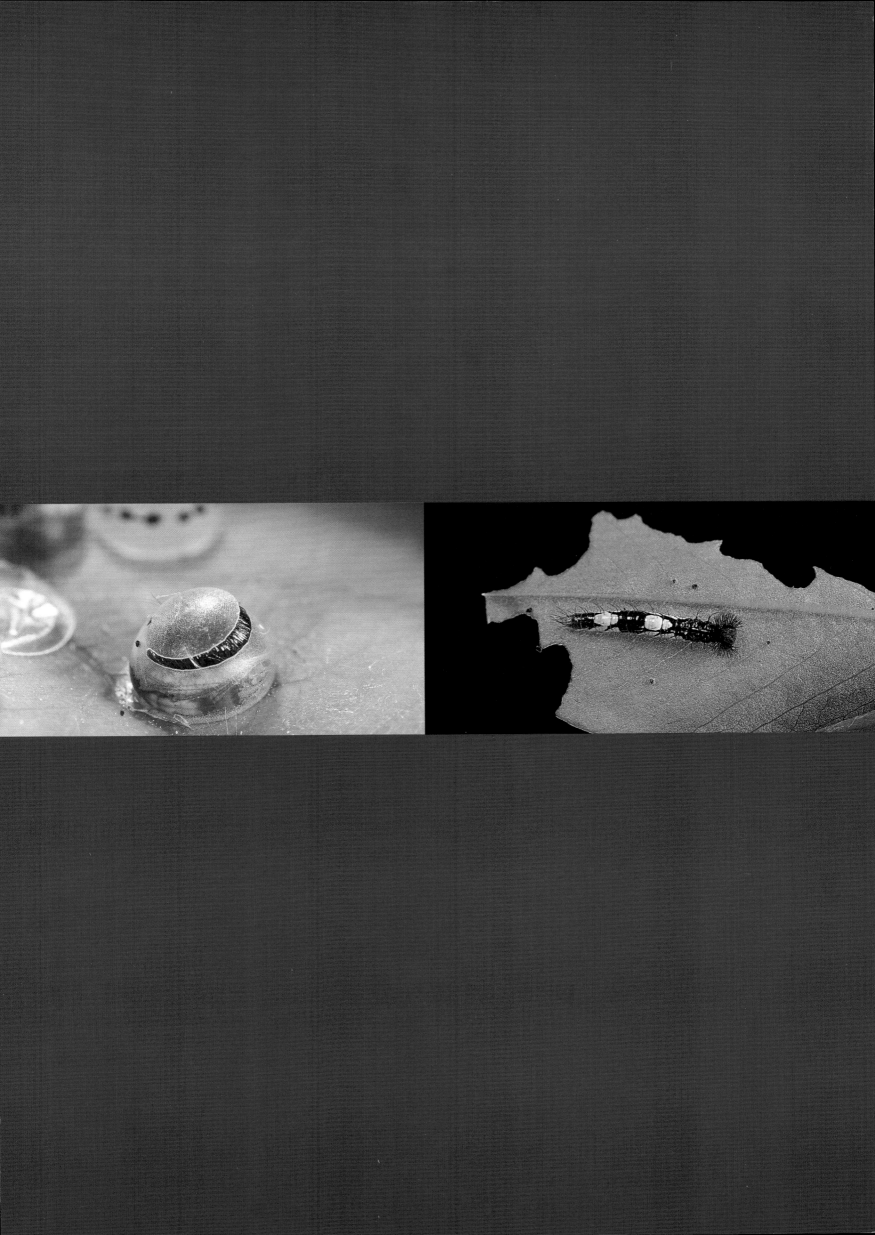

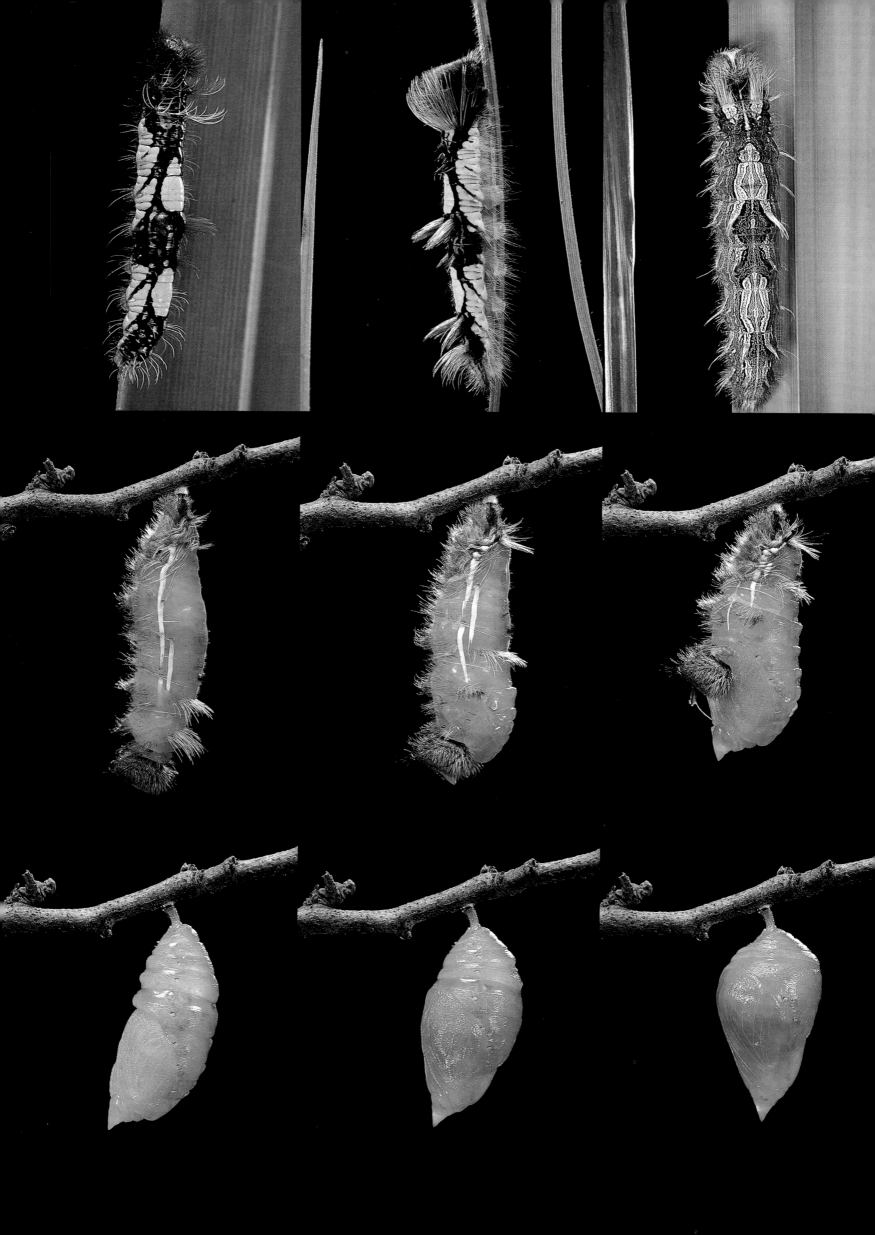

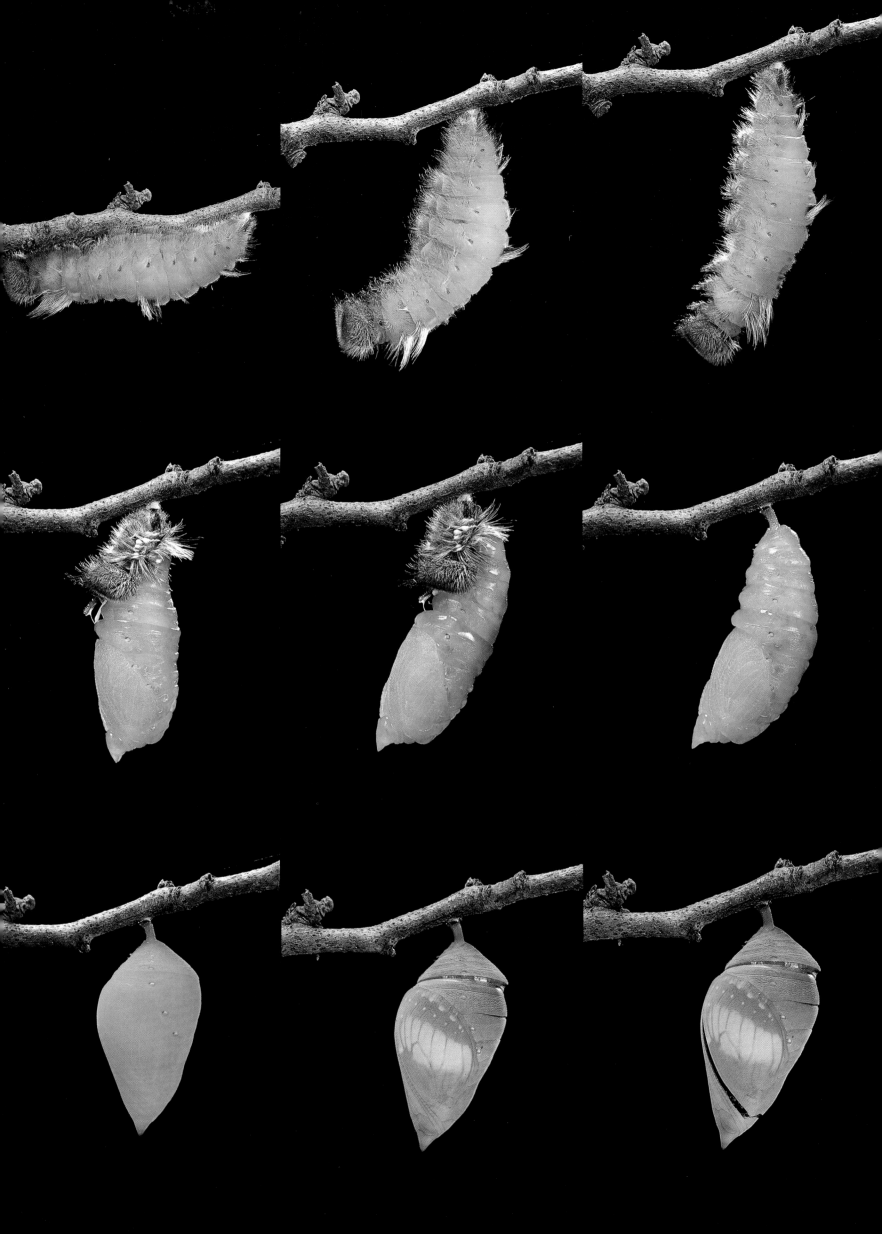

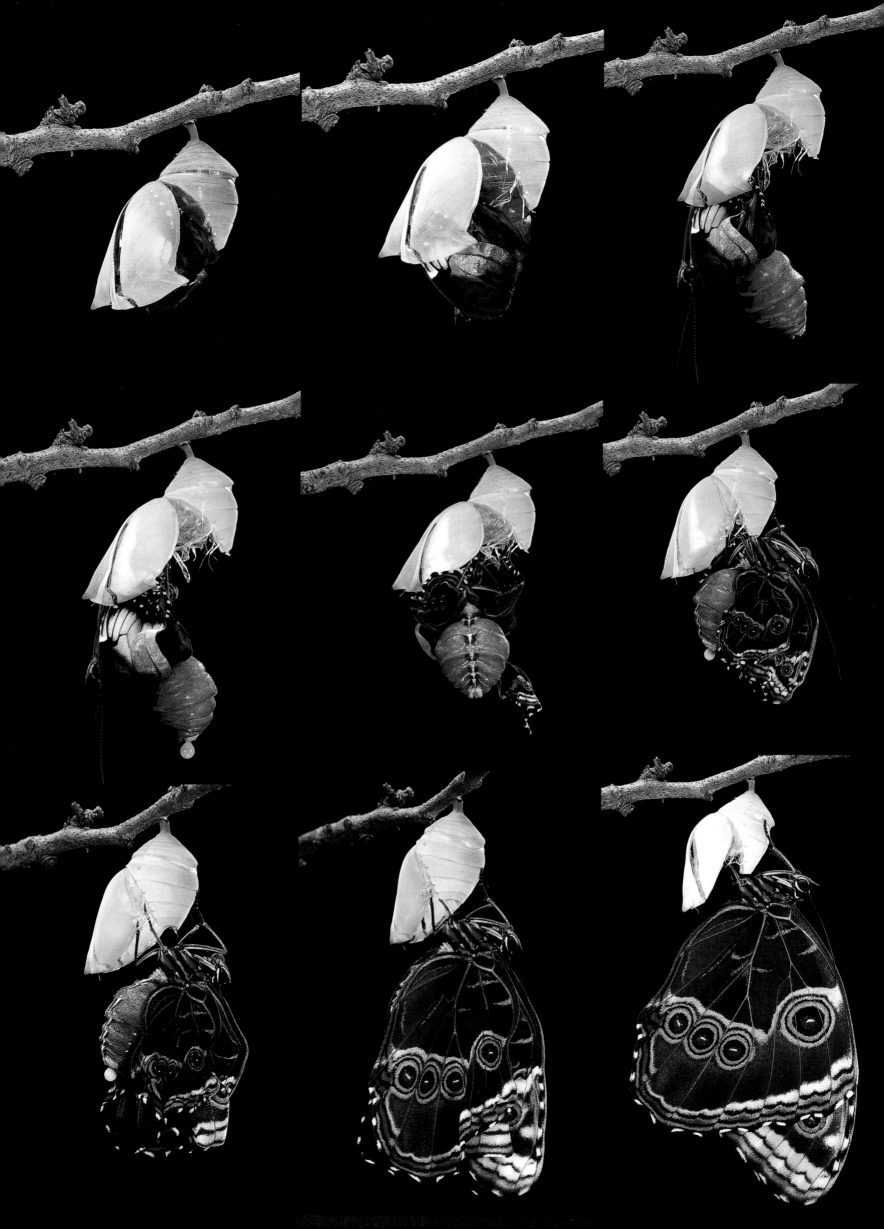

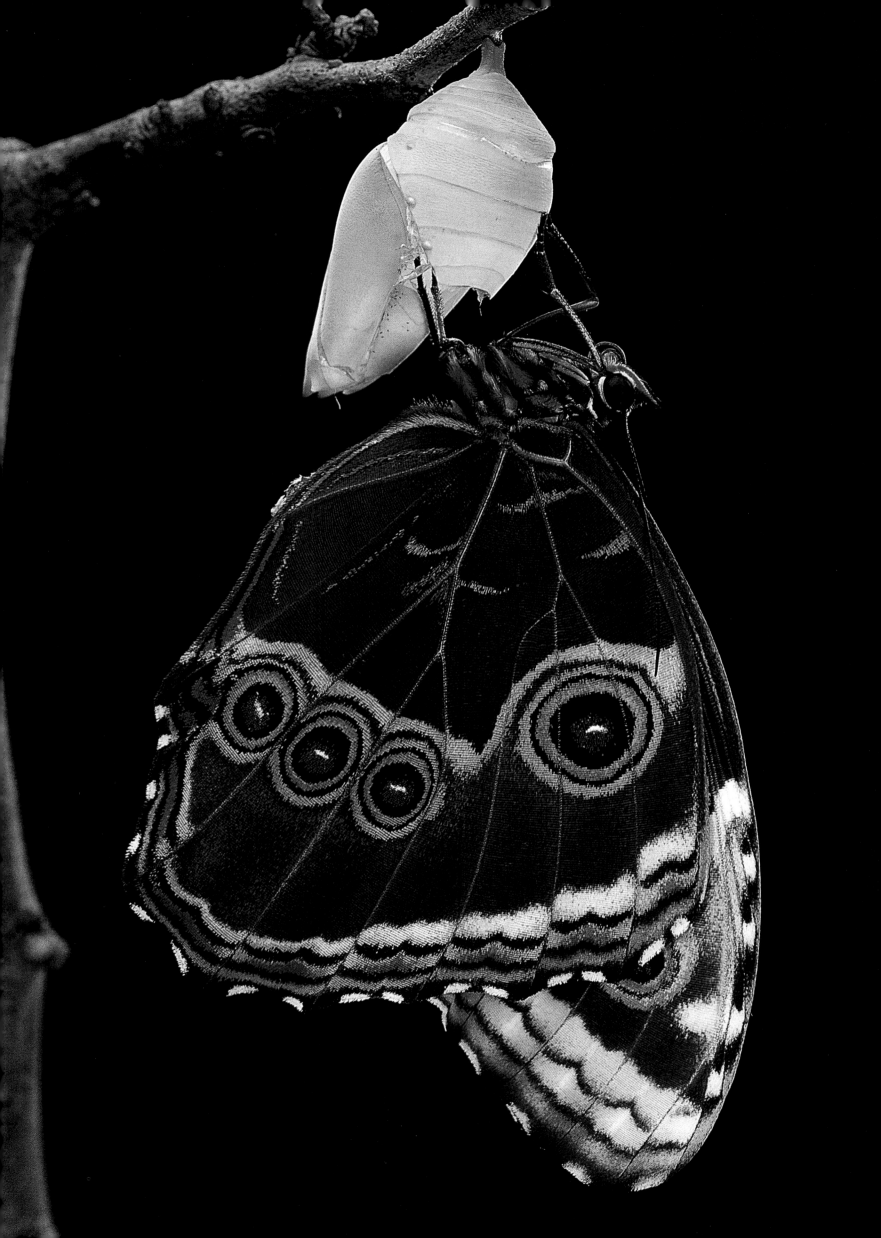

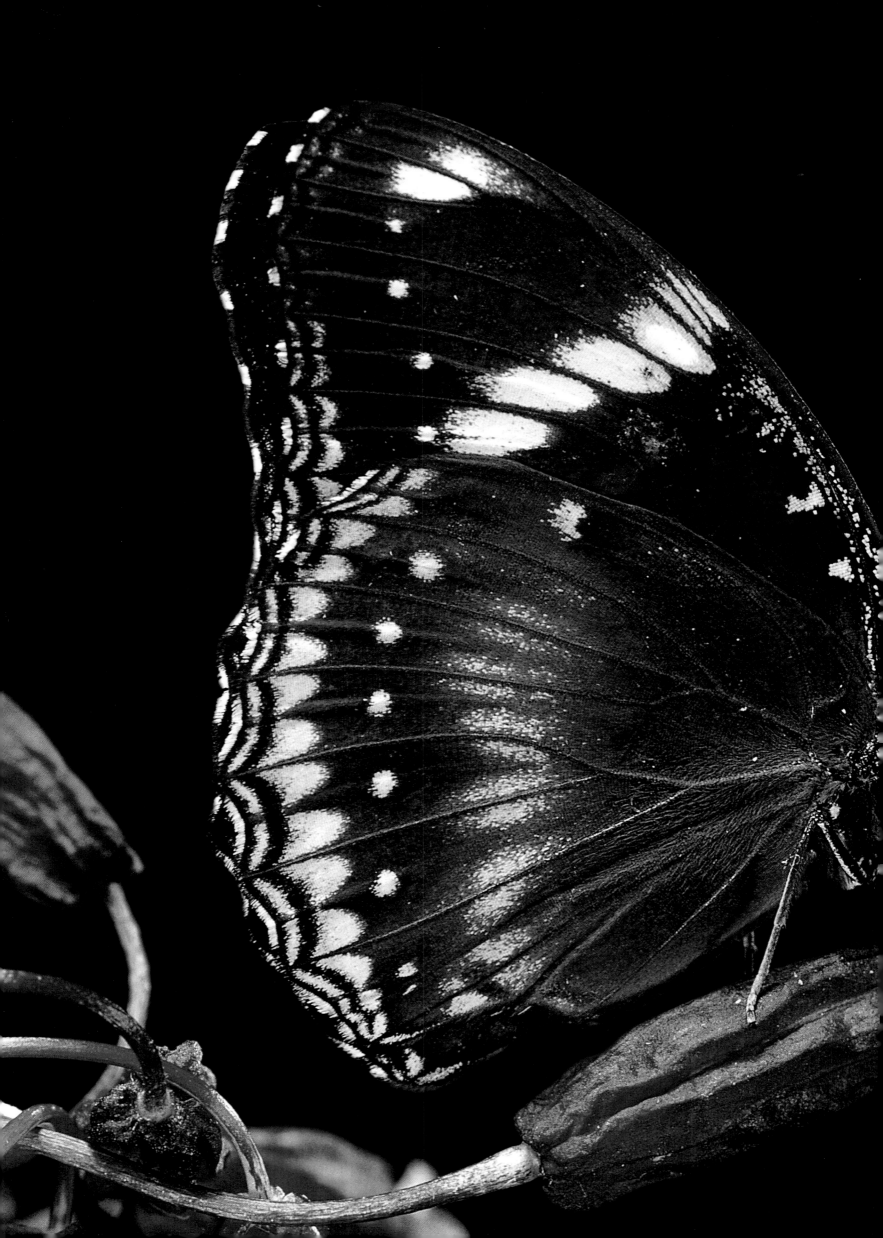

Butterflies

Butterflies rest with their wings closed over the back in a vertical position. Their antennae end in a "club," and their proboscis is always fully formed and functional. The pupae hang from a silk pad by a stalk (cremaster), and some are supported by a threadlike silk girdle about the body. They are very variable in shape and either naked or with very few hairs.

PREVIOUS DOUBLE-PAGE SPREAD

hypolimnas bolina (x 4.8)

Family: Nymphalidae
Distribution: Tropical Asia
Host plants: various Acanthaceae and Urticaceae

Brassolidae

This small family of about eighty species exclusive to tropical America includes the largest butterflies on the continent, with some *Caligo* specimens having a wingspan of 20cm (8in). The larvae feed principally on palms and banana trees and can cause severe damage leading to significant financial loss.

eryphanis aesacus (x 4)

The larva turns into a pupa that is camouflaged by dried bamboo leaves.

Distribution: tropical America
Host plants: bamboo

OVERLEAF

caligo idomeneus "owl butterfly" (x 2.8) & (x 2.2)

This butterfly owes its common name to the large ocelli (eyelike markings) on the hindwings. The purpose of these markings is not to frighten away birds, but to attract the attention and focus the attacks of predators onto parts of the butterfly less vulnerable to injury.

Distribution: South America
Host plants: various Marantaceae

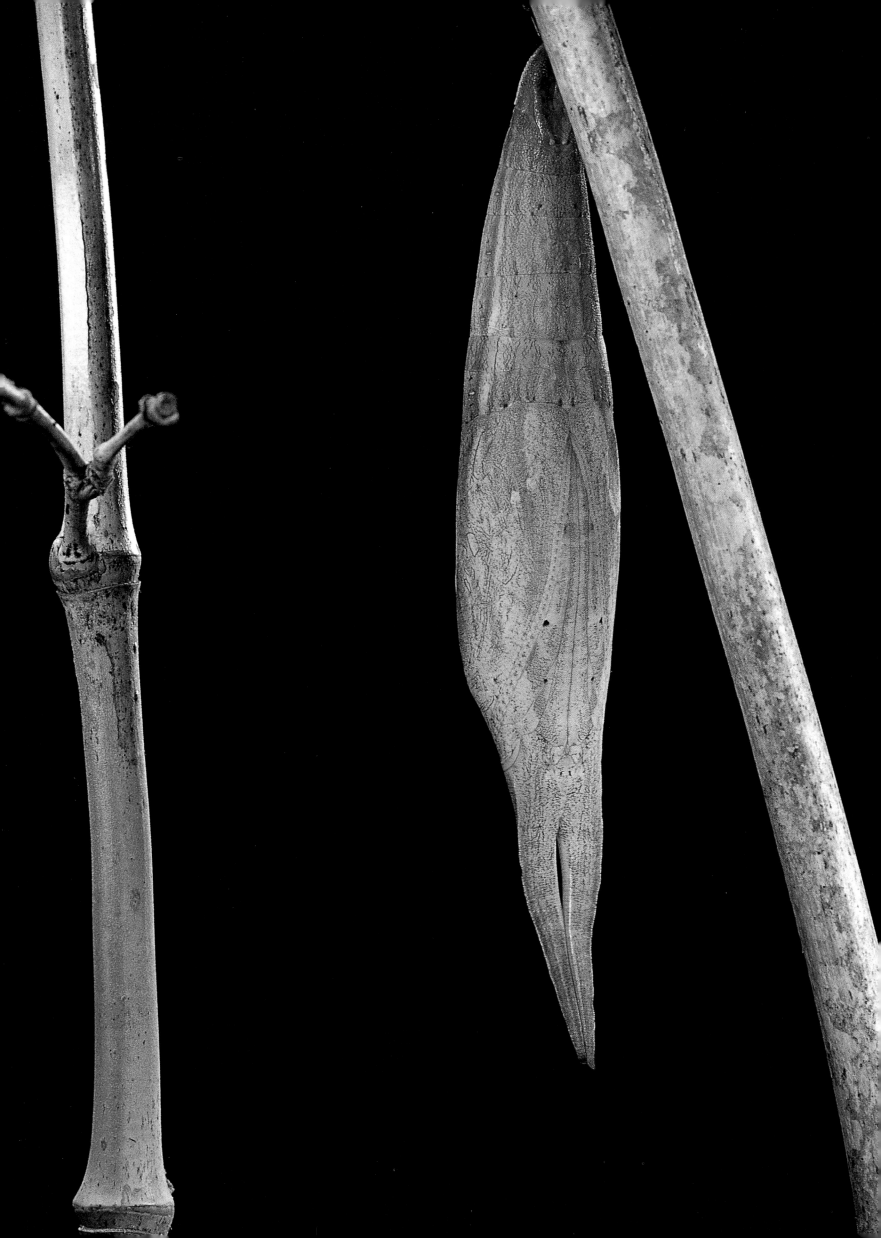

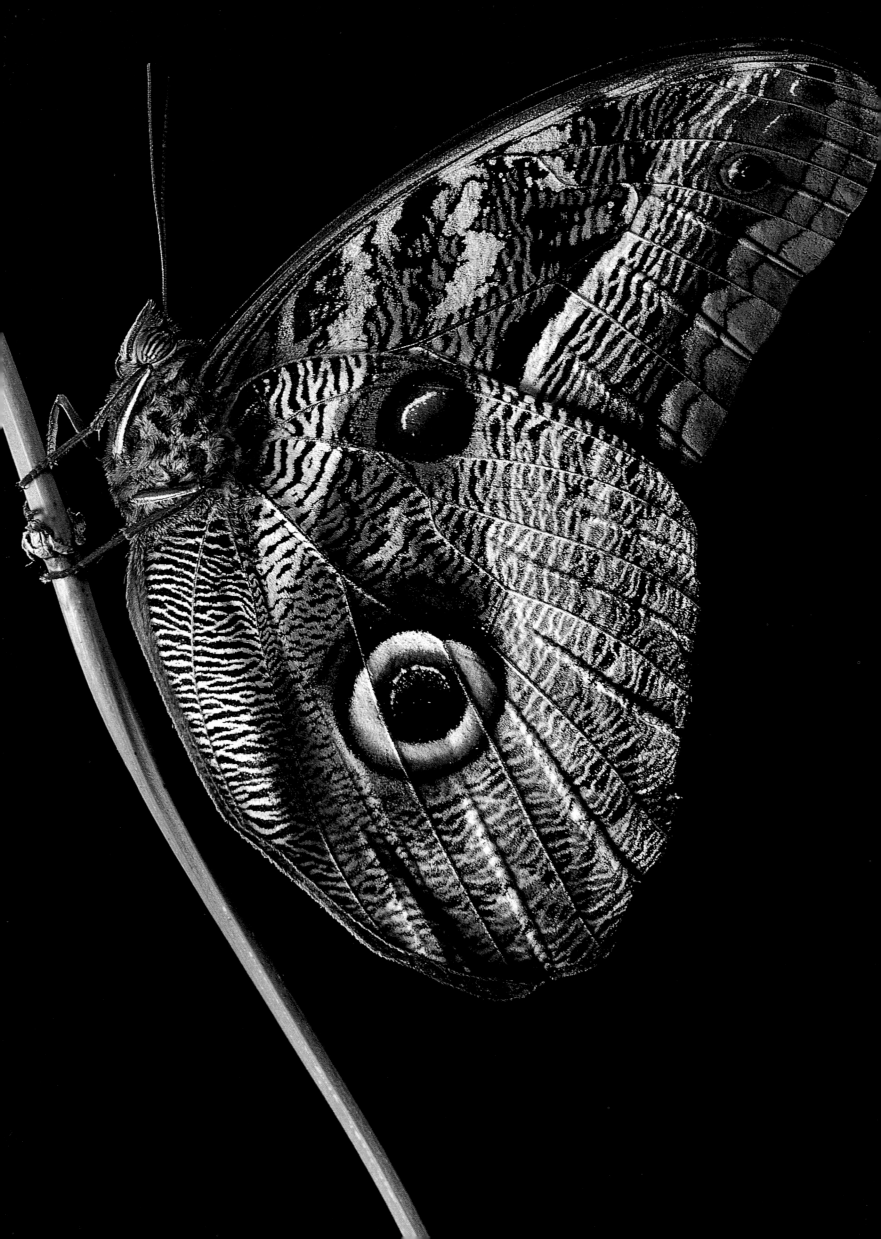

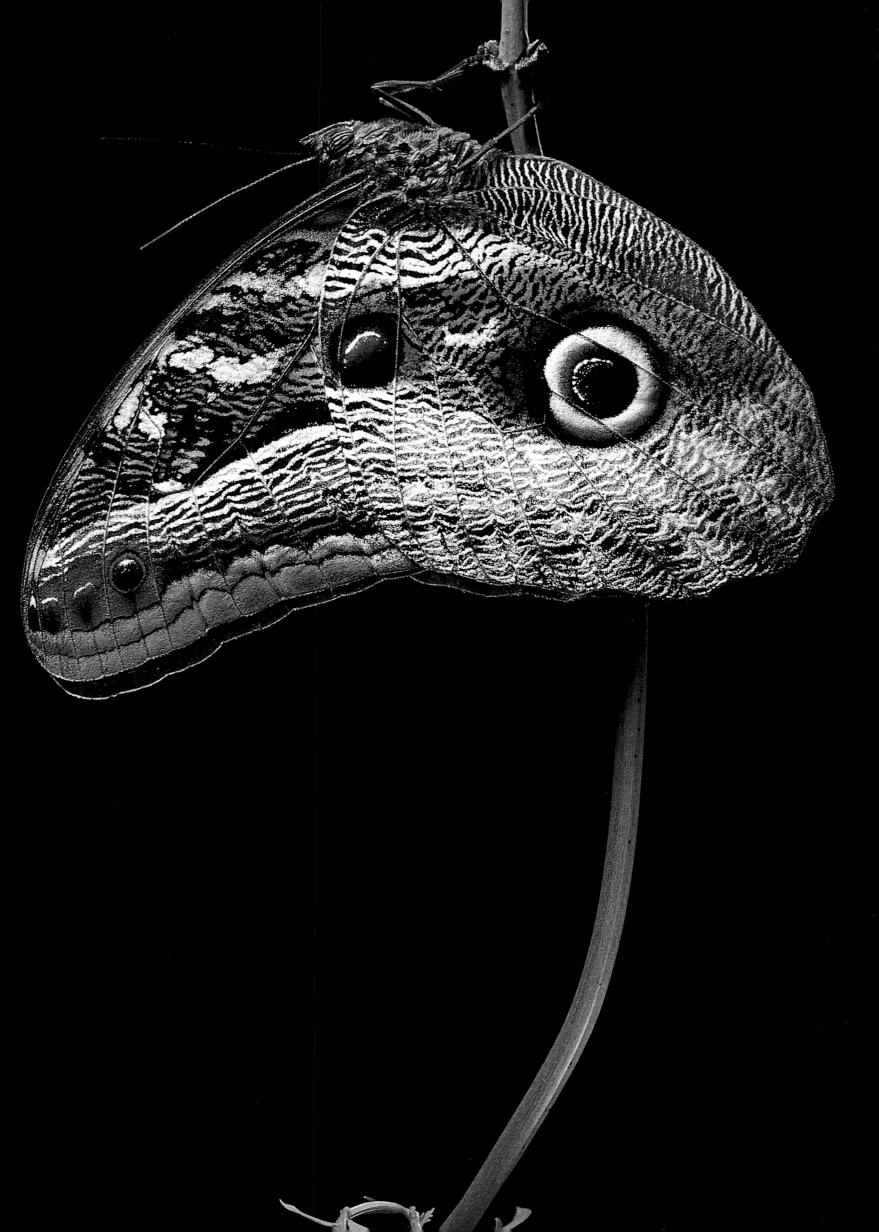

eryphanis aesacus
(x 7.4)

Detail on the upper side of the wings. Thanks to these irregular patterns and cryptic (camouflage) colors this butterfly can spend most of the day on tree trunks without being noticed.

Distribution: tropical America
Host plants: bamboo

OVERLEAF

Danaidae

All the Danaïdae live on poisonous or toxic plants (*Asclepiadaceae, apocynaceae, Moraceae*) making them the most "protected" and therefore the most "mimicked" family of all the butterflies in terms of Batesian or Müllerian mimicry. There are about 300 species in all, ranging from average to large size, mainly distributed throughout the inter-tropical zones.

idea leuconoe
(x 3.9)

This is the largest of the Danaidae (12 -15 cm/5-6in), and it flies very slowly. It has been compared to a piece of paper floating through the air.

Distribution: tropical Asia
Host plants: *Tilophora* (Asclepiadaceae)

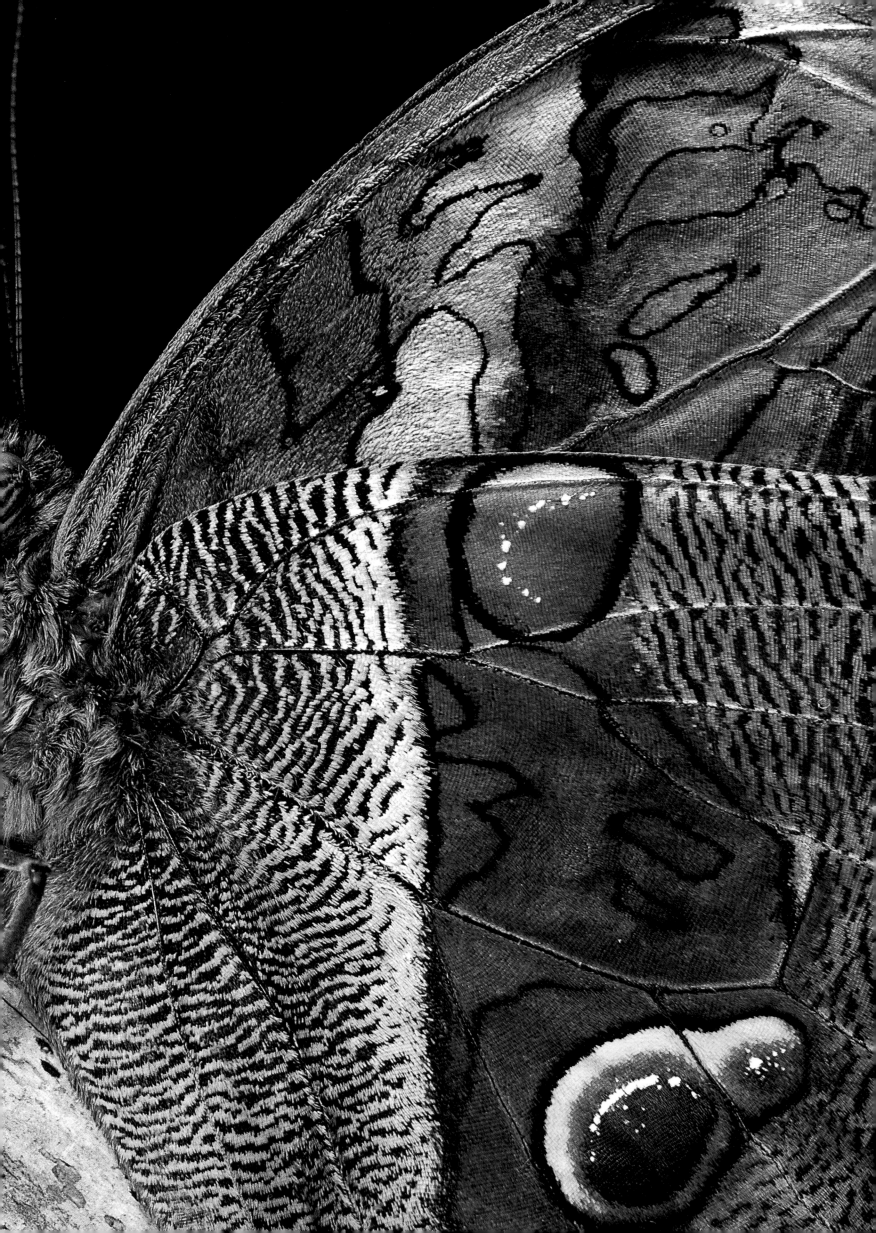

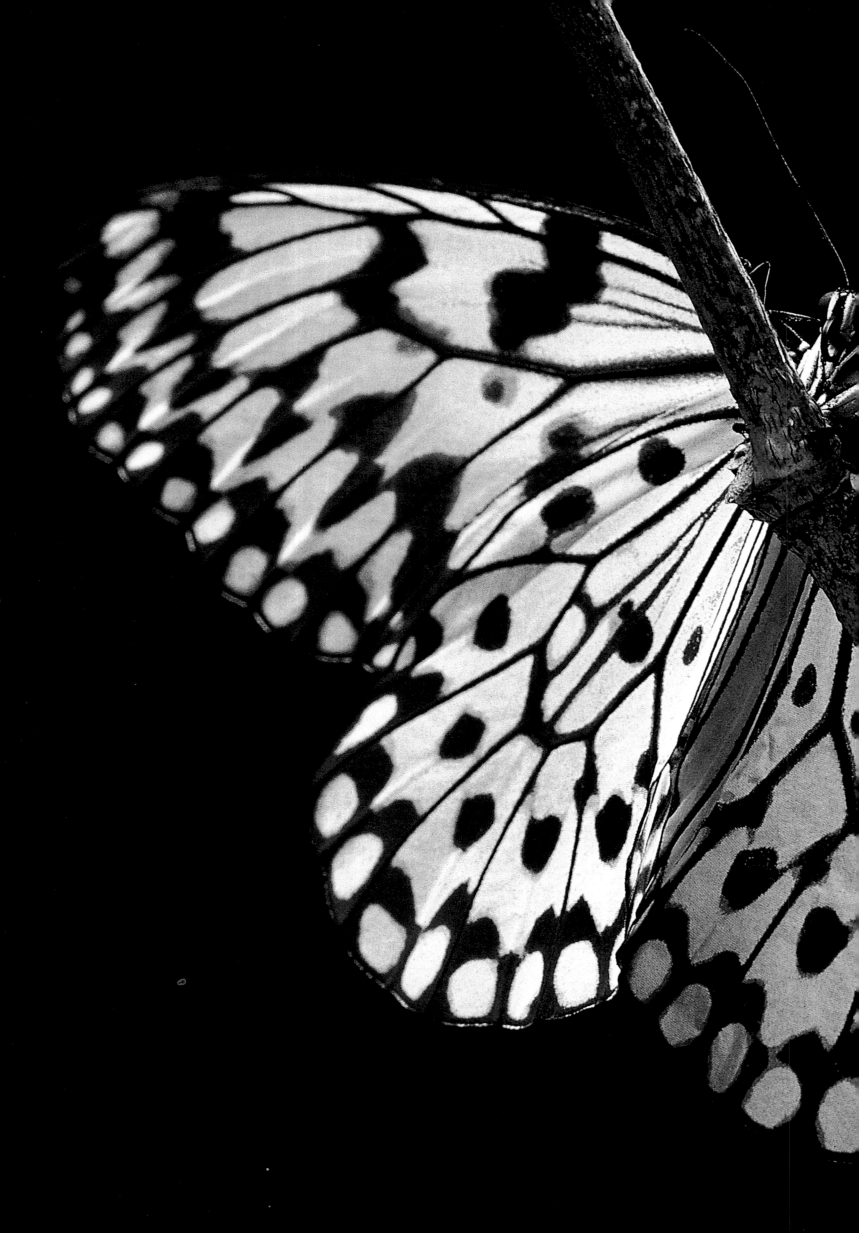

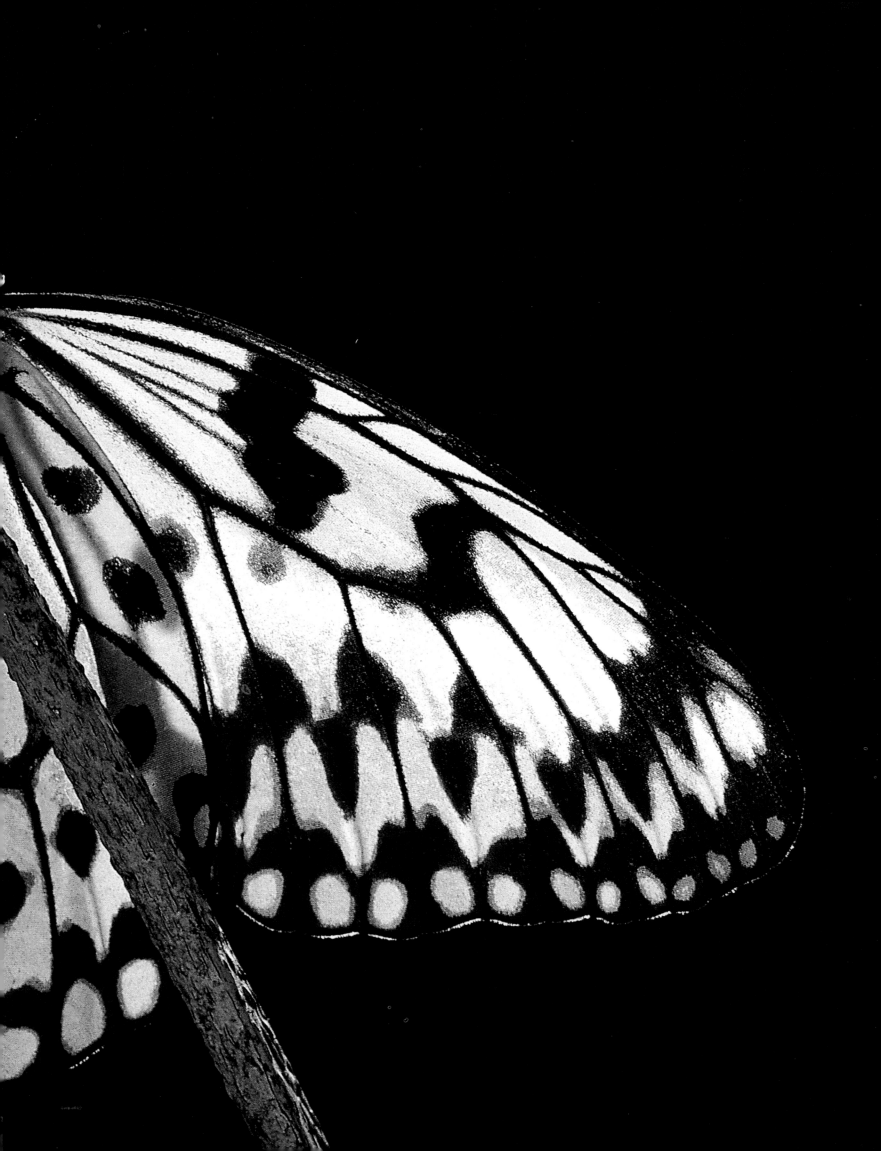

Heliconidae

This small family of seventy medium-size butterflies is exclusive to inter-tropical America. They feed solely off passiflora and are therefore relatively poisonous to predators. With their narrow wings, slim body, and long antennae, these butterflies have rather a sickly appearance; but with a lifespan of sometimes more than six months, they in fact rank among the most durable butterflies in the world.

dryas julia (x 6.8) & (x 4)
"flame of flambeau"

Above, larva nibbling a *Passiflora caerulea* leaf. Below, pupa hanging from a passiflora tendril. This species is found as far away as the southern states of the USA.

Distribution: tropical America
Host plants: passiflora

OVERLEAF
heliconius melpomene (x 6)
"postman"

Distribution: tropical America
Host plants: passiflora

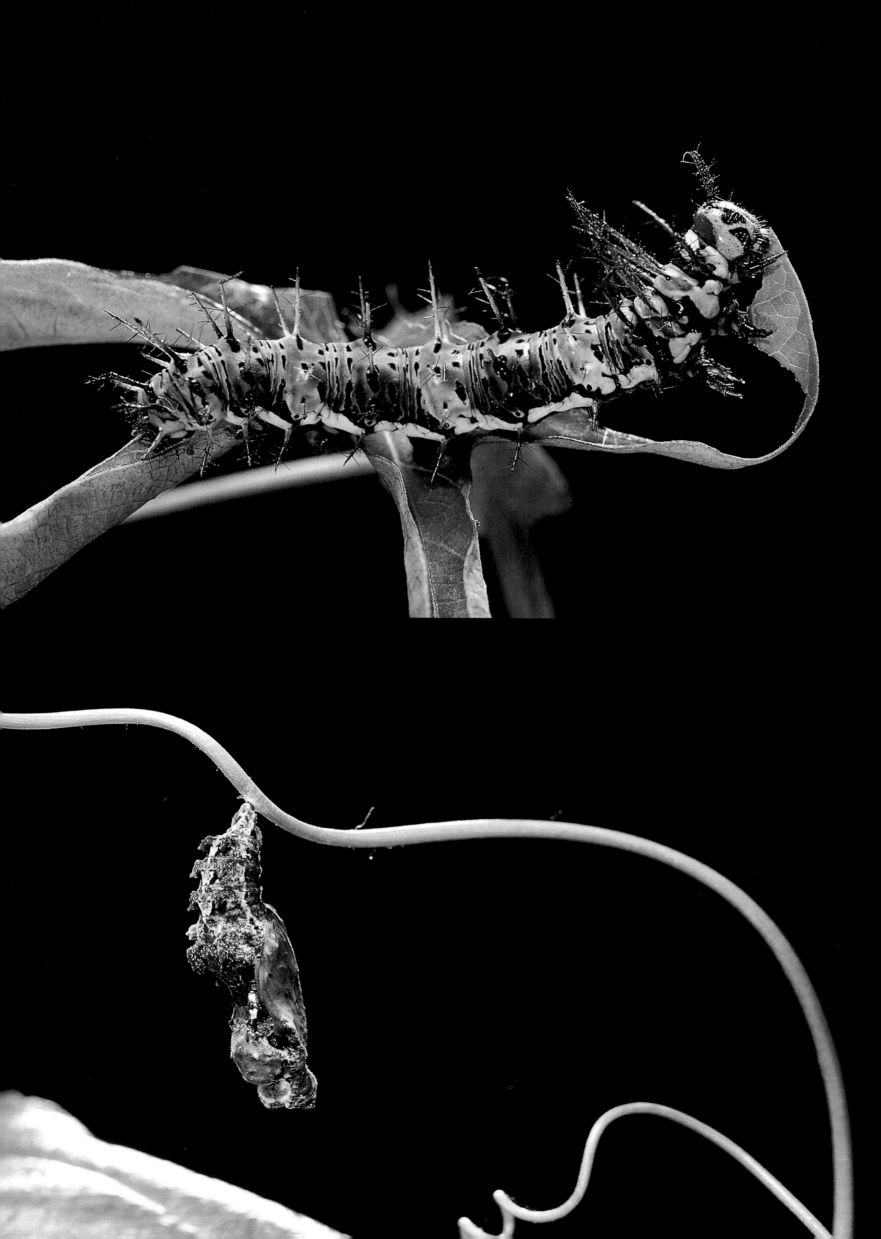

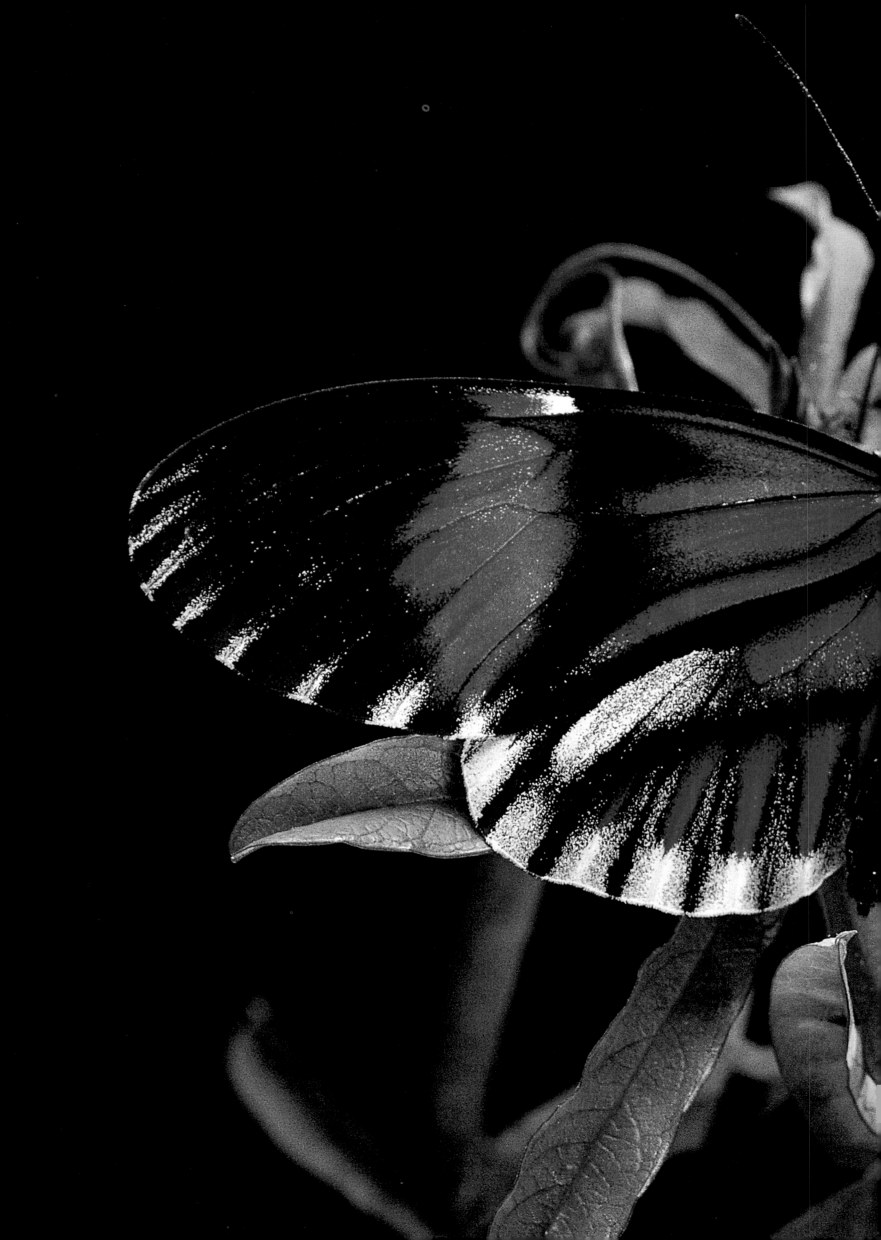

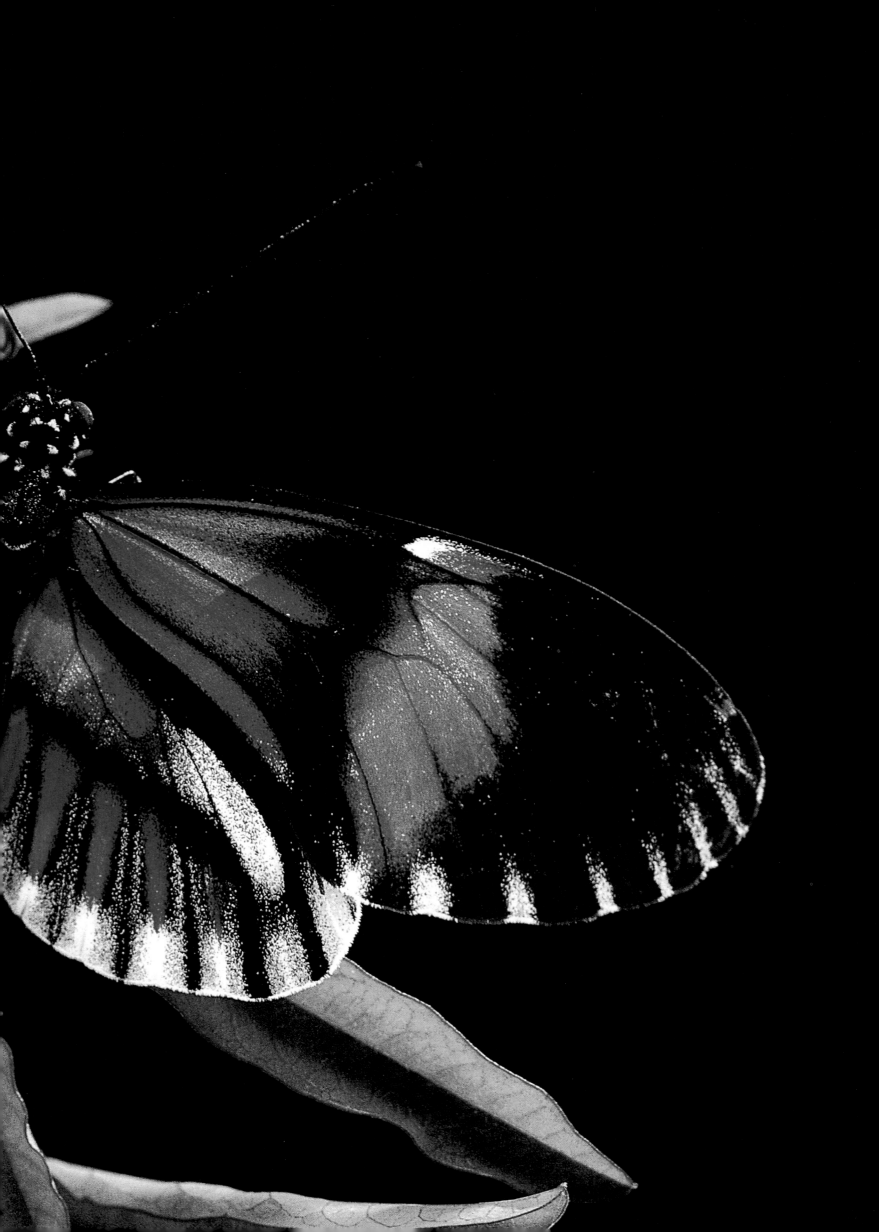

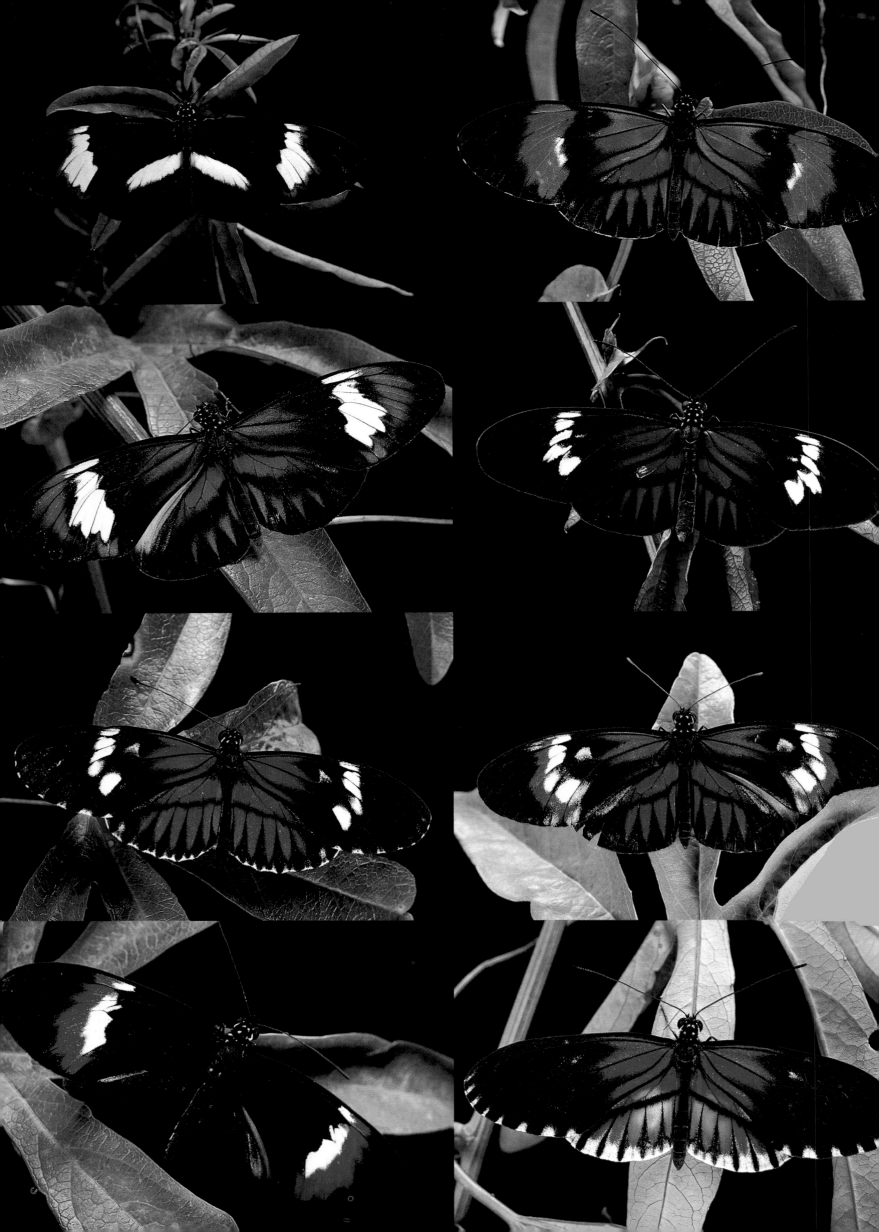

heliconius melpomene
"postman"
[x 1.5] x 8

Species that are found over a wide dis-
tribution area often develop marked
variations leading to the creation of
subspecies, some of which are more
different than others. In areas where
these subspecies meet, vigorous cross-
breeding adds to the diversity.

Distribution: tropical America
Host plants: passiflora

heliconius melpomene
"postman"
(x 48.7)

Heliconius develops rapidly: the larva hatches a few days after laying, and three weeks later turns into a pupa that one week later releases a butterfly.

Distribution: tropical America
Host plants: passiflora

heliconius hecale
(x 14.6)

The eggs are often laid on the young passiflora tendrils. As soon as they hatch, the young larvae move to the tip of the tendril and tuck into their first meal.

Distribution: tropical America
Host plants: passiflora

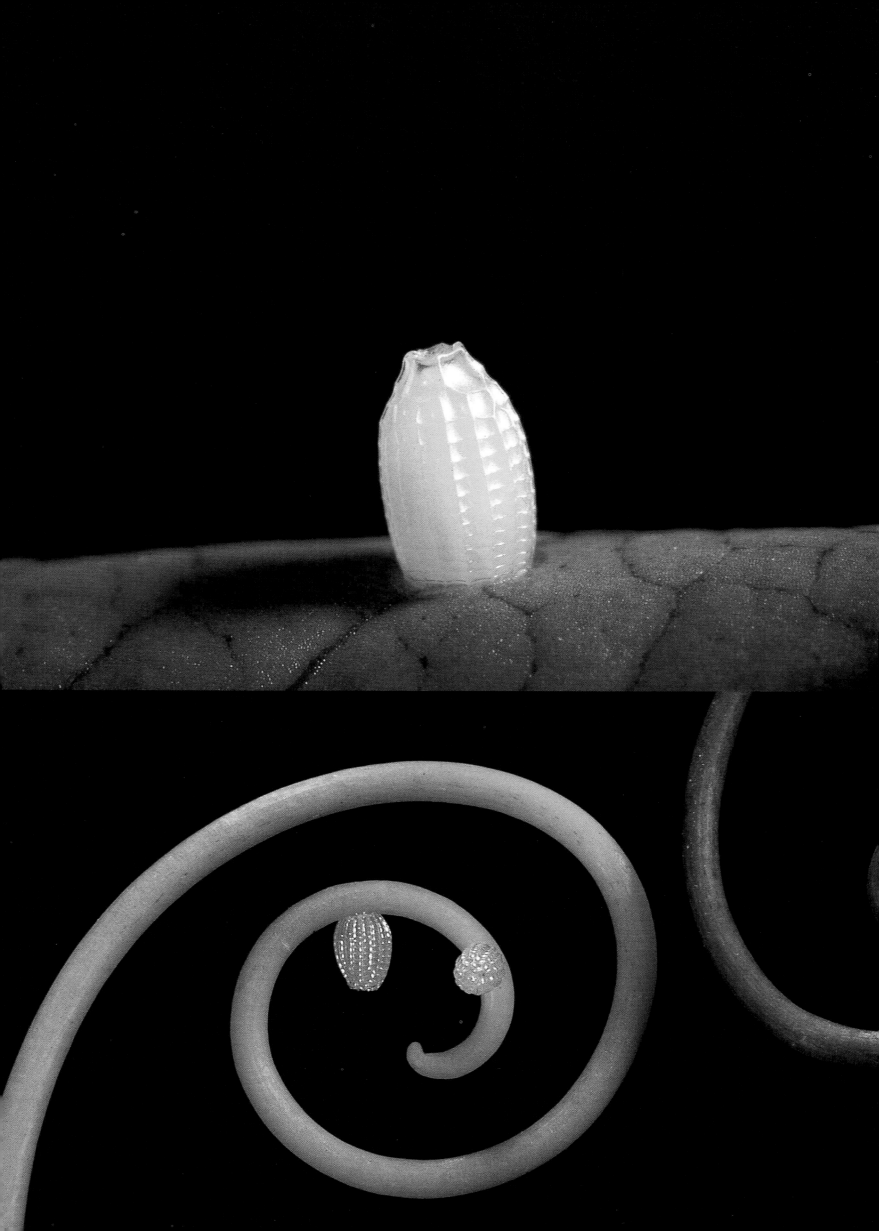

Ithomiidae

The Ithomiidae comprise about 400 small- to medium-size species, all found in tropical America except for one in Australia and Papua. They are protected from predators by foul-smelling body fluids that render them inedible. The larvae are hairless, and the pupae are often decorated with varying amounts of gold pattern.

ABOVE AND FACING

greta oto (x 10.4) & (x 4.2)
"glasswing"

This pupa suspended from the underside of a food-plant leaf will eventually release a butterfly with wings as transparent as a dragonfly. What an advantage it is to be practically invisible when you fly absurdly slowly and live in the darkness of a tropical rain forest!

Distribution: tropical America

Host plants: Cestrum (Solanaceae)

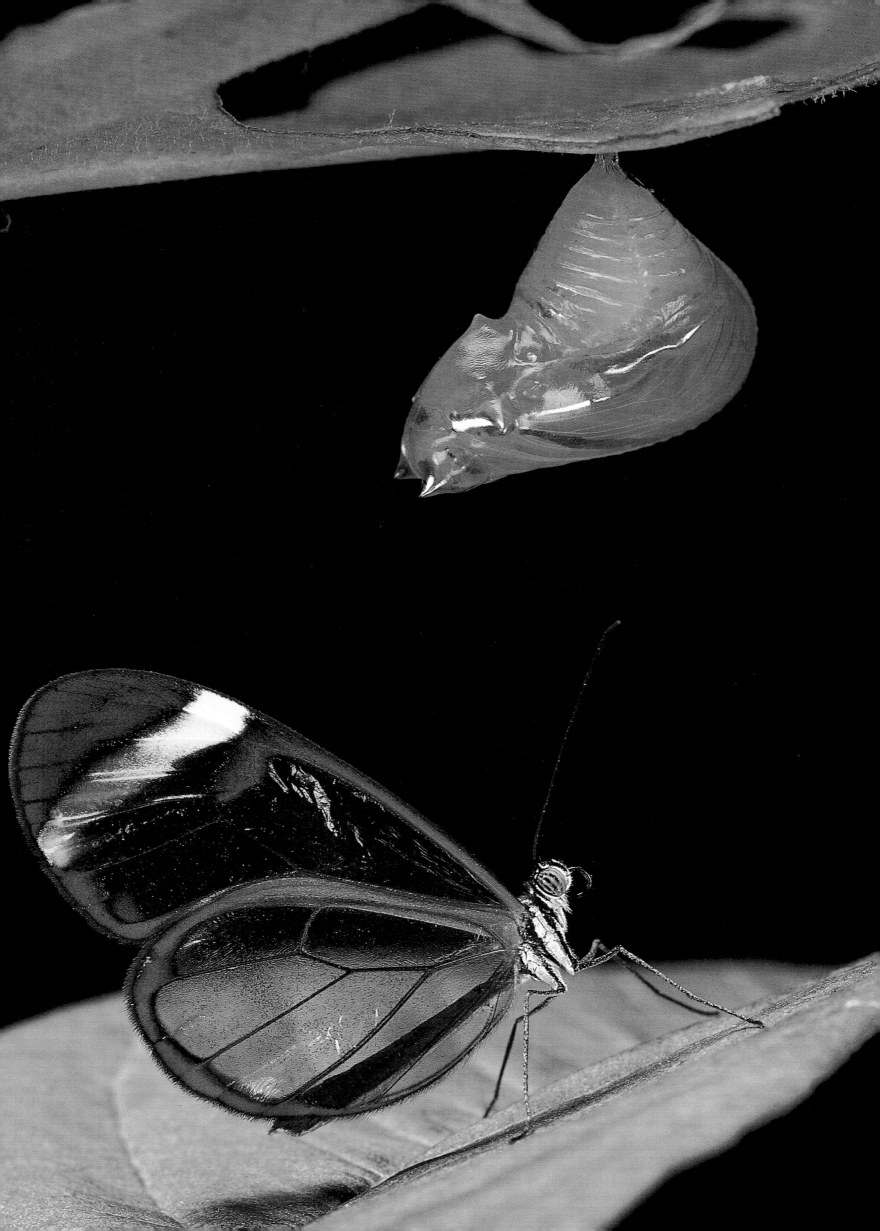

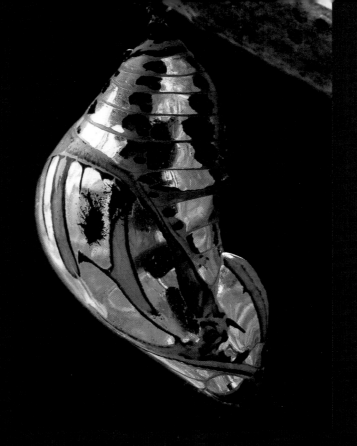

tithorea harmonia (x 5.4)

Distribution: tropical America

Host plants: *Prestonia* (Apocynaceae)

RIGHT

mechanitis polymnia (x 5.3)

Distribution: tropical America

Host plants: *Solanum* (Solanaceae)

OVERLEAF

Nemeobiidae

There are more than 2,000 species of Nemeobiidae in tropical America, but only one in Europe. They are all quite small, but come in an extraordinary variety of shapes and sizes.

helicopis cupido (x 8) & (x 8) (silverspot)

This little jewel is commonly found in swamplands, but it will also venture into the suburbs of towns provided there are ditches damp enough to accommodate its nutritive plant. It is a popular butterfly that owes its name to the raised silver markings on the upper side of the hindwings.

Distribution: tropical America

Host plant: *Montrichardia* (Araceae)

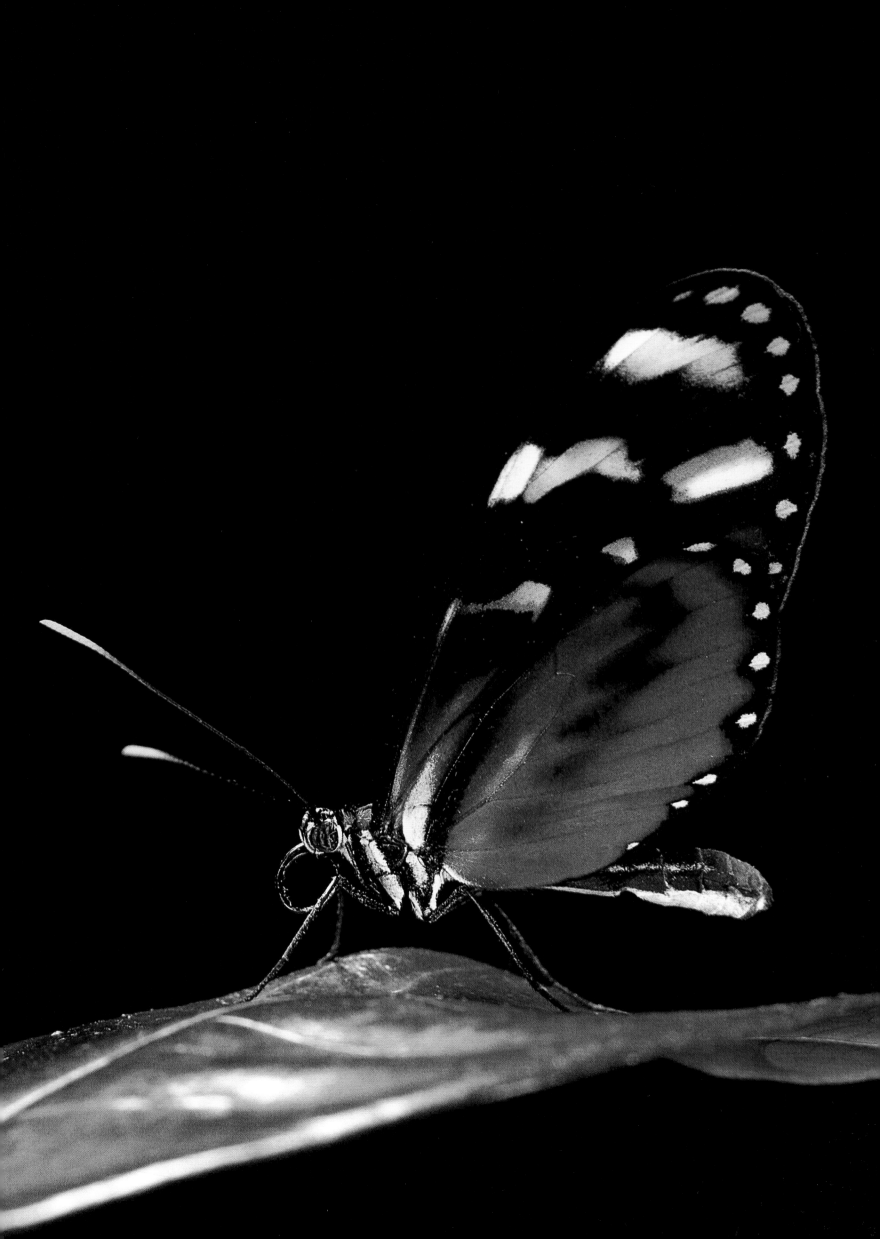

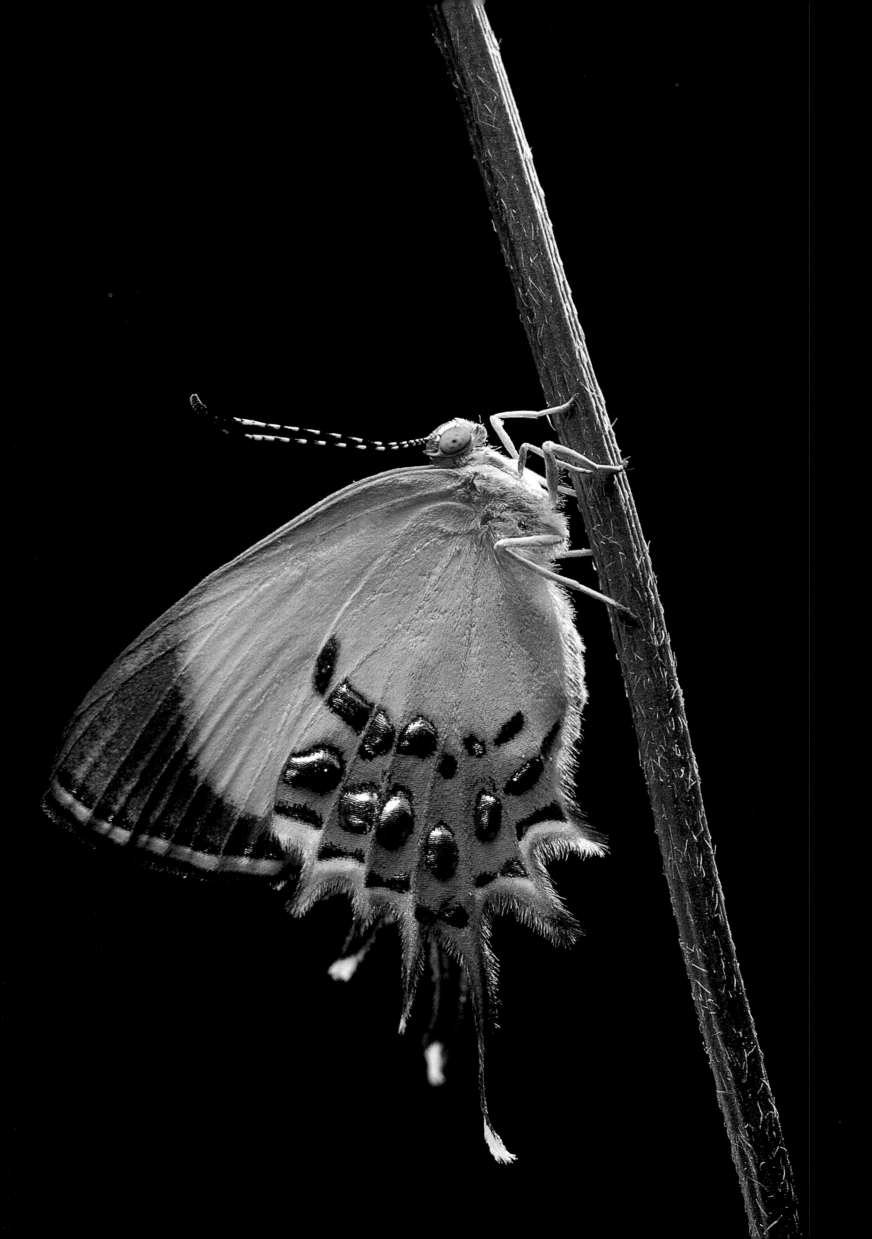

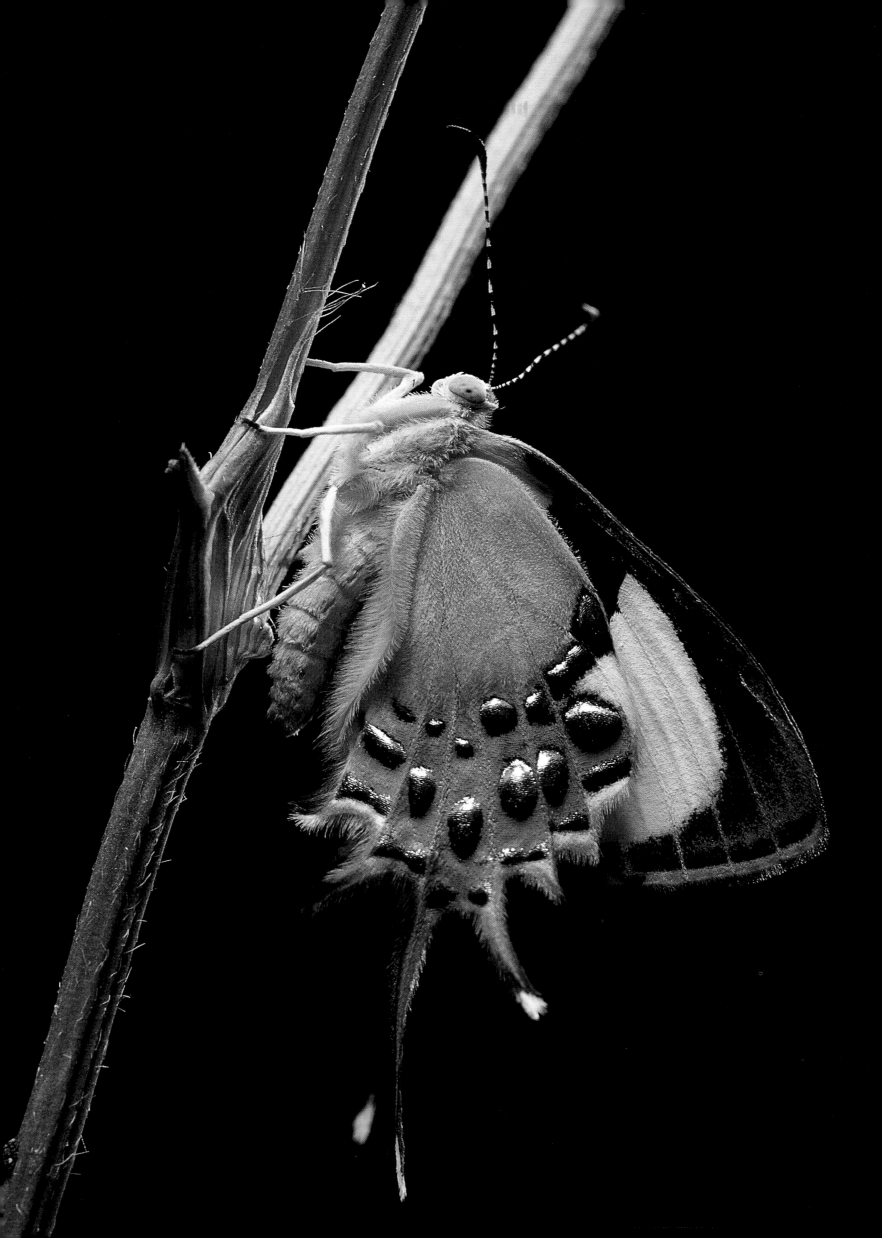

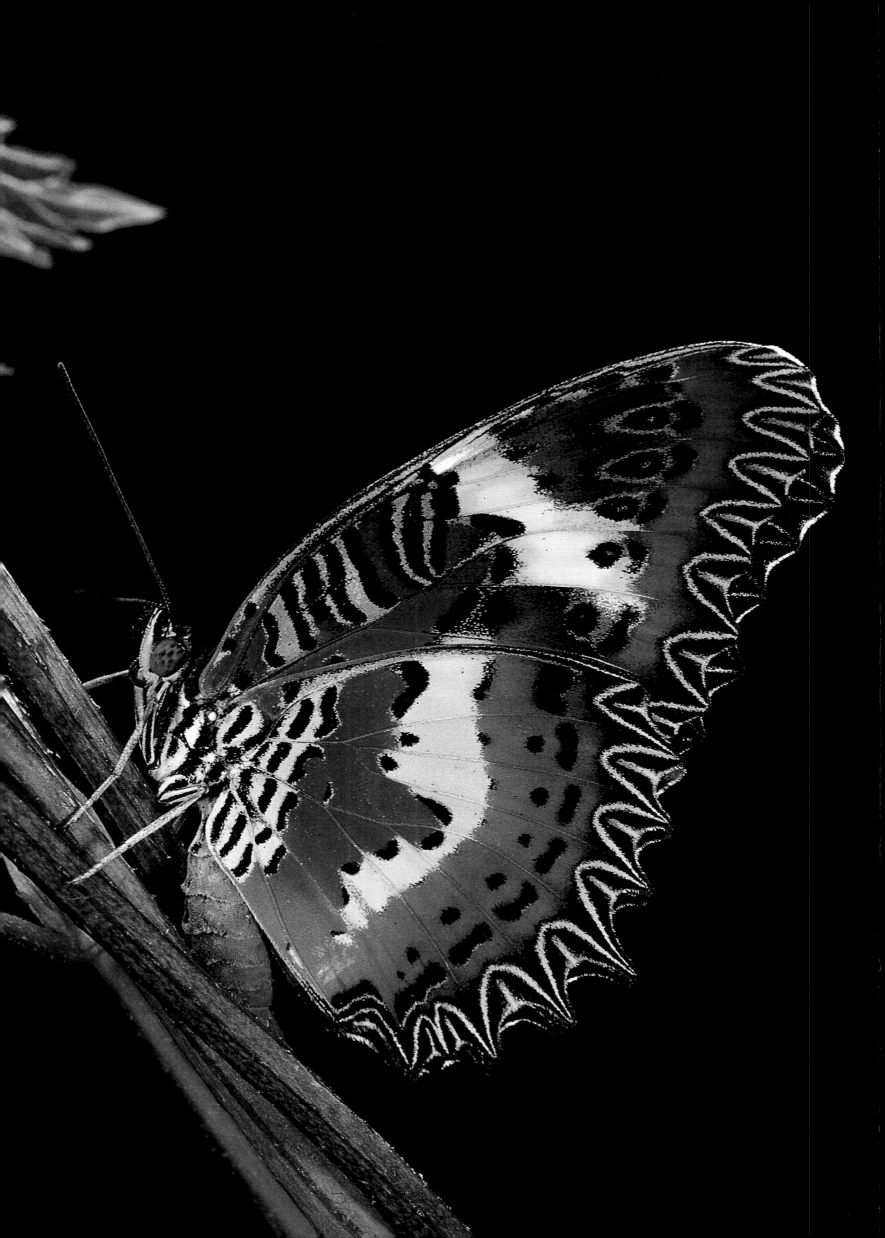

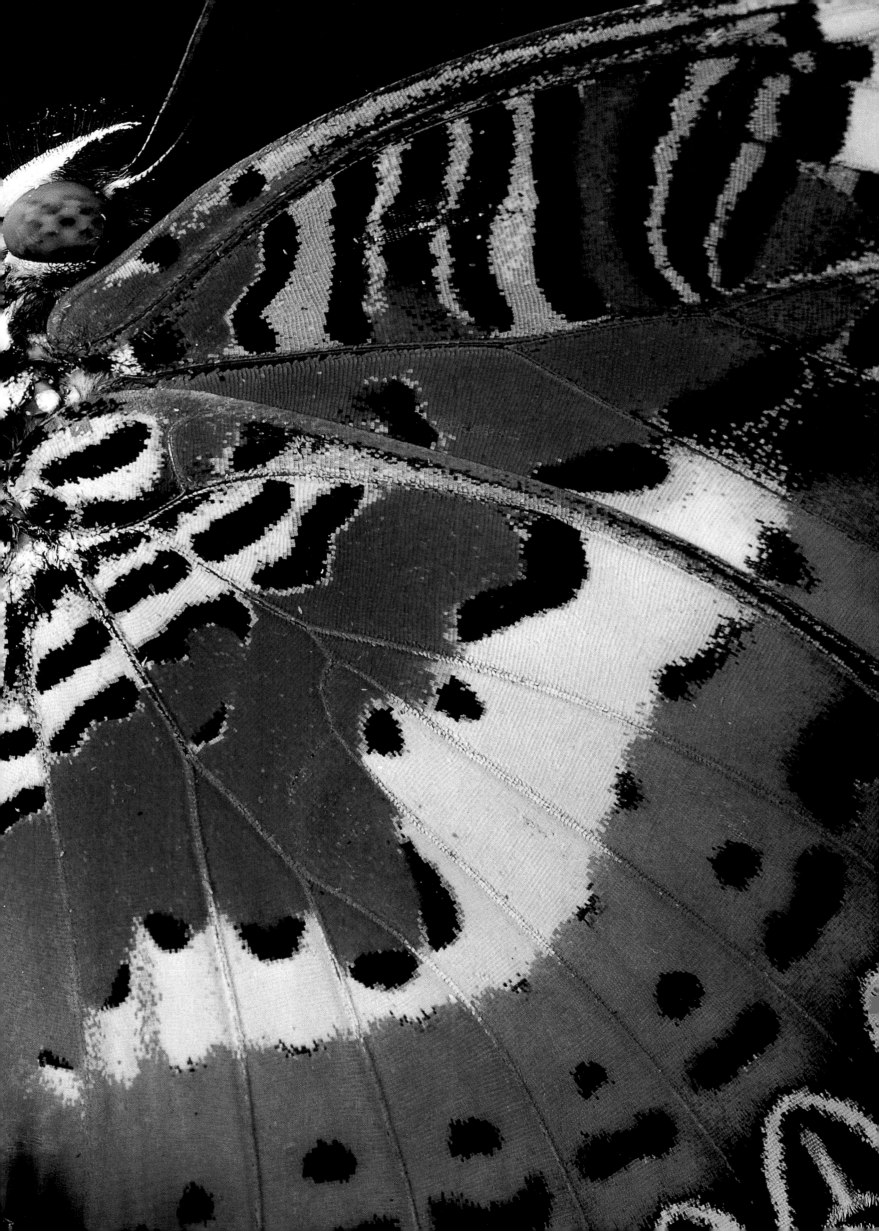

Nymphalidae

This is one of the largest butterfly families, comprising several thousand species that are found the world over and in every kind of habitat. The ones featured here are medium- to large- size (13 cm/5in), often brightly colored, with different shapes and often complex patterns. The larvae are frequently spiny and live off a great many different plants. The pupae are always suspended and may be smooth or feature various appendages that help to reinforce mimicry.

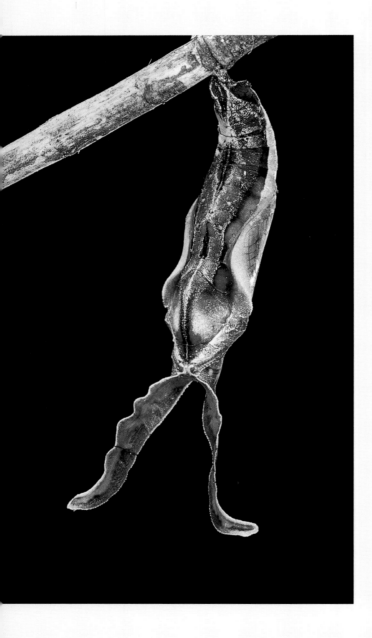

PREVIOUS DOUBLE PAGE

cethosia hypsea (x 4.3) & (x 10.6)

Distribution: tropical Asia
Host plants: various Passifloraceae

OPPOSITE

hamadryas amphinome (x 3.3) "cracker"

Distribution: tropical America
Host plants: *Dalechampia* (Euphorbiaceae)

RIGHT

charaxes varanes (x 2.1) & (x 2.4)

Charaxes have powerful bodies and are strong fliers. Nearly all the species are confined to Africa. As with a great many large Nymphalidae, they do not feed off flowers, but live off all sorts of fermented or decomposing matter. In some countries they are known as "shitophagous," which suggests what kind of food they prefer.

Distribution: tropical Africa
Host plants: various Sapindaceae

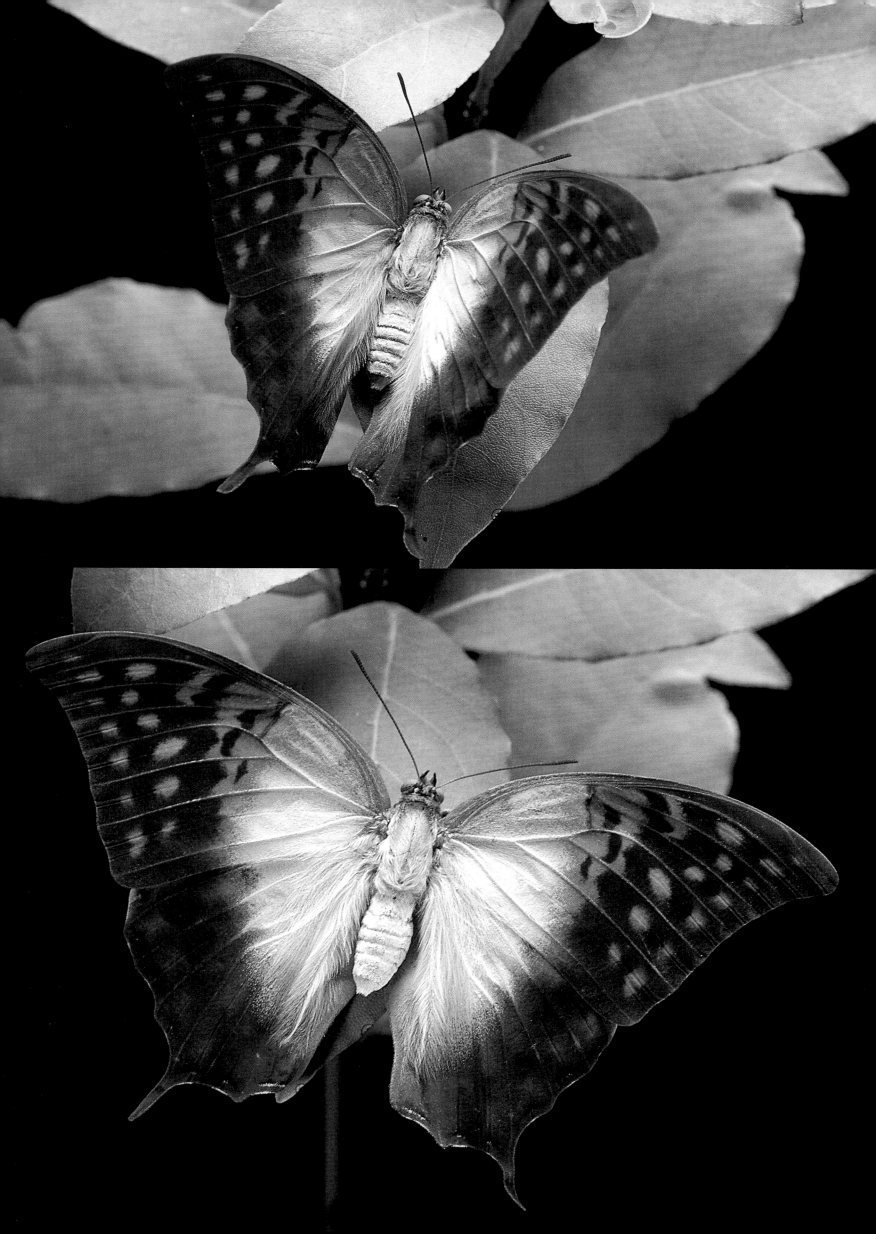

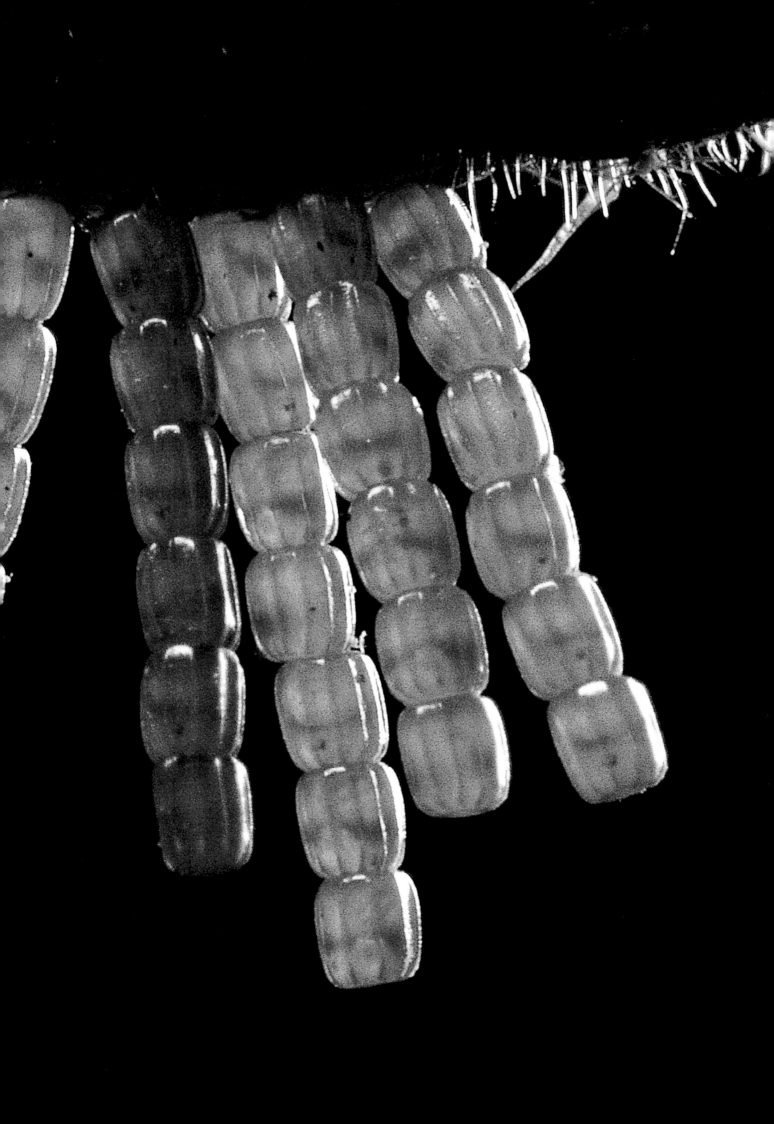

PREVIOUS DOUBLE-PAGE SPREAD

chnia levana [x 49]
(summer brood)

he French have another name for this butterfly
hat they call the "Carte géographique"
geography map) due to the complex patterns
n the under side of the hindwings, where you
an almost see road networks, rivers, and more.
he female lays her eggs under nettle leaves in a
most unusual way, piled one on top of the other.

istribution: Europe to Japan
ost plants: Urticaceae

IGHT

araxes jasius [x 4.5]

his butterfly that we find hovering in
owns and perched on the rims of glasses
utside cafés and restaurants has learned to
dapt to the ways of man; the larval food
lant is highly ornamental and grows widely
n gardens. As for the imago, a municipal
aste tip laden with leftovers provides an
nexhaustible supply of rich pickings.

istribution: on the borders of the Mediterranean
ost plants: arbutus

VERLEAF

nisio peacock [x 6]

ike many of the Vanessa, the Peacock with a life
an of ten months, lives longer than any other
nago, and in northern regions there is only one
eneration per year. Butterflies born in the
ummer soon go into hibernation, where they
emain tucked away for eight months without
oving or eating, only emerging to breed when
he fine weather returns. In fact, their active life is
o longer than two months, with the remaining
ght months being a sort of little death.

stribution: throughout Eurasia
ost plants: Urticaceae, hops

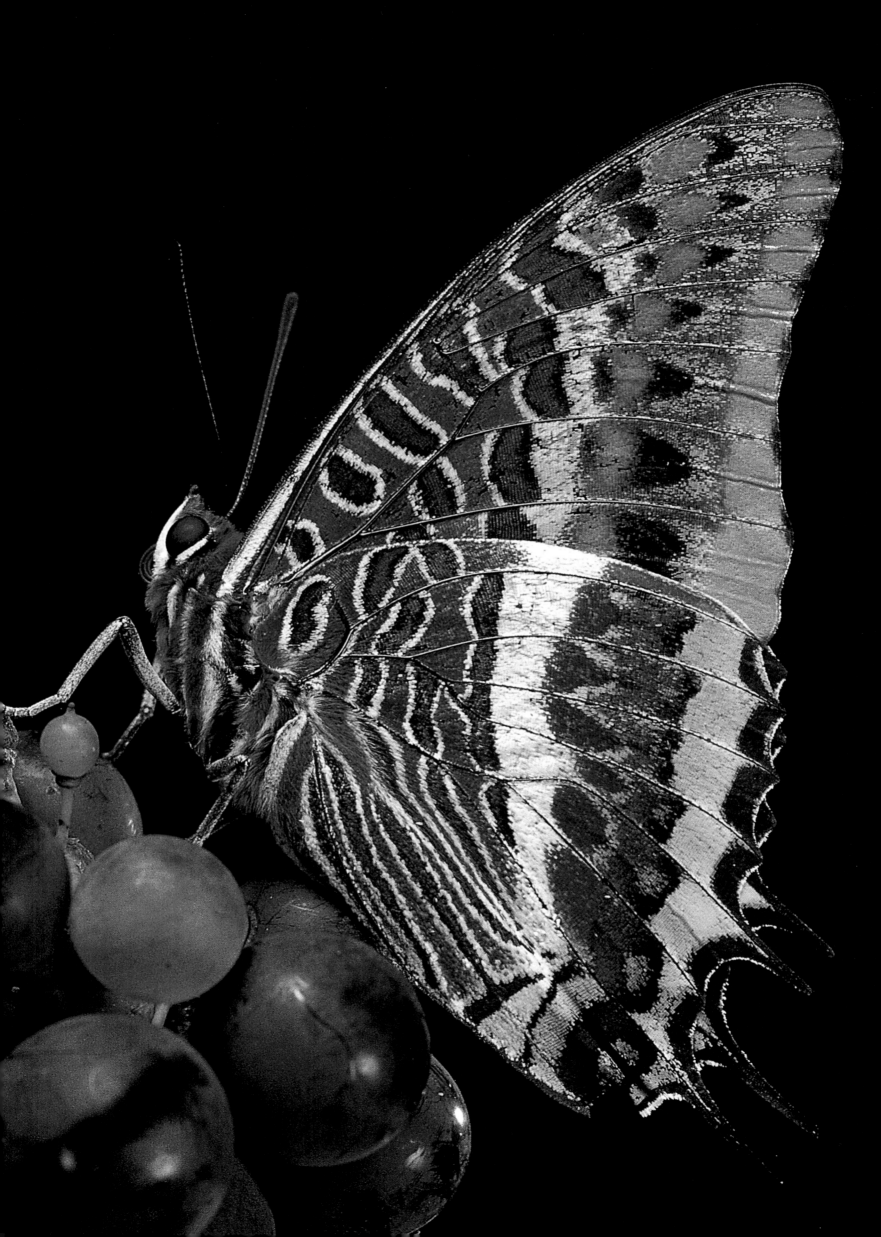

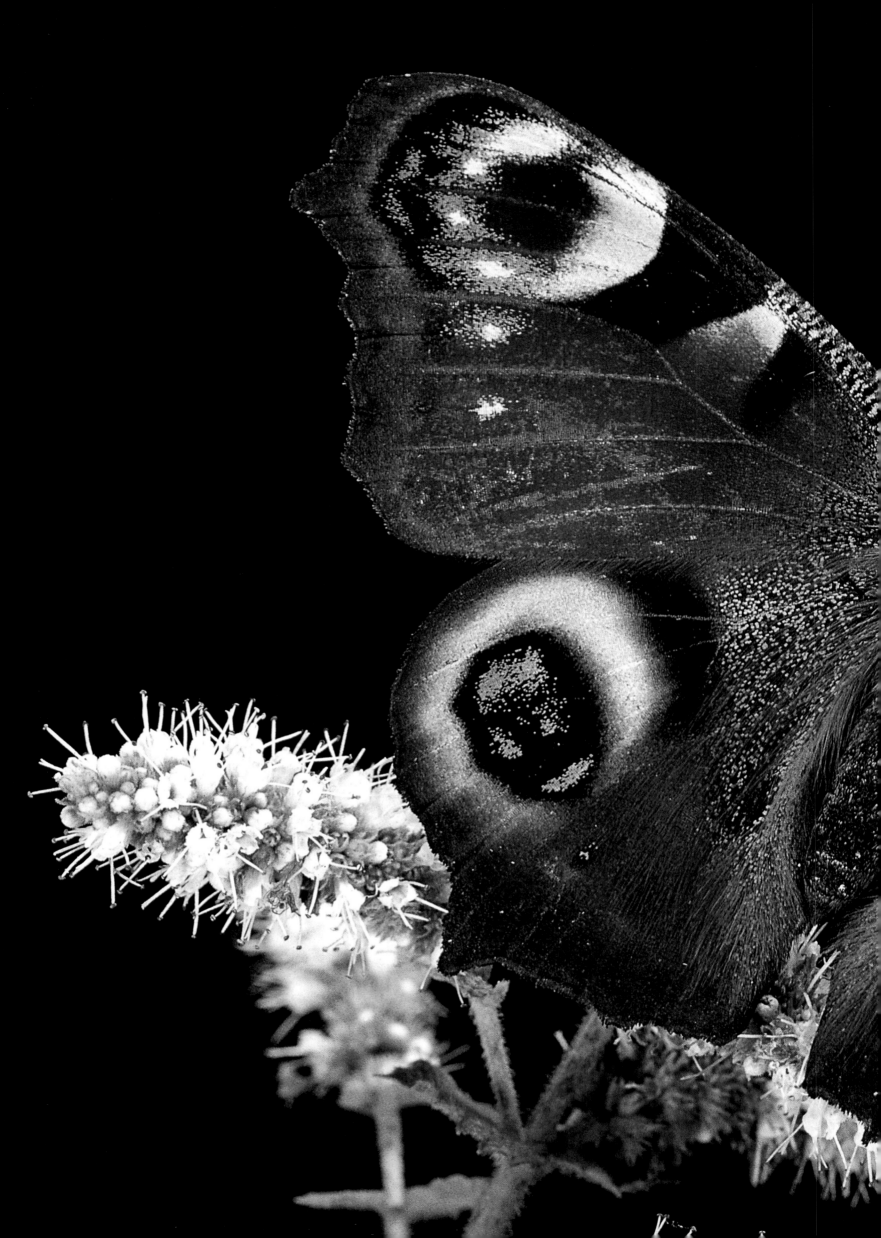

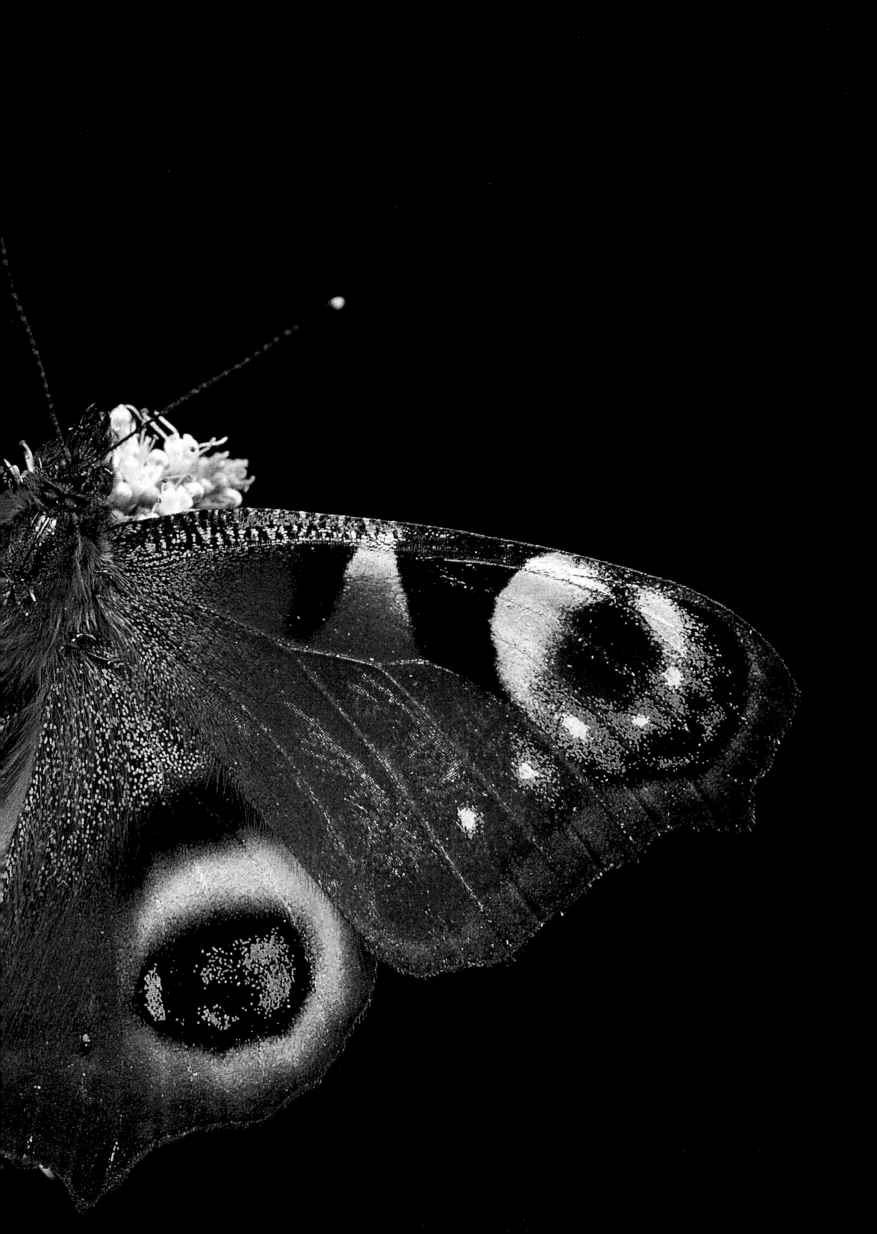

vanessa itea
(x 44)

Two eggs laid on the stinging hair of a nettle leaf.

Distribution: New Zealand
Host plants: Urticaceae

kallima inachus (x 52.5)
"dead-leaf butterfly"

Egg planted among the soft hairs of a strobilanthe leaf.

Distribution: tropical Asia
Host plants: *strobilanthe* **(Acanthaceae)**

OVERLEAF

kallima paralekta (x 4.2)
"indian-leaf butterfly"

In this species, no two specimens have identical colors and patterns, but they all have the same leaf shape that makes them invisible against the plant.

Distribution: tropical Asia
Host plants: various Acanthaceae

PAGE 68

polygonia c-album (x 4.1)
"comma"

Distribution: temperate Eurasia
Host plants: Urticaceae, willow, currant bush

PAGE 69

precis andremiaja
(x 6.6)

Distribution: Madagascar
Host plants: coleus

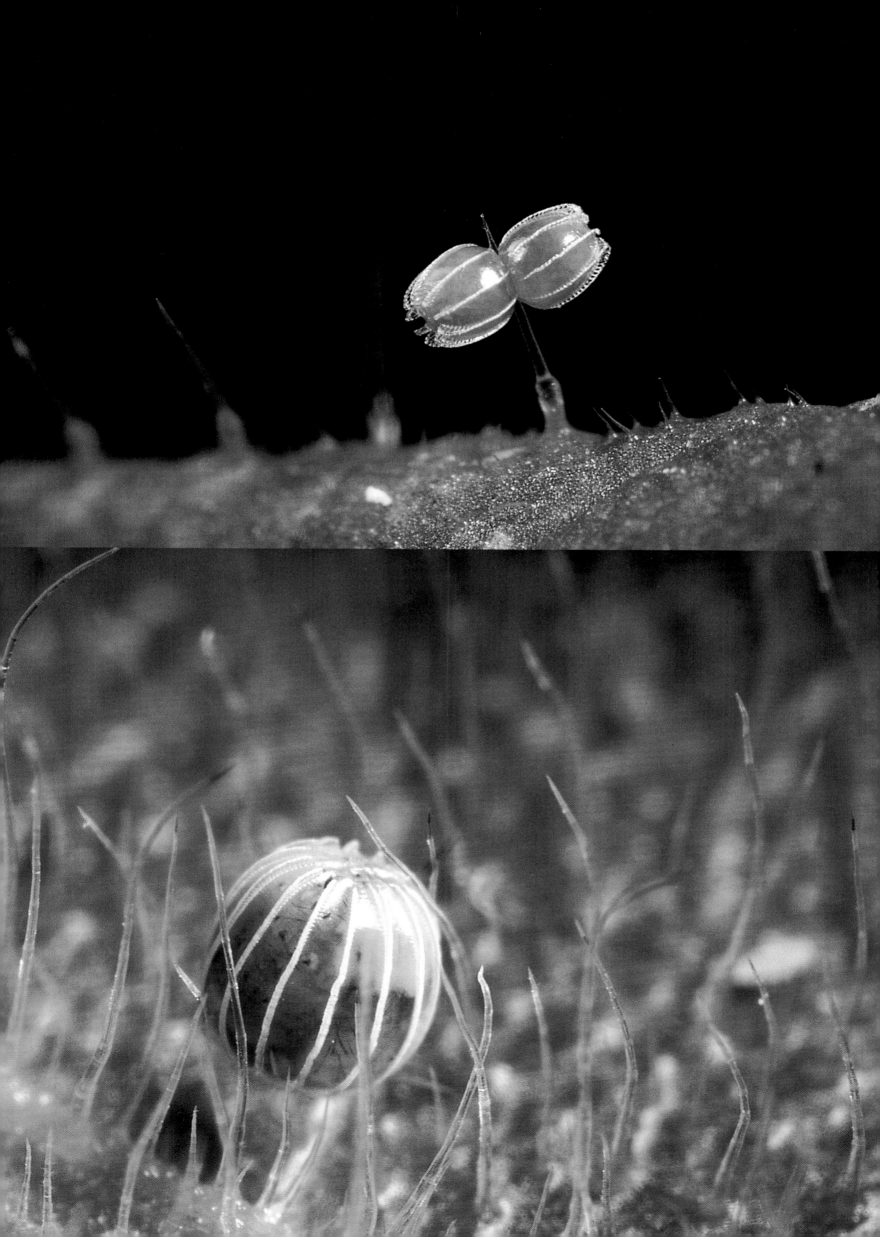

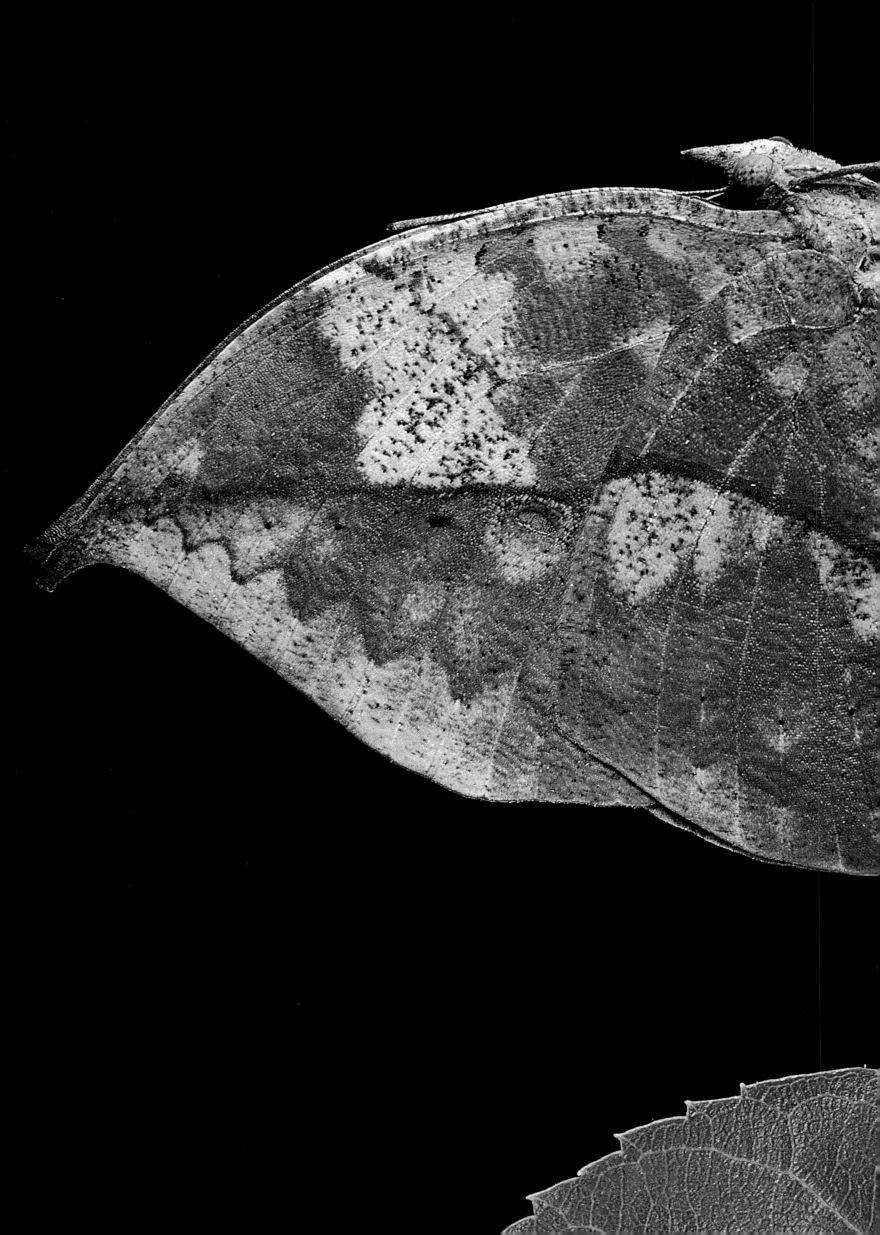

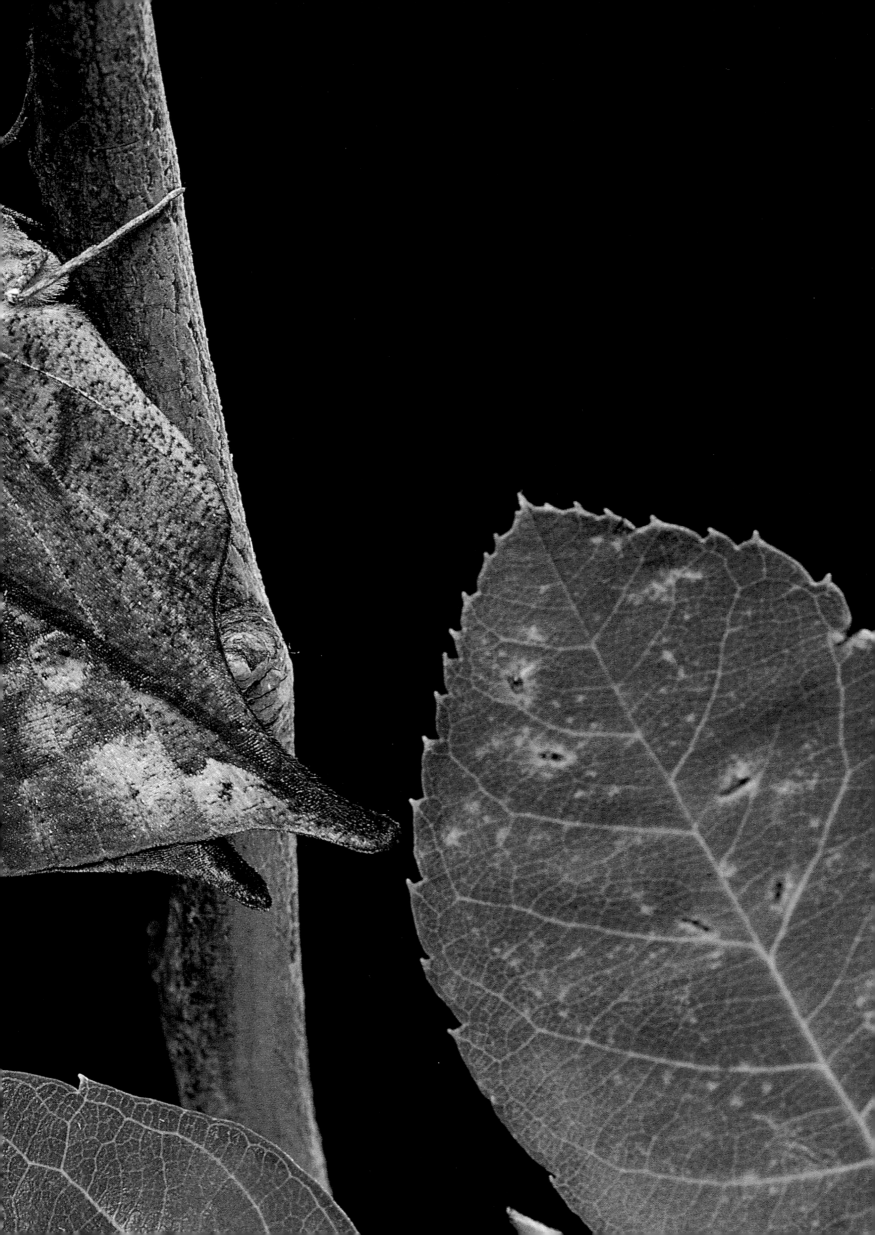

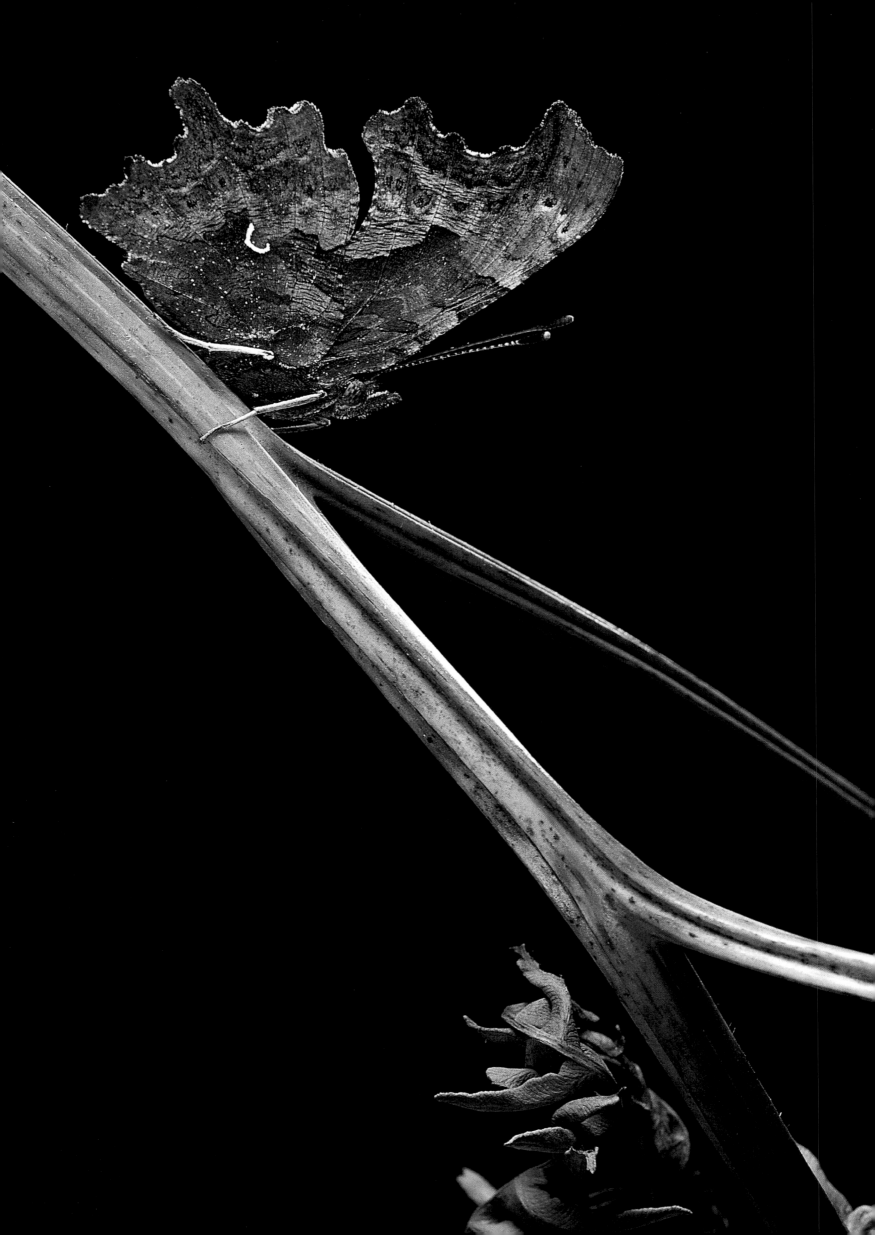

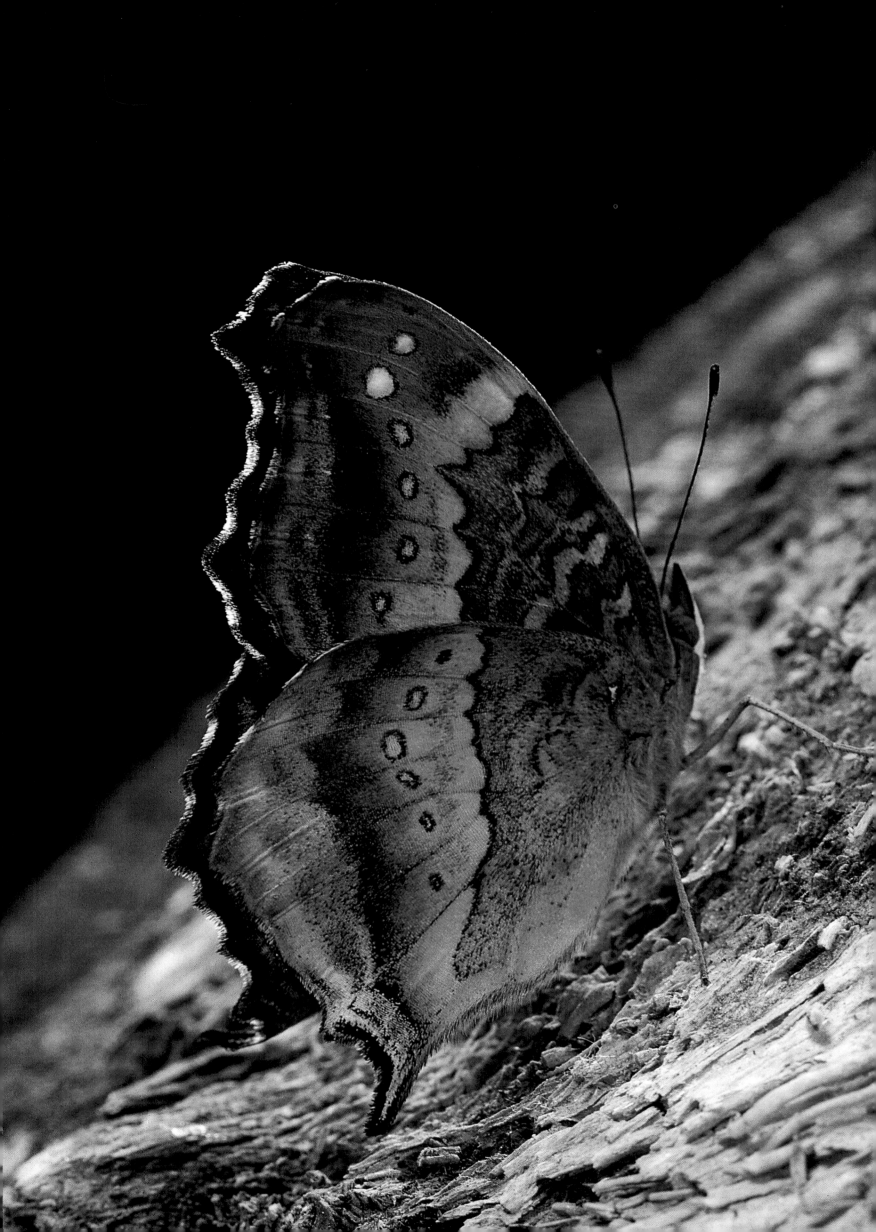

RIGHT

melitaea cinxia
granville fritillary

At the least sign of trouble, the larvae of this butterfly take no chances; they roll into a ball and simply drop to the ground.

Distribution: Europe
Host plants: plantago

LEFT

anartia amathea

This is probably the first butterfly that anyone ever sees on arrival in South America. It seems to like the company of man, and is to be found wherever there are signs of civilization, no matter how remote. What the butterfly is actually after is the nutritive plants that men unwittingly plant around their houses: a lawn substitute to prevent mud.

Distribution: South America
Host plants: *Blechum* and other Acanthaceea

OVERLEAF

nessaea batesi

All butterflies when they emerge from the pupae have a proboscis divided into two mandibles. The butterfly joins them by rolling and unrolling them so as to form a functional tube with which to suck up the liquids it feeds off (nectar, fermented fruit juices, etc).

Distribution: Guyana

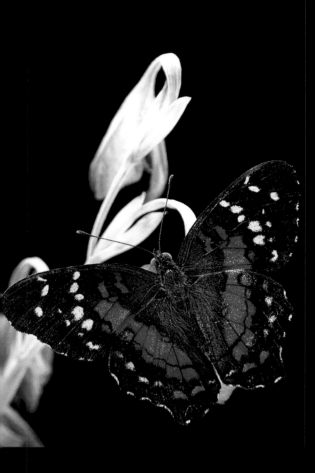

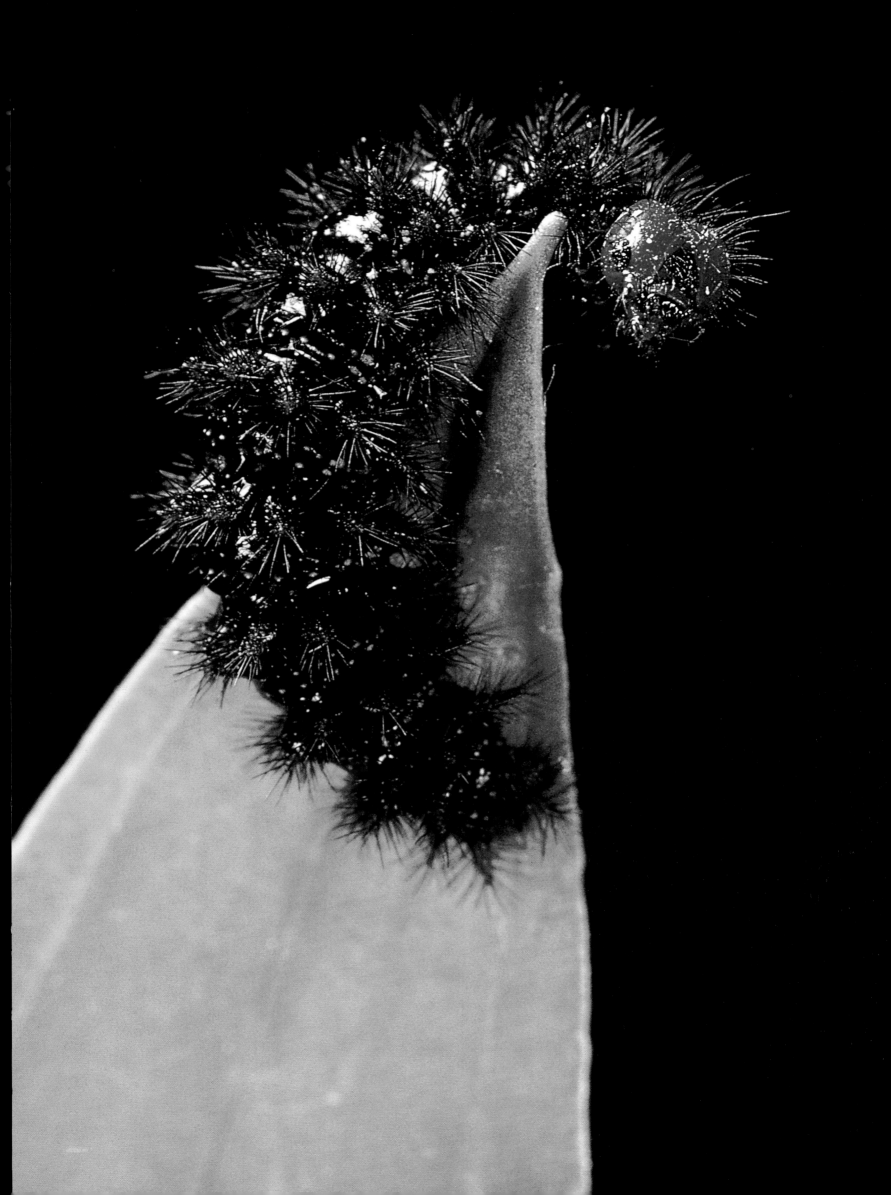

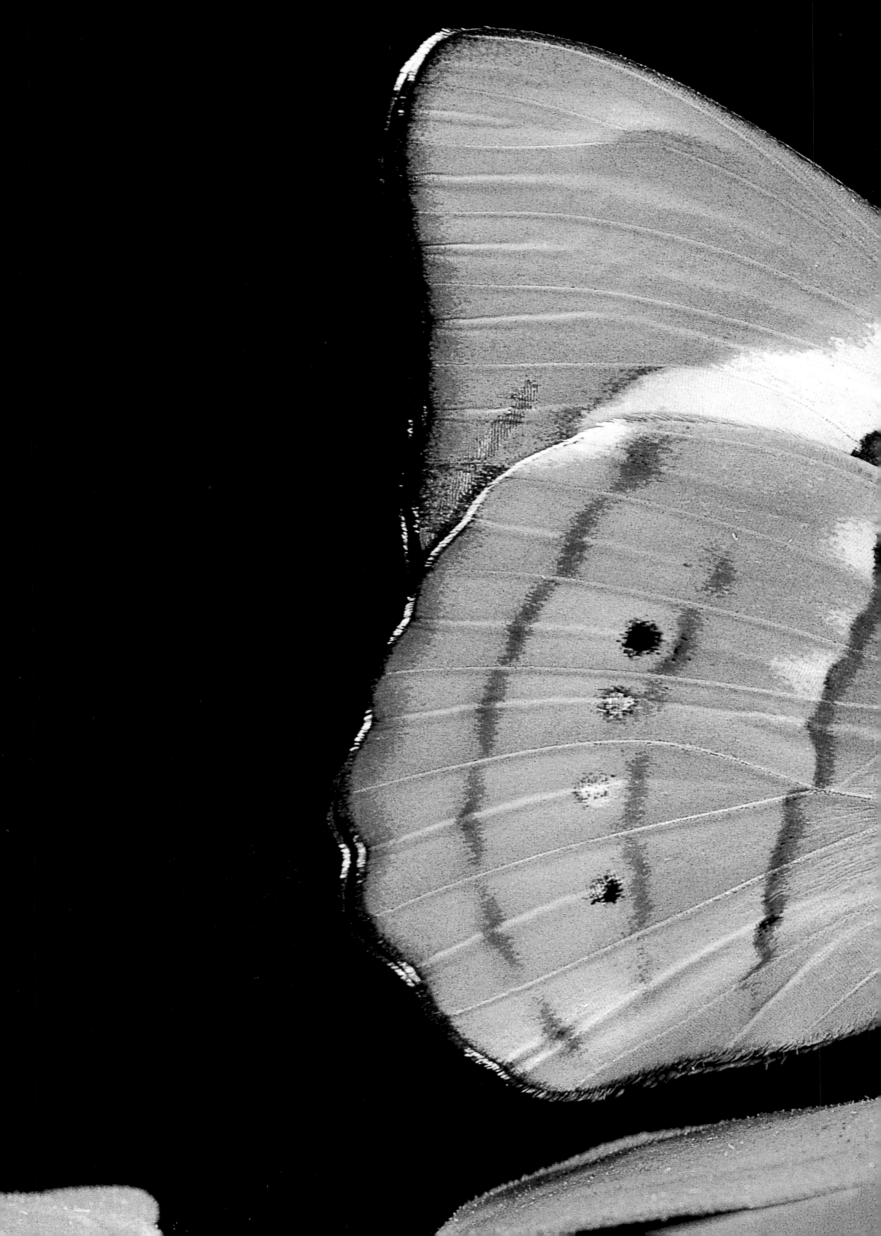

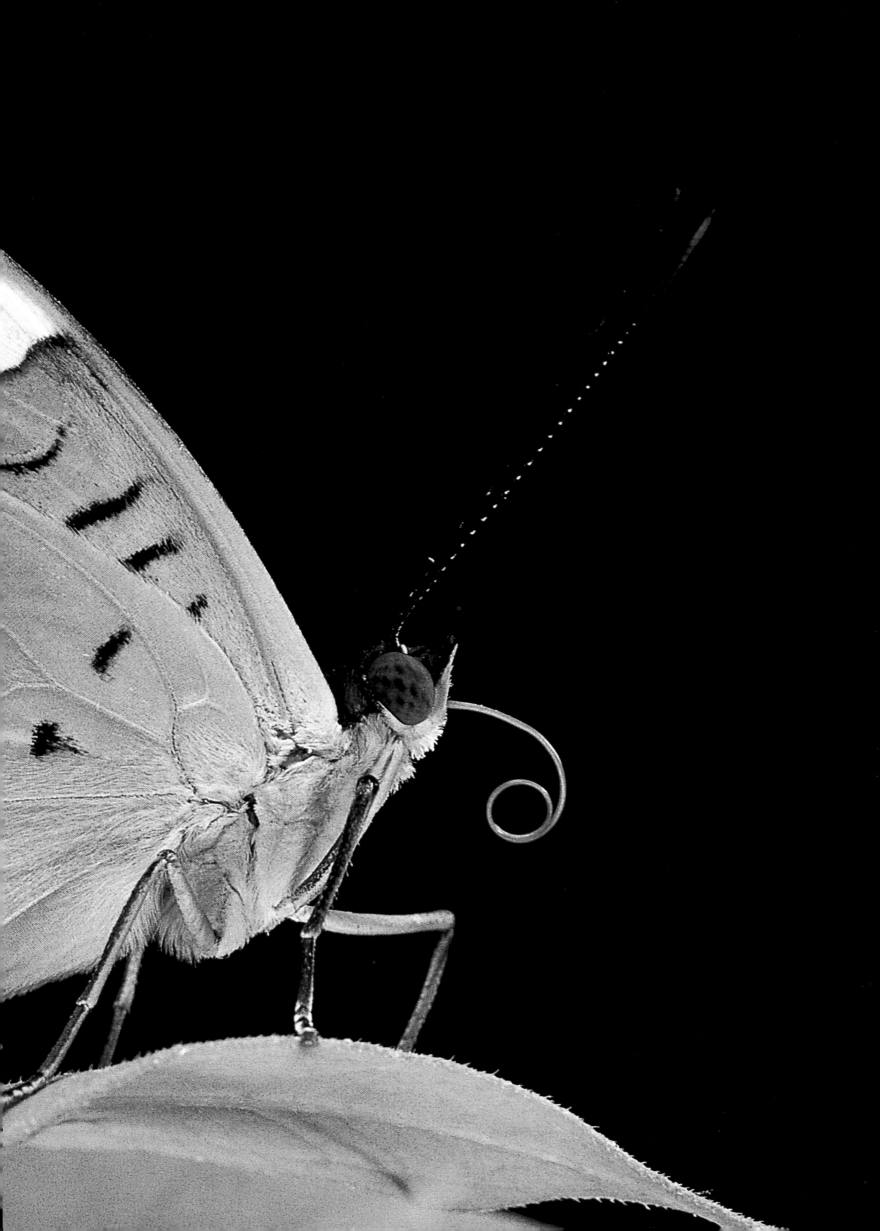

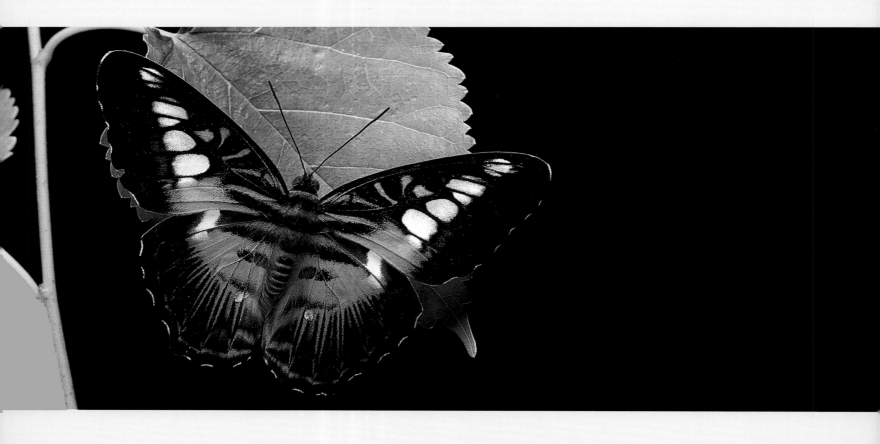

● ● ●

parthenos sylvia
(x 1.3) & (x 2.8)

This species includes numerous sub-
species that vary according to region.
The brown specimen is to be found in
the Philippines, and the blue specimen
in Malaysia.

Distribution: tropical Asia
Host plants: *Modeca* (Passifloraceae)

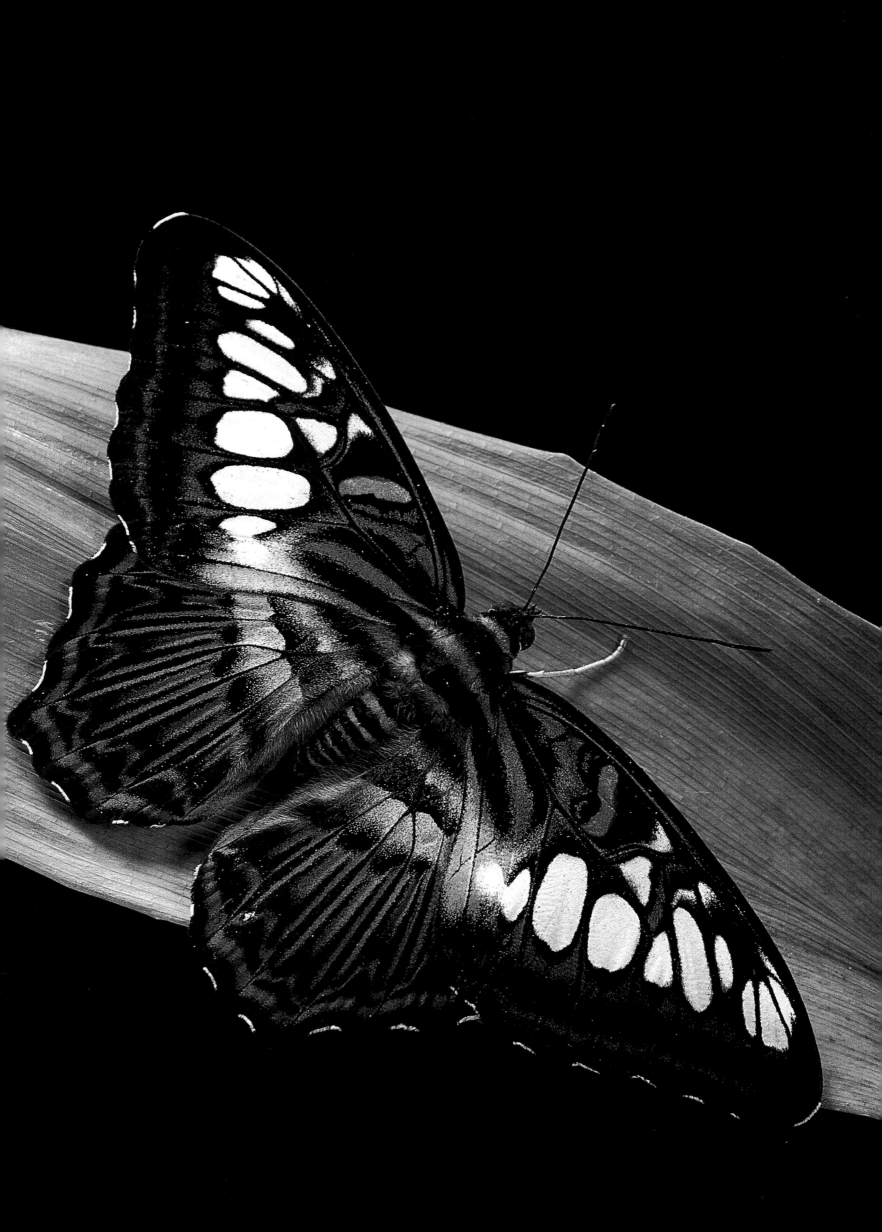

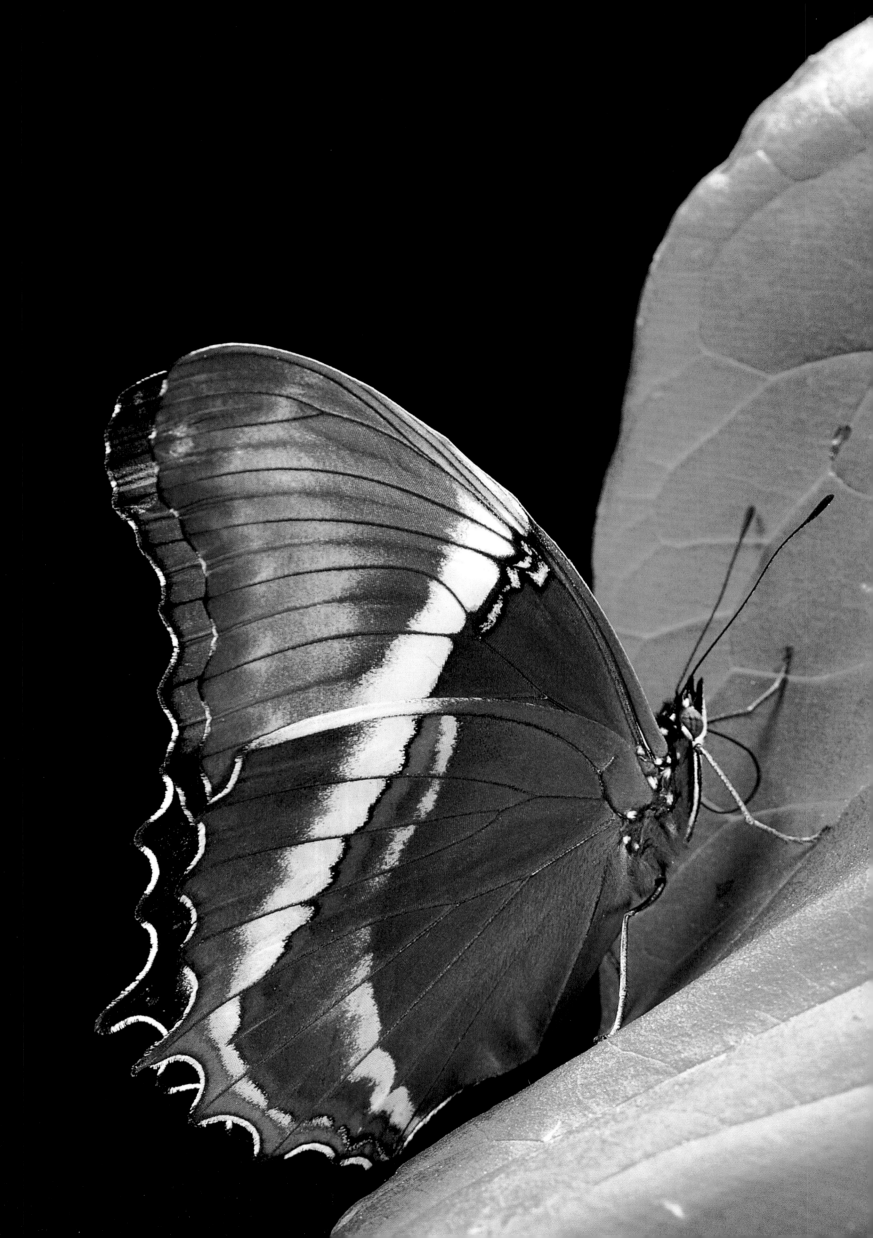

siproeta epaphus (x 13.1)
"brown bamboo page"

This butterfly flies at ground level
in forests looking for fallen fruit on
which it settles to suck up the
juices.

Distribution: central America

Host plants: *Ruellia* and other Acanthaceae

Papilionidae

This family consists of some 700 species worldwide but mainly in the tropics. Nearly all the butterflies are large or very large, including some giant butterflies with a wingspan of about 25cm/10in (such as the female ornithoptera or birdwing butterfly in New Guinea). The absence of any central vein makes the hindwings look arched, revealing the insect's abdomen. The principal larval food plants are Rutaceae, Aristolochiae (birdwort) and Lauraceae. The pupae are supported by a threadlike silk girdle around the body.

atrophaneura polyeuctes (x 10)

Few creatures mimic plastic as well as this pupa, which despite its appearance, is very much alive. Another remarkable characteristic is the way in which the color on this larva "runs" when it rains, due to the elongated red markings on the side that release a red pigment resembling drops of blood.

Distribution: tropical Asia
Host plants: Aristolochiae

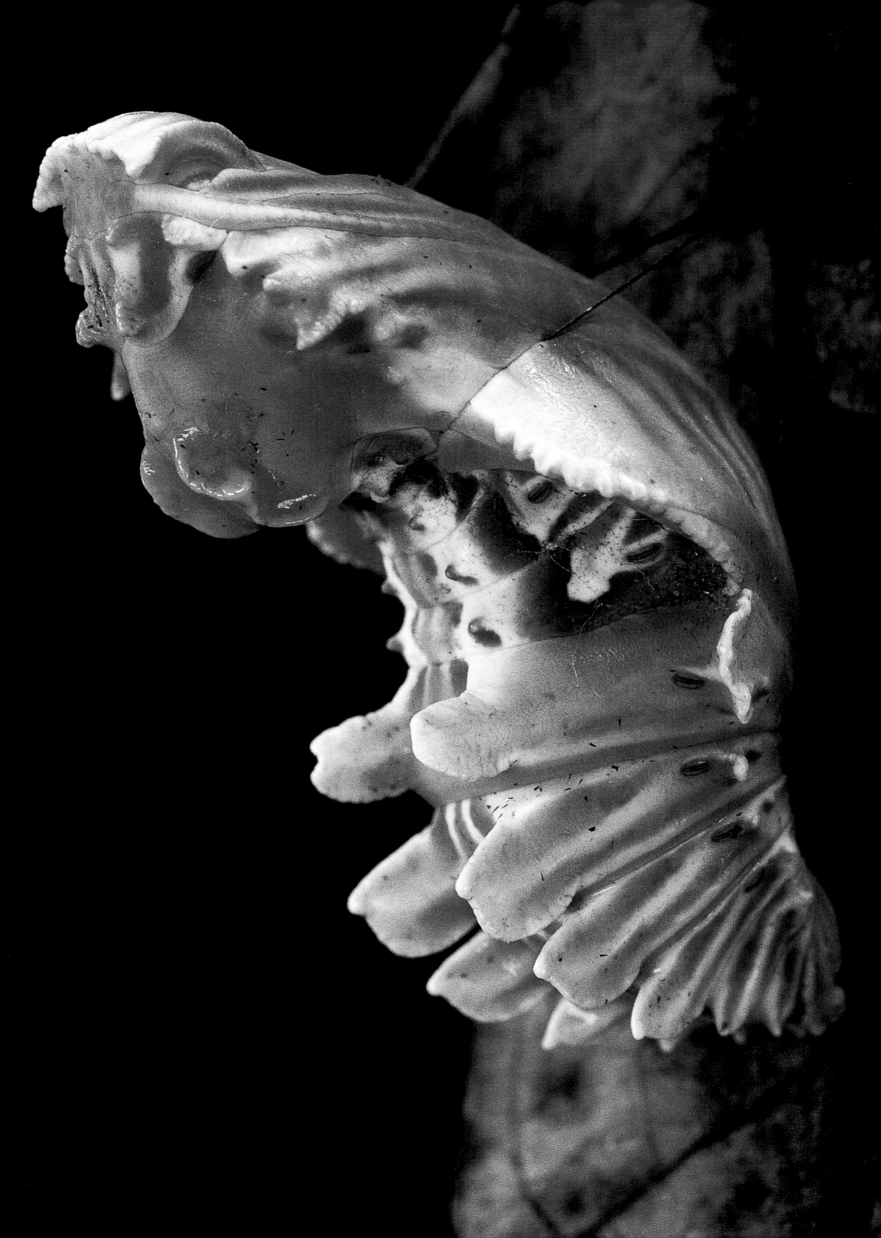

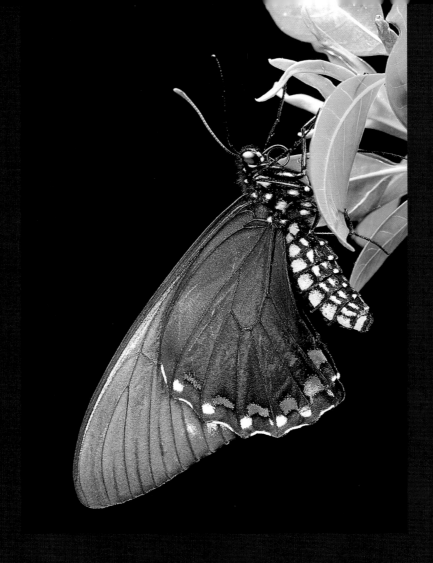

battus belus
(x 1.4) & (x 12.8)

A butterfly's body may be more
or less hairy. This one is scaly
and the scales are easily visible
in the enlarged view.

Distribution: tropical America
Host plants: Aristolochiae

OVERLEAF AND PAGES 84-85

papilio arcturus (x 4)
(x14.4) & (x 15.5)

When you catch a butterfly, the colored
dust it leaves on the fingers is composed
of a mass of tiny particles: the characteristic
covering of dust-like scales on the wings.
The name Lepidoptera, which applies to
this insect order as a whole, is derived
from the Greek meaning "scaly winged."

Distribution: tropical Asia
Host plants: *Citrus*

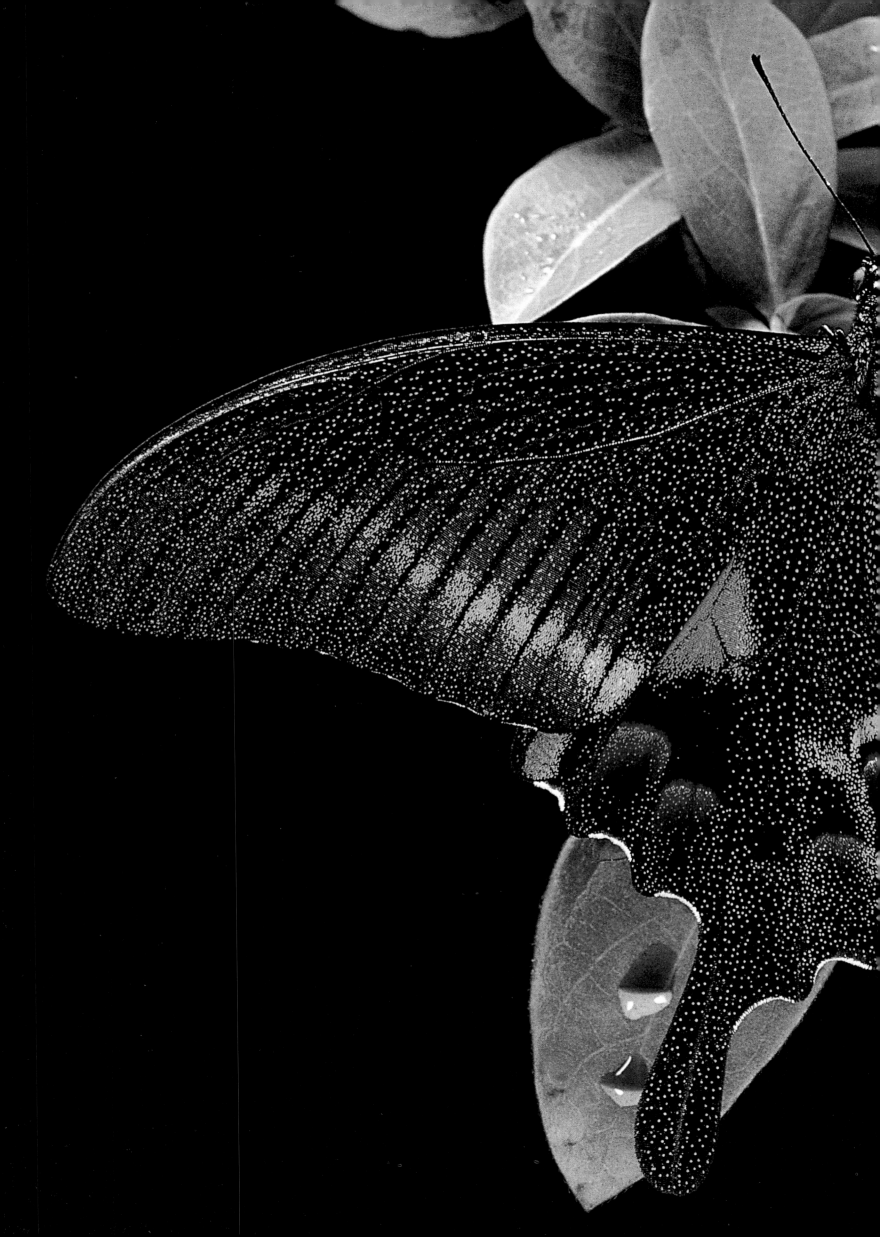

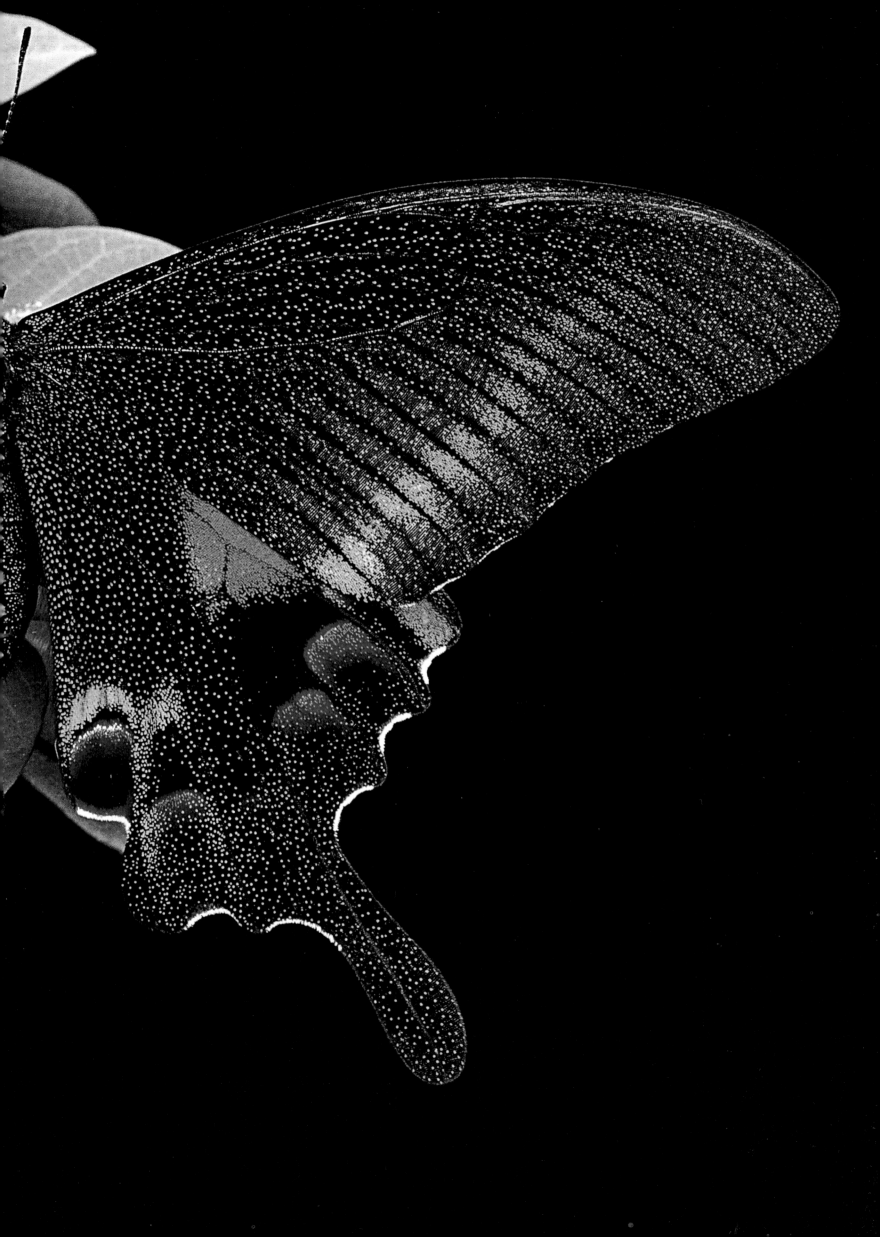

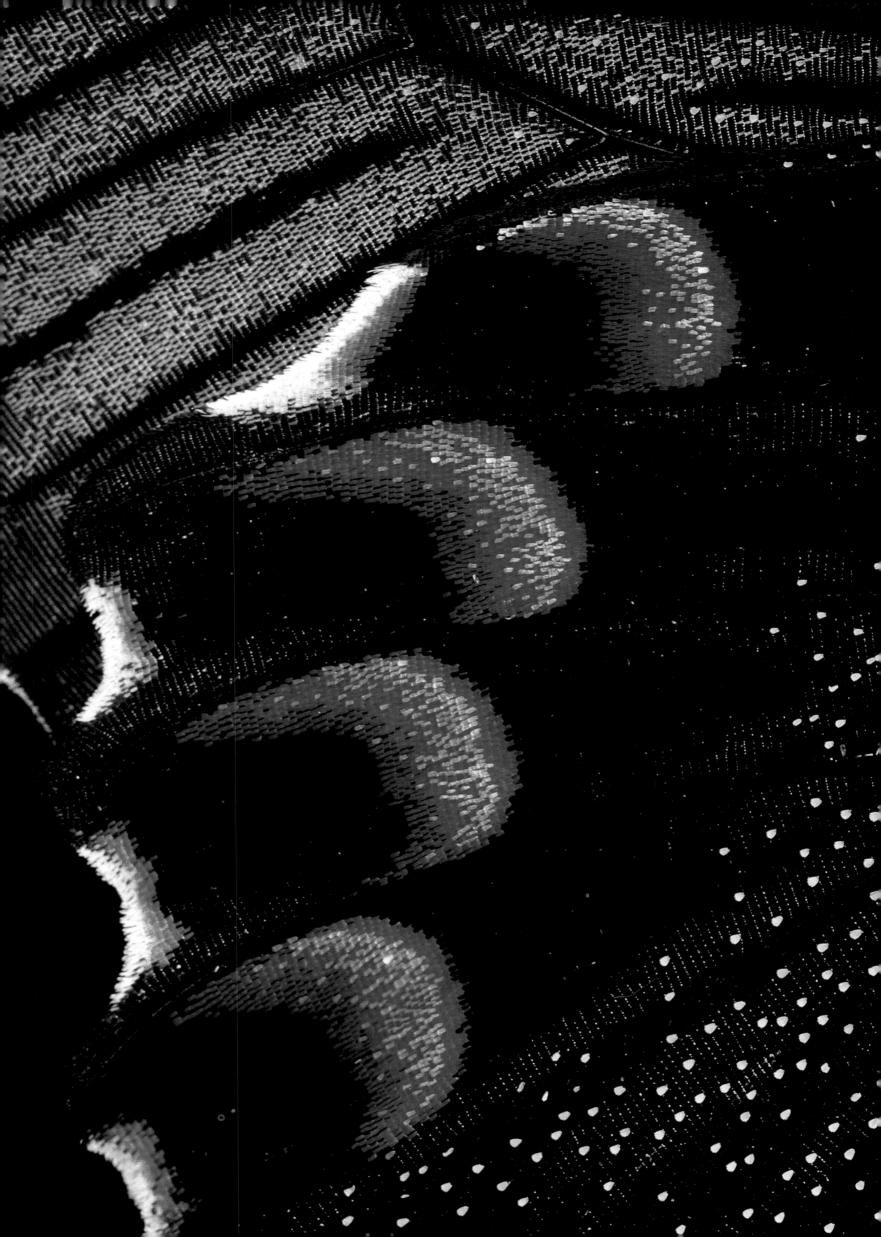

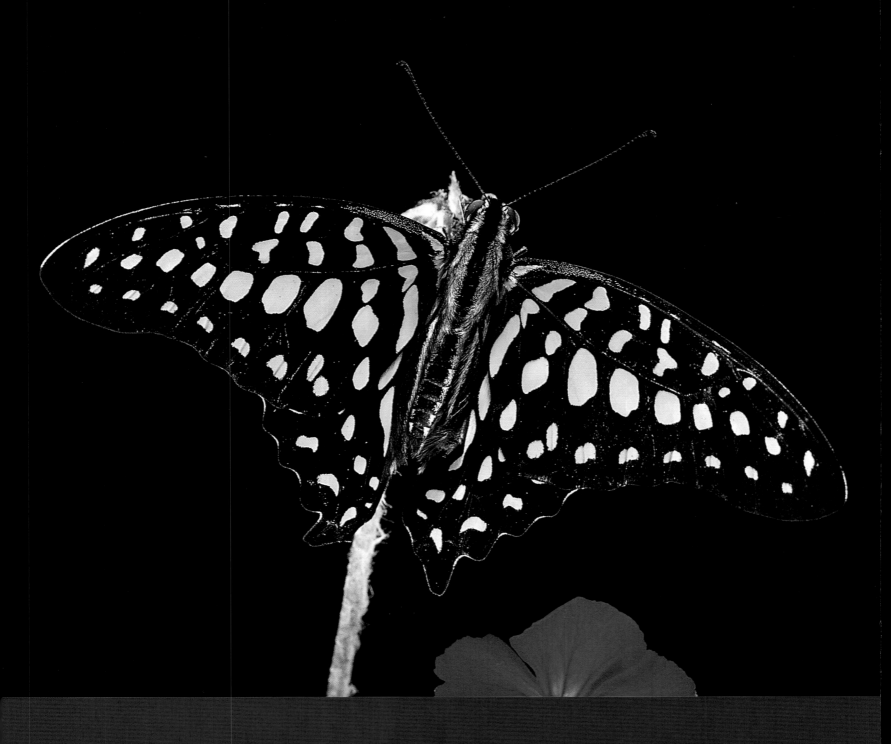

graphium agamemnon
[x 2.5]

Distribution: tropical Asia
Host plants: various Anonaceae

ABOVE, RIGHT

[x 2.25]
papilio dardanus

Spot the pupae; there are two of them. They resemble the leaves down to the tiniest detail, being flat in shape and darker on the upper side than the under side.

Distribution: tropical Africa
Host plants: many types of Rutaceae

chilasia clytia (x 7.7)

It would be hard to look more like a stick than this pupa. Some pupae go even further than this, with green appendages that make them look like lichen.

Distribution: tropical Asia
Host plants: various Lauraceae

papilio machaon (x 6.6)
"swallowtail"

When the time comes to pupate, *Papilio* larvae have a choice of color depending on their surroundings: green if surrounded by leaves, brown or gray on a tree trunk. The advantage of course is that in either case they become less visible.

Distribution: northern hemisphere
Host plants: many types of Apiaceae

papilio aegeus (x 11)

Distribution: Australia and surrounding islands
Host plants: many types of Rutaceae

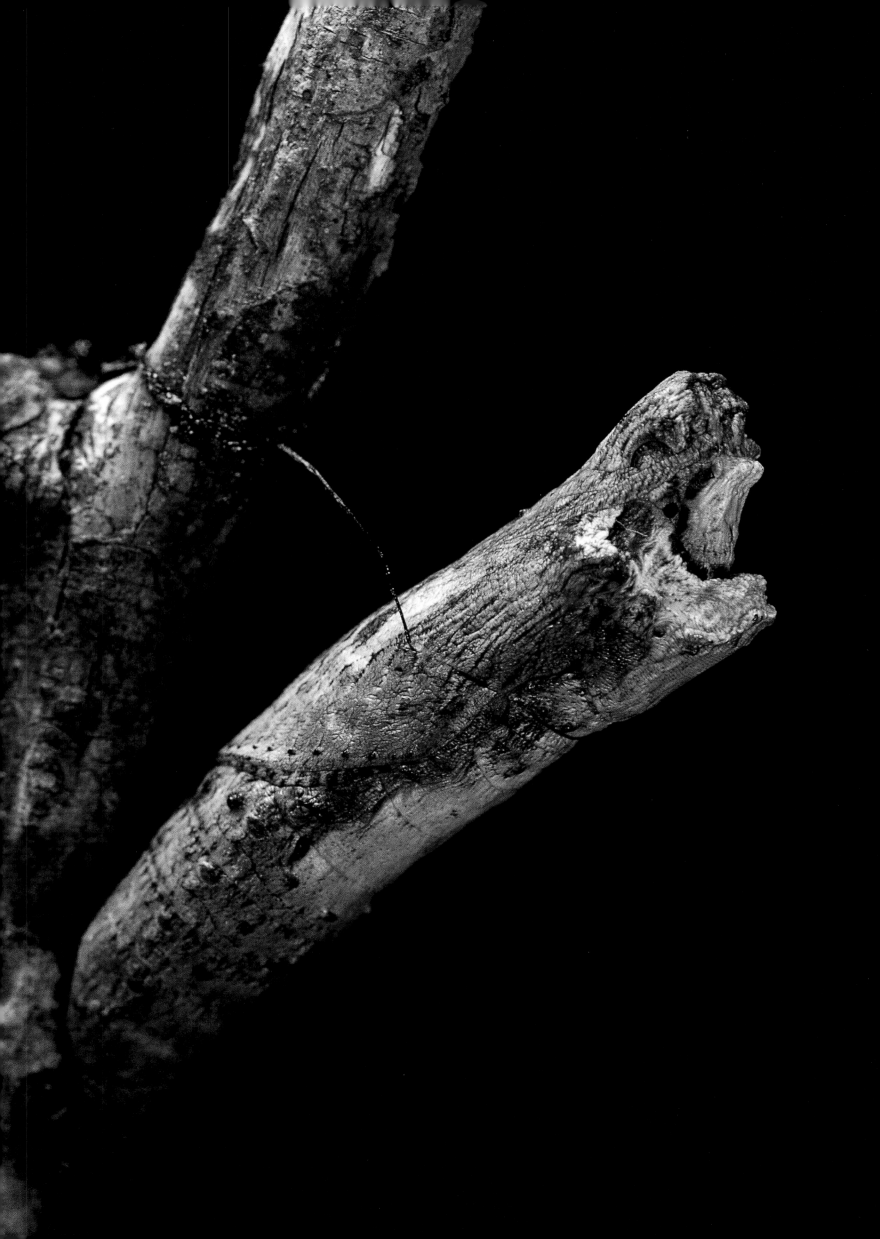

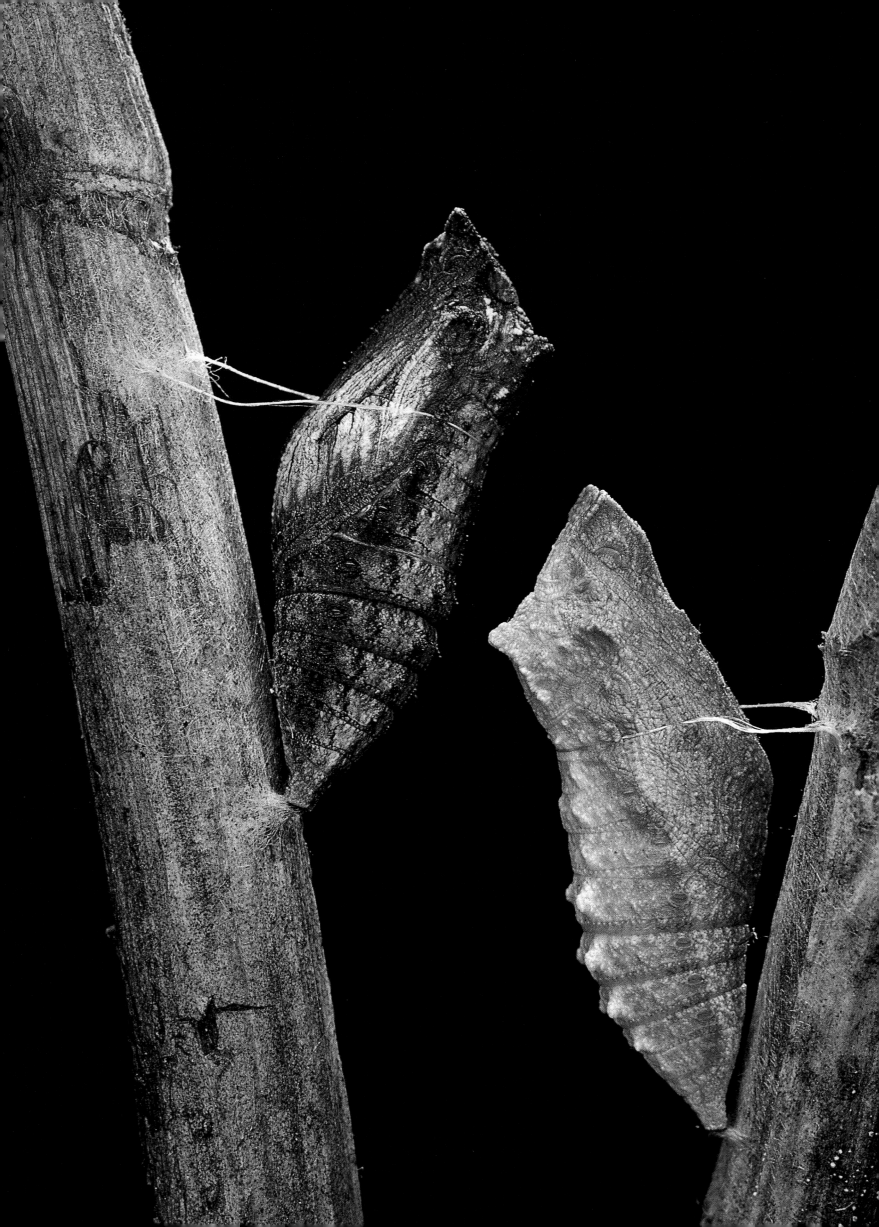

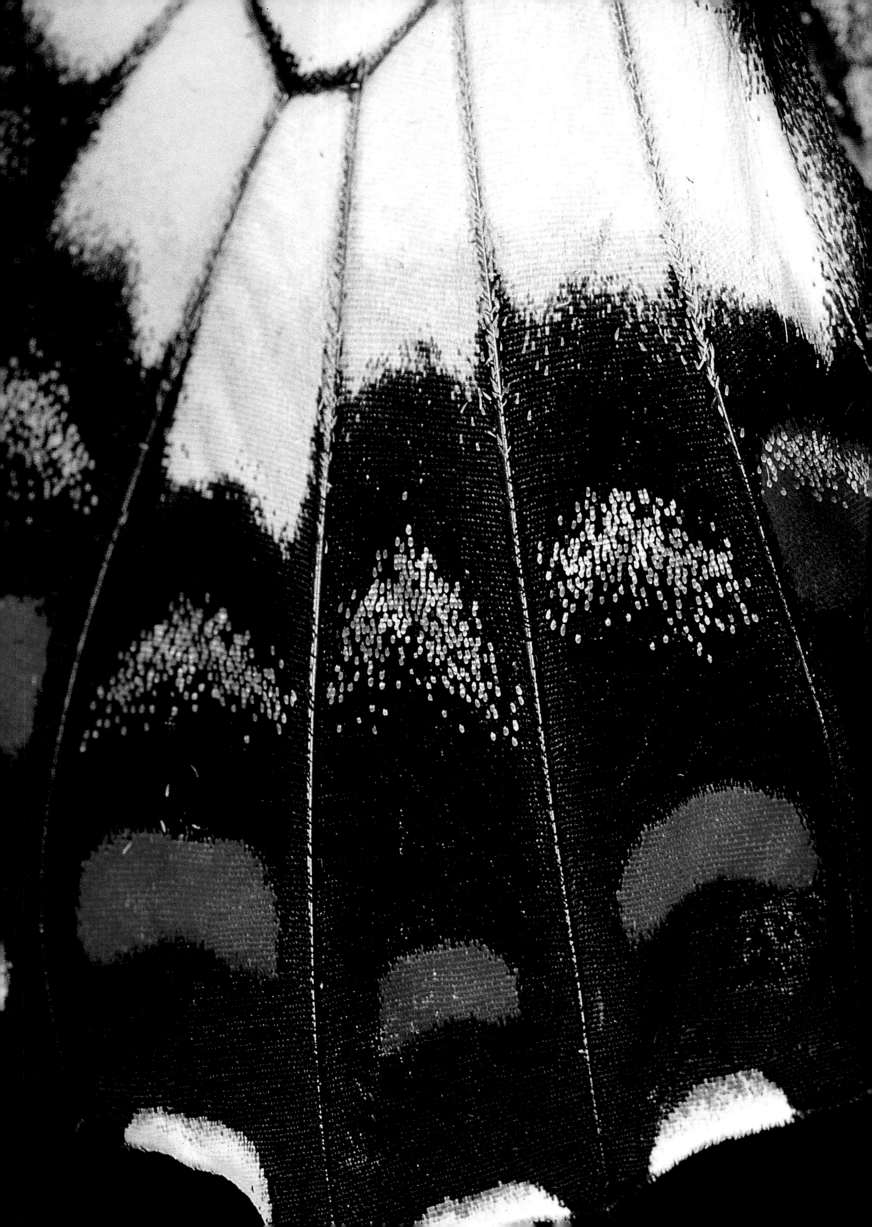

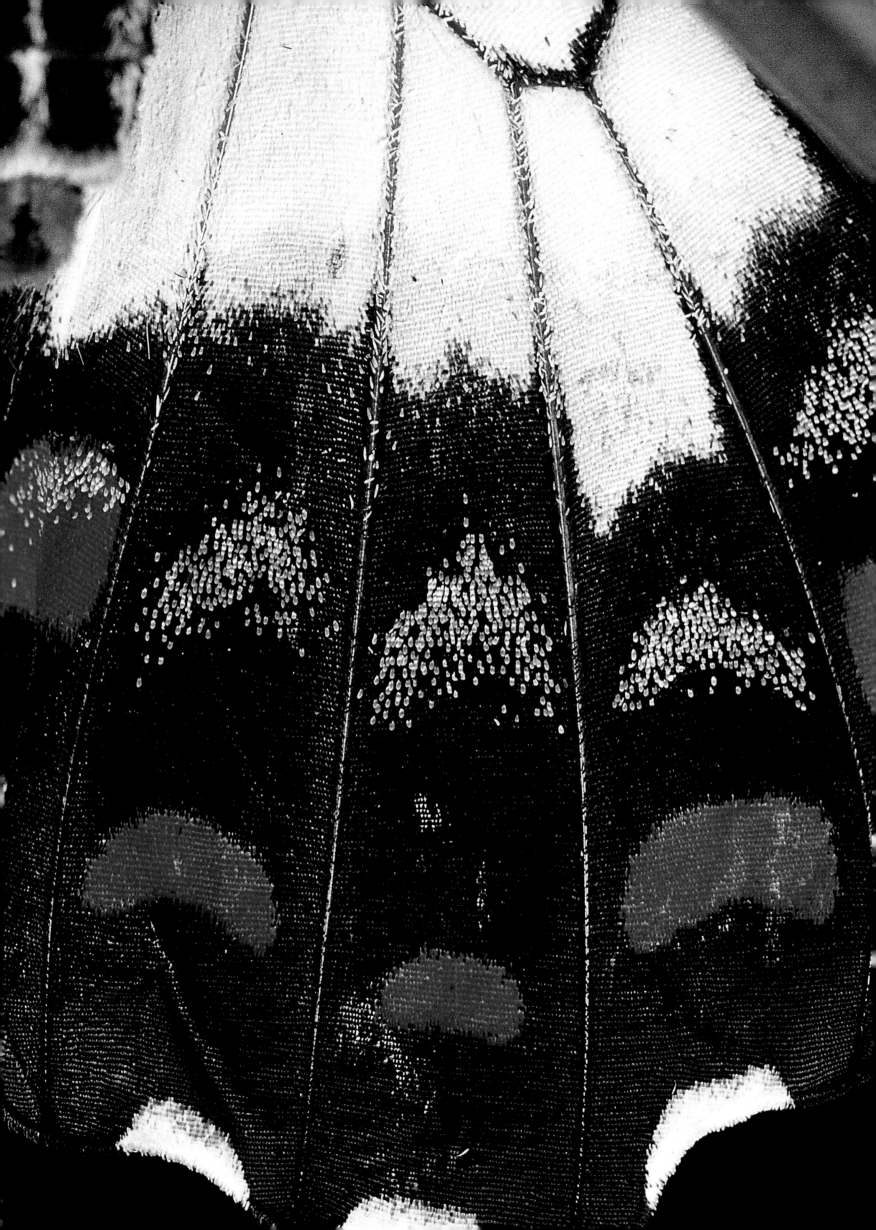

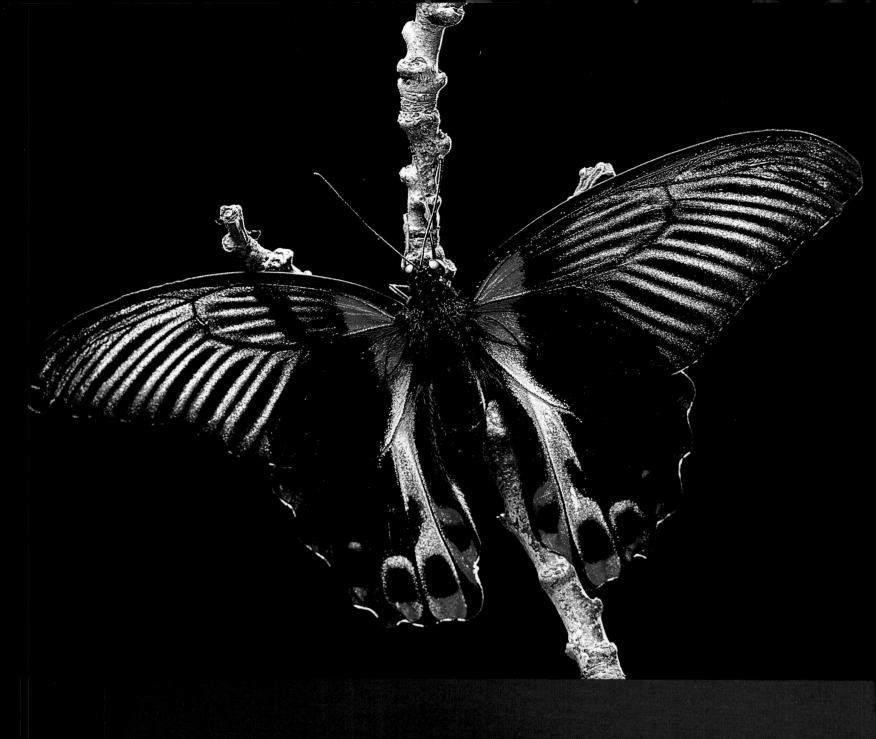

ABOVE AND RIGHT

papilio rumanzovia (x 1.6) & (x 2.1)

Males and females quite often vary in color and sometimes even in shape. Here it is the colors that are different, as shown by the female on the left and the male on the right. In rare cases, the male even has a choice of different types of female.

Distribution: Philippines
Host plants: *Citrus*

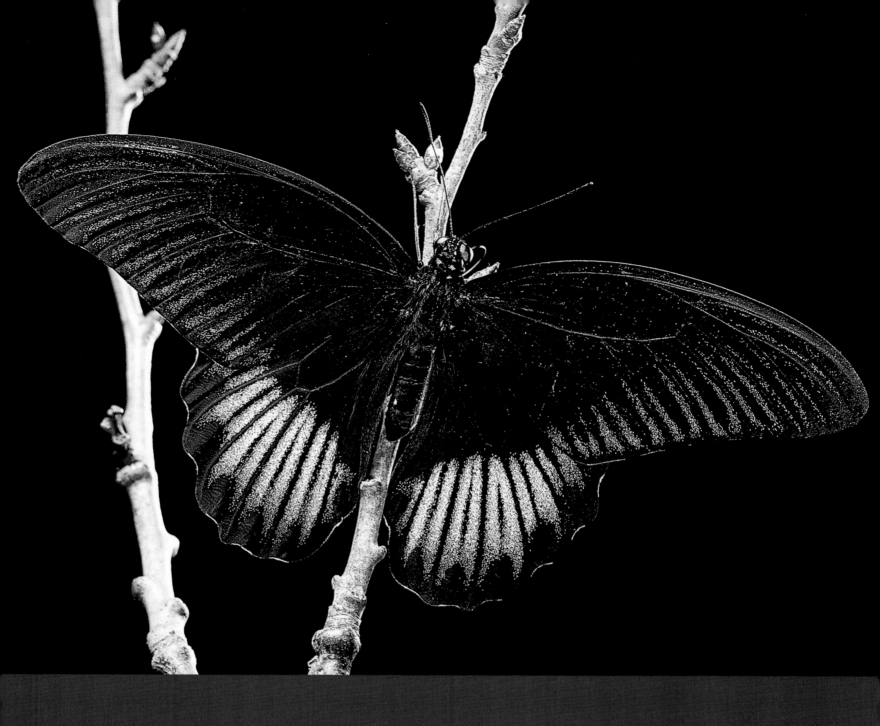

OVERLEAF

papilio peranthus (x 13.2)

Distribution: tropical Asia
Host plants: many types of Rutaceae

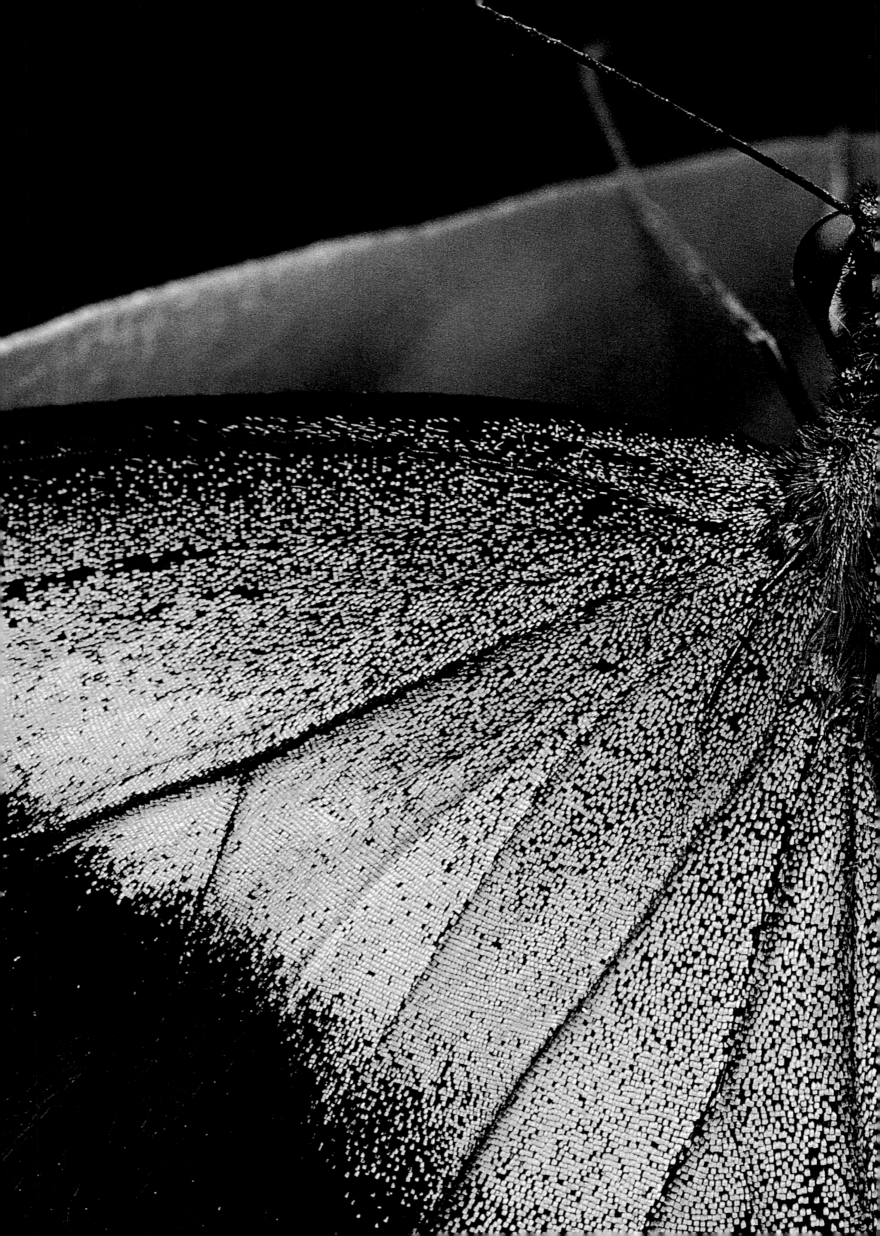

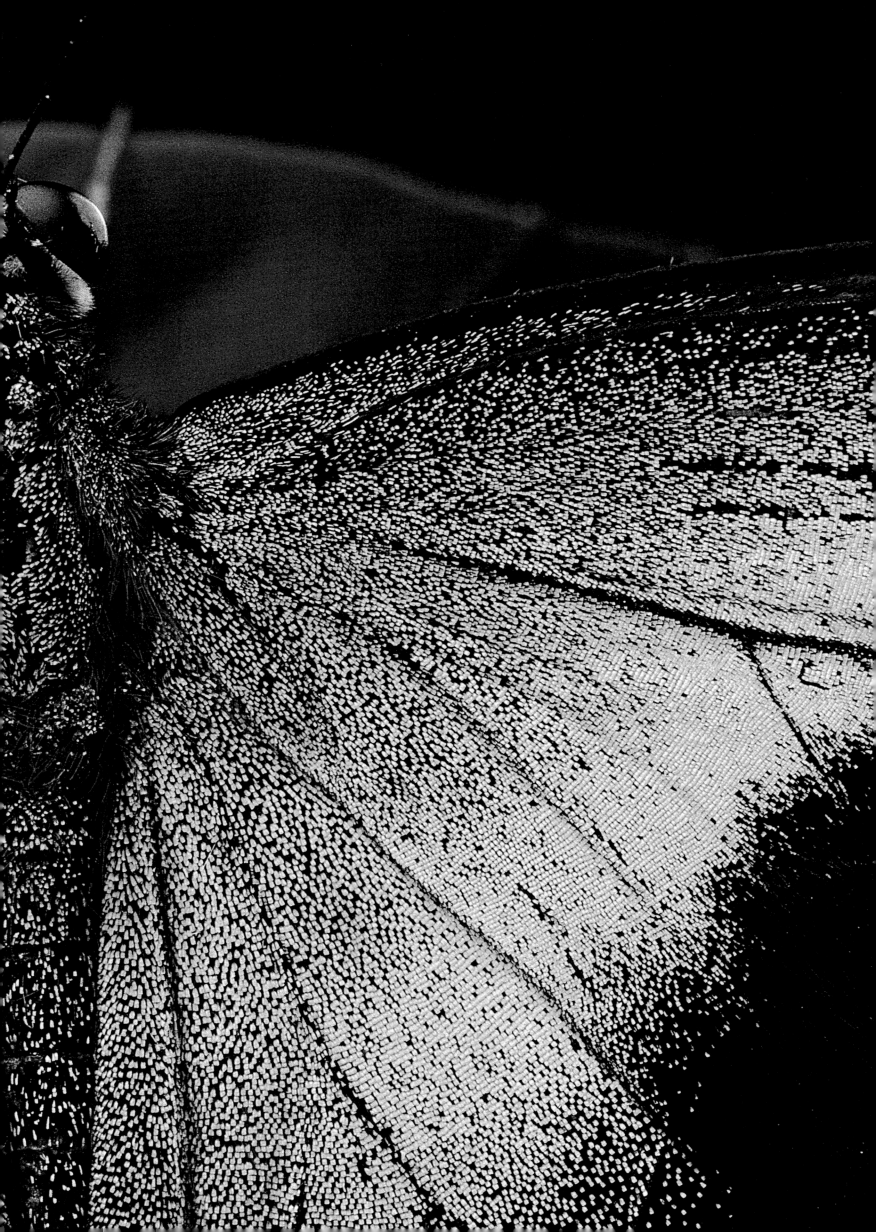

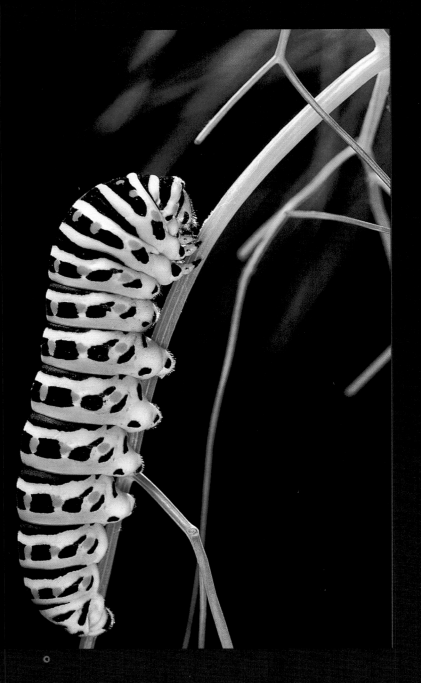

parides iphidamas (x 3.6)

Like the butterfly, these larvae feed
off Aristolochiae (birdwort),
acquiring a bitter taste that makes
them unattractive to predators.

Distribution: central America
Host plants: Aristolochiae

OPPOSITE

papilio machaon (x 8.9)
"swallowtail"

This larvae is well known to
gardeners who commonly find it
in their vegetable plot feeding off
carrot leaves. With such bright
colors, they could hardly fail to
spot it. For all its aggressive
coloring, this little creature lives
alone and does no real damage.

Distribution: northern hemisphere
Host plants: many types of Apiaceae

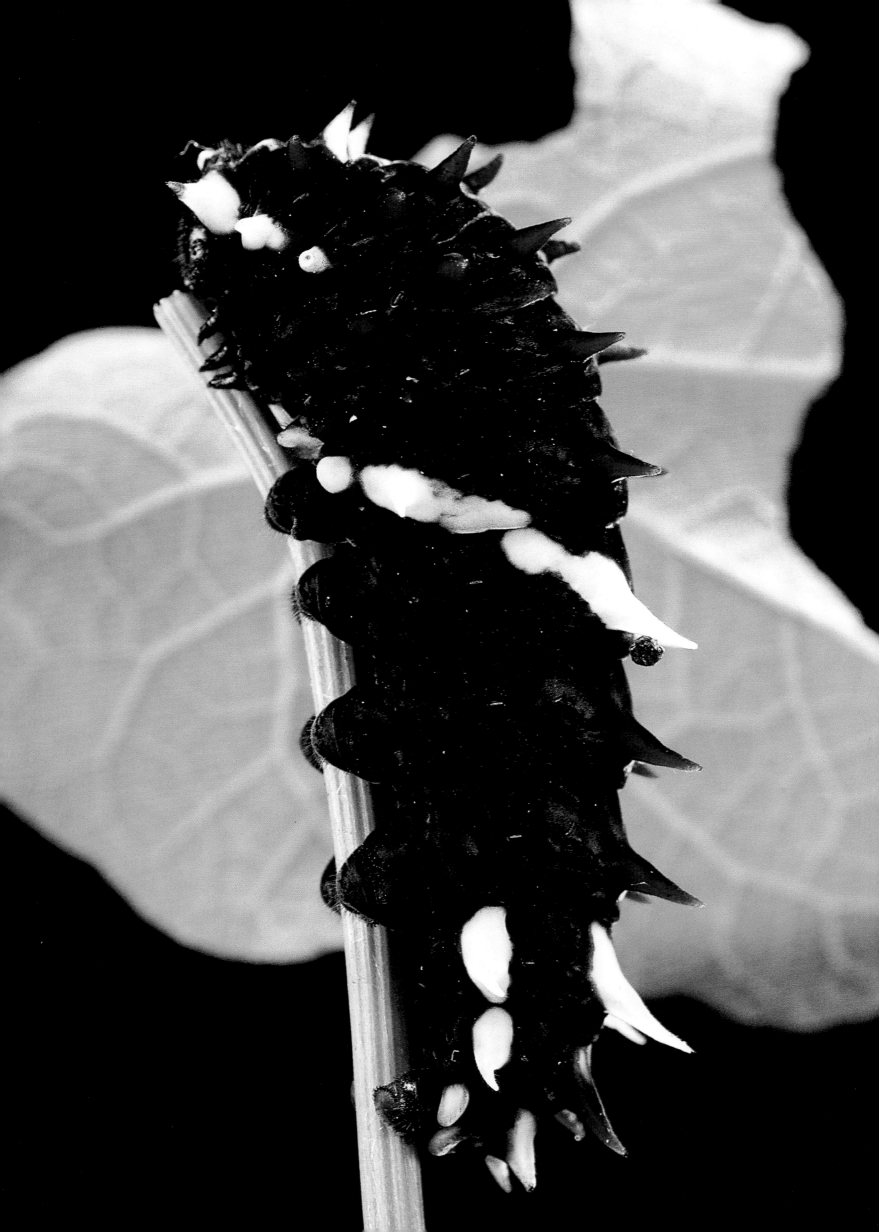

OPPOSITE

parides photinus (x 3.8)

Distribution: central America
Host plants: Aristolochiae

OVERLEAF

papilio neophilus (x 15.7)

Distribution: central America
Host plants: Aristolochiae

PAGES 102-103

parnassius apollo (x 27)
"apollo"

This butterfly's egg is in no hurry to hatch, and it will be eight months before the larva finally emerges. Actually, it is fully formed in just three weeks at the start of the summer, but waits for the following spring before hatching.

Distribution: mountainous Europe
Host plants: *sedum*

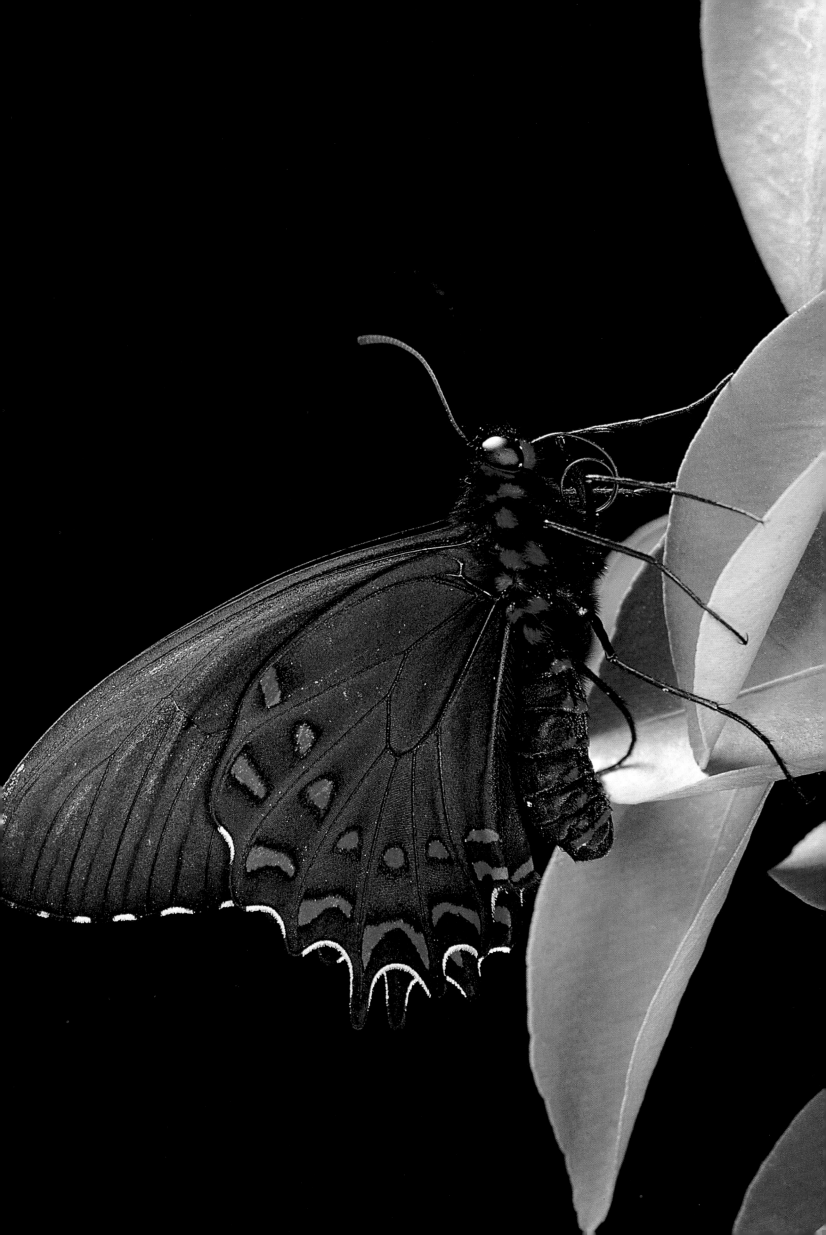

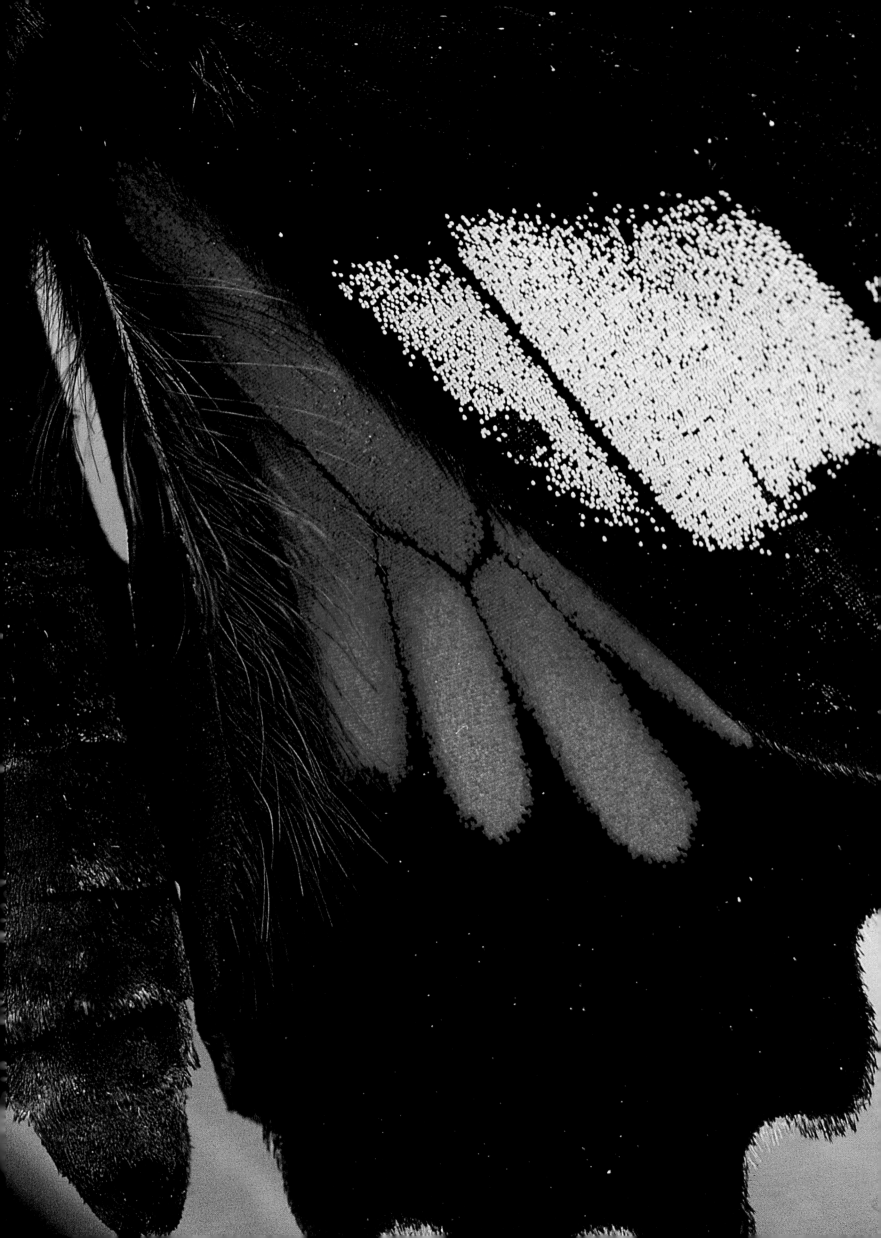

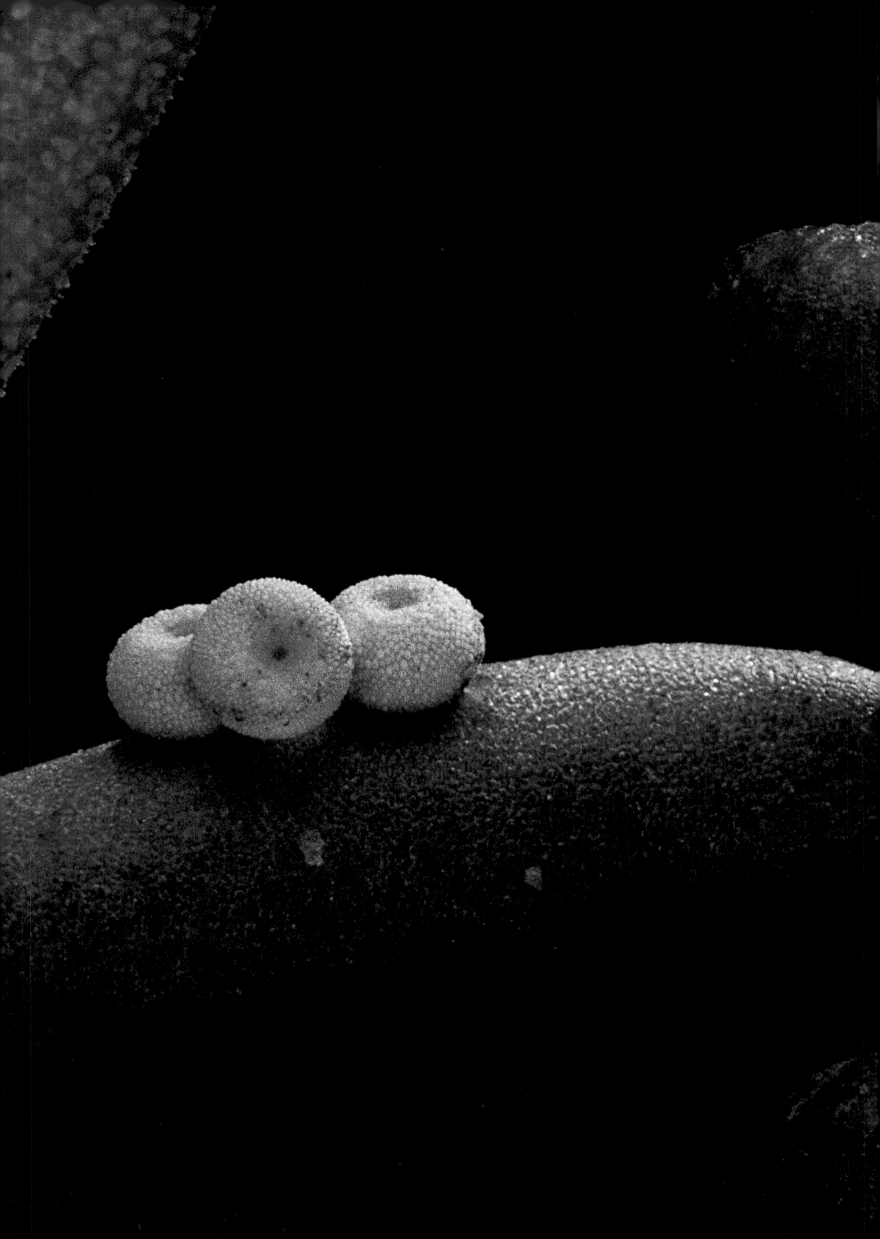

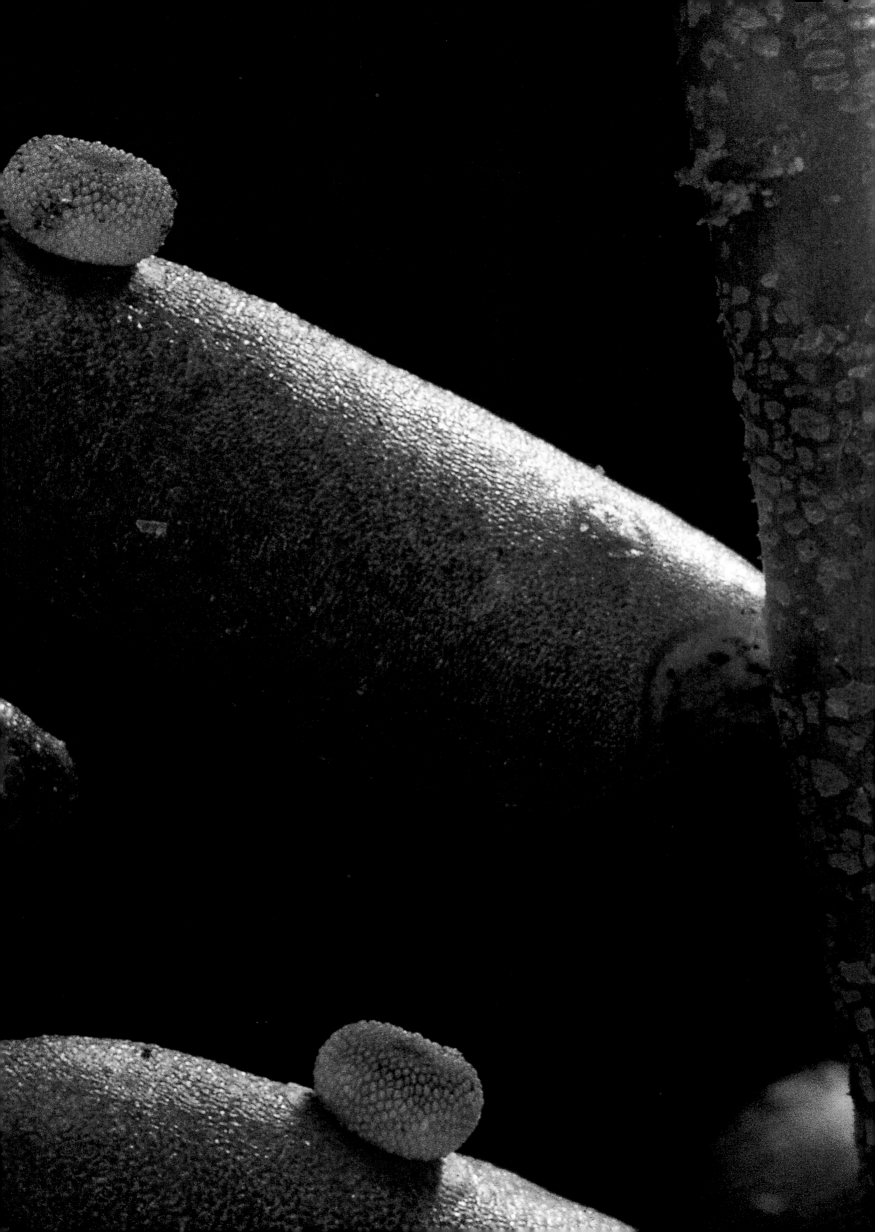

Pieridae

This is a large family of about 2,000 species. Except for Dismorphiinae, a highly atypical subfamily that mimics Heliconiinae, this is quite a homogenous family with rounded wings free of all indentations and predominantly colored white, yellow, and black. The pupae are always supported by a threadlike silk girdle.

aporia crataegi (x 3.3)
"black-veined white"

The wings on this butterfly have the semi-transparency of gauze. It is currently in decline and has disappeared from England and northern Europe where it used to be the scourge of fruit trees.

Distribution: temperate Eurasia
Host plants: fruit trees (Rosaceae)

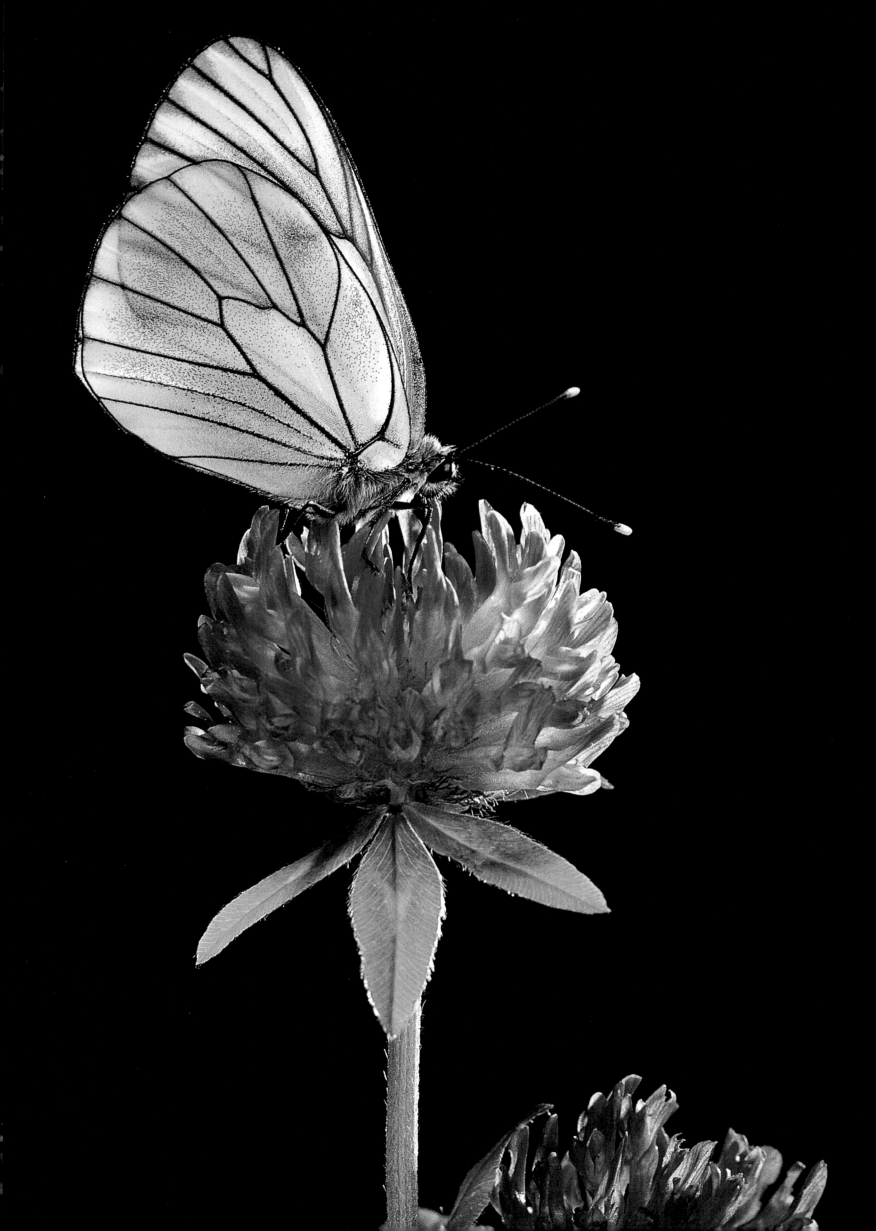

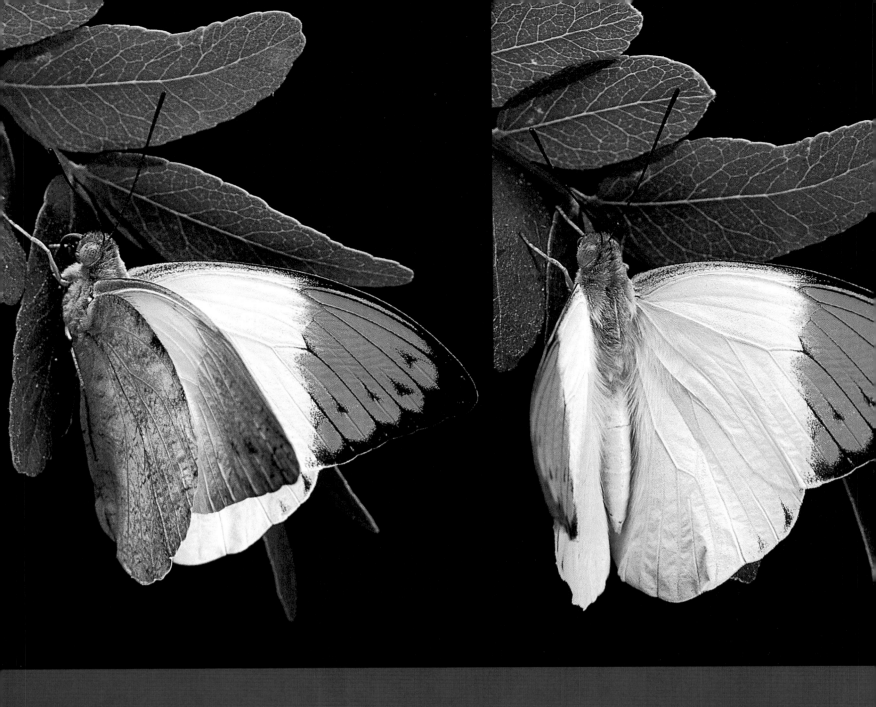

OPPOSITE AND RIGHT

hebomoia glaucippe
[x 2.4], [x 2.6] & [x 2.

Distribution: tropical Asia
Host plants: caper plant

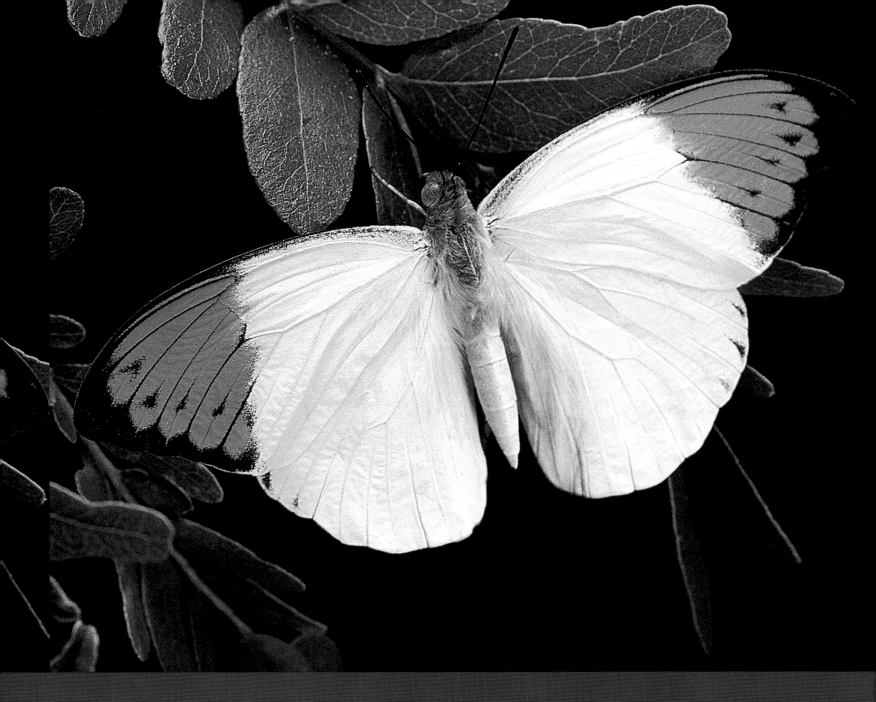

OVERLEAF

anthocharis cardamines (x 13)
"orange tip"

When this butterfly hatches, it is a sign that winter is over and spring is here at last. The "orange tip" produces only one generation per year, and the butterfly remains inside the pupa for ten months, secretly waiting for the following spring.

Distribution: temperate Eurasia
Host plants: various Brassicaceae

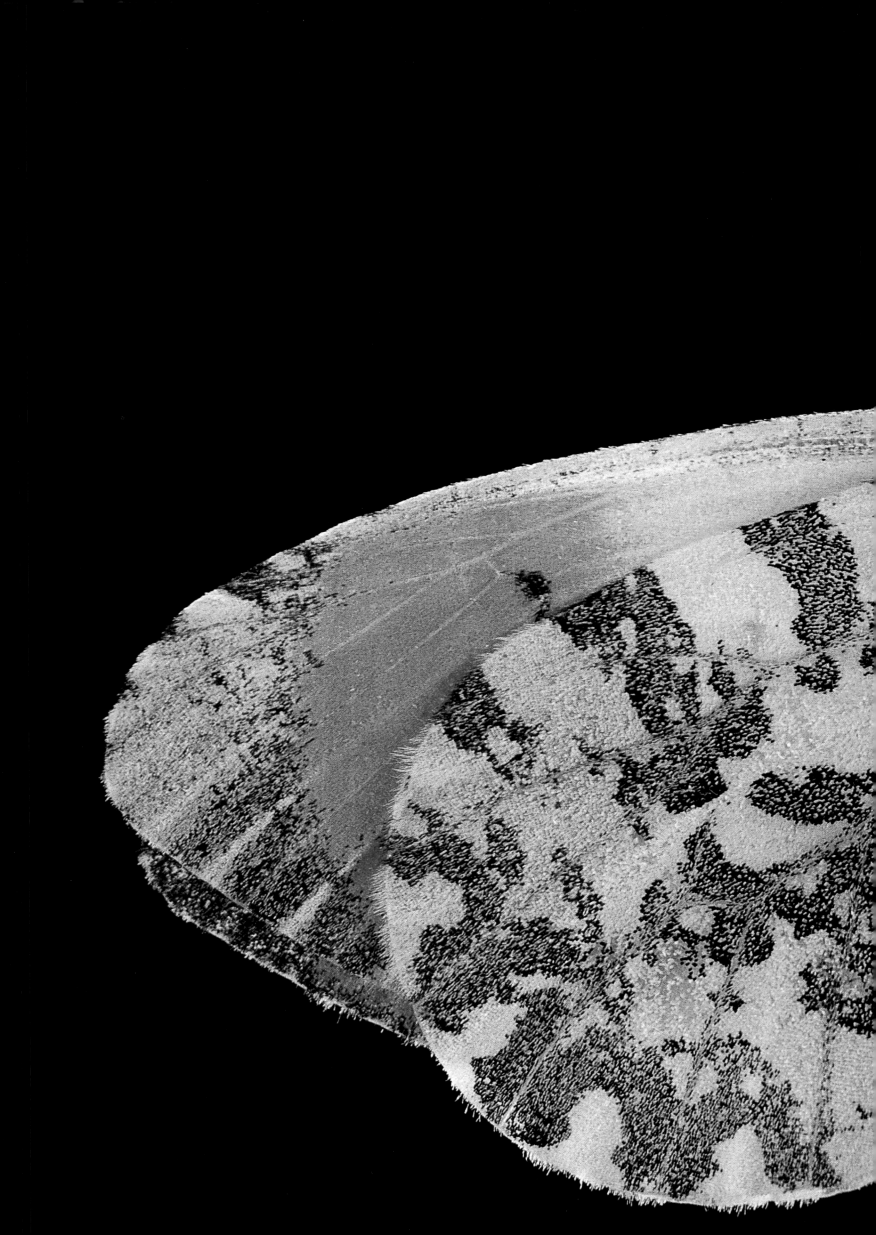

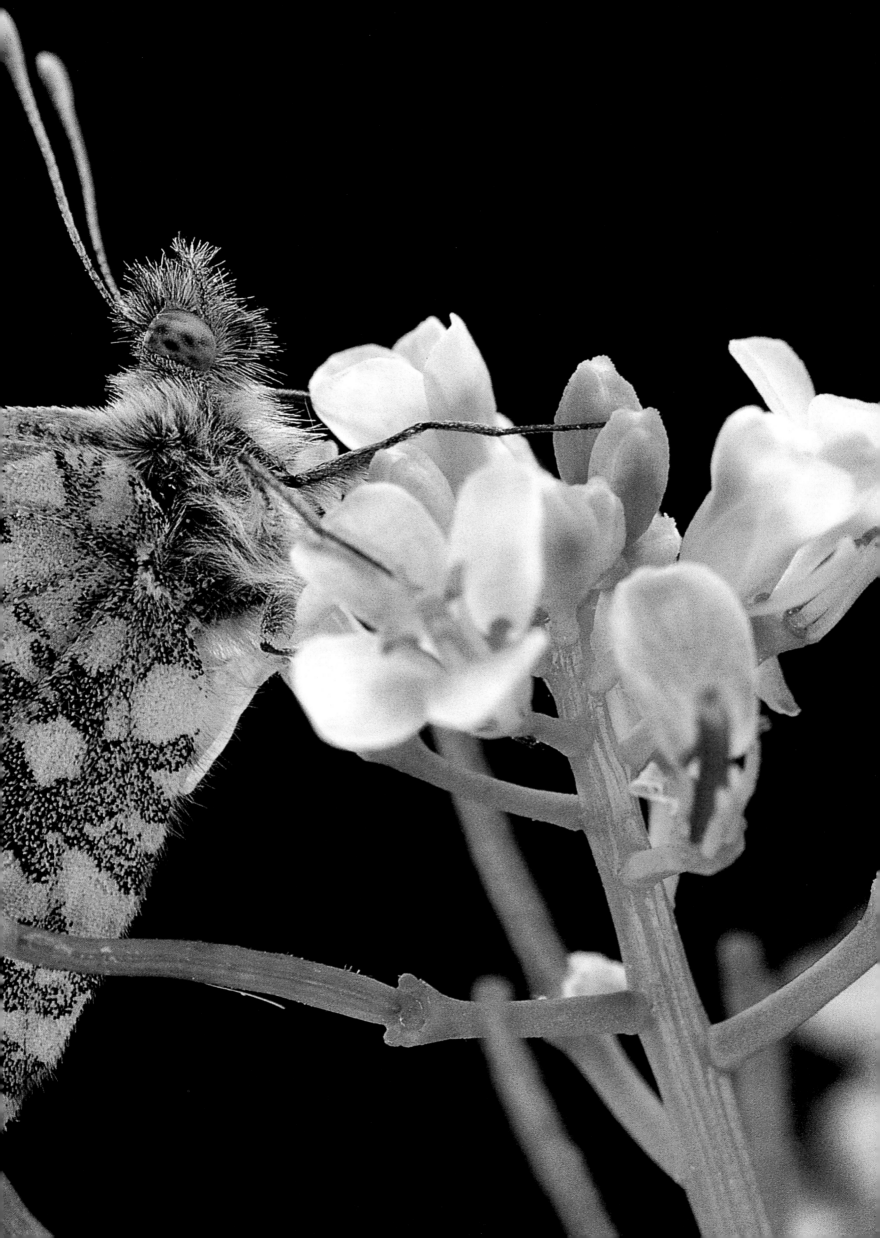

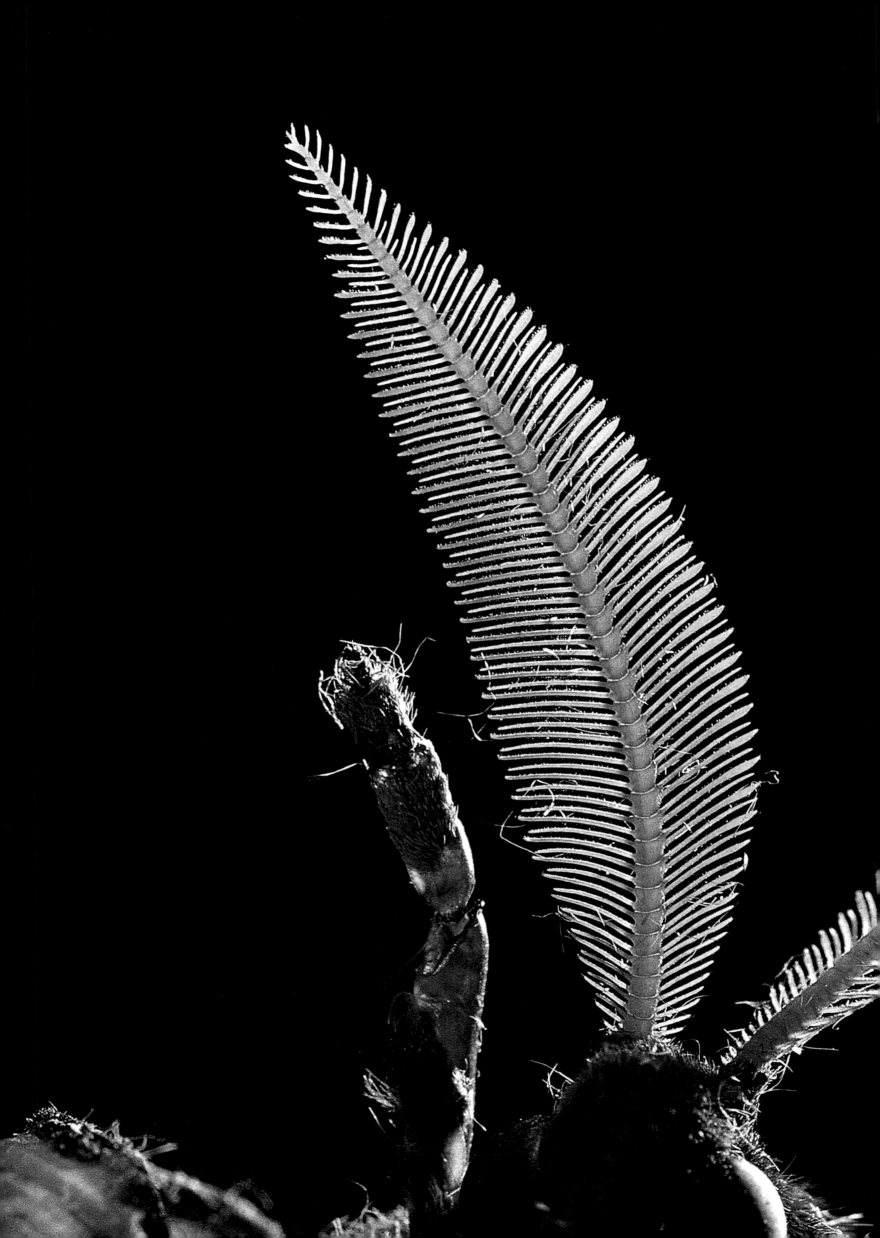

Moths

NEARLY NINE-TENTHS OF LEPIDOPTERA ARE MOTHS. THEIR

ANTENNAE ARE NEVER CLUBBED BUT VARY IN SHAPE, FROM THREADLIKE

AND FEATHERY TO PECTINATE (COMB-

SHAPED). SINCE COLOR IS NOT MUCH USE AT NIGHT, MOST MOTHS ARE

RATHER DULL IN COLOR AND MAINLY GRAY AND BEIGE. MOTH

LARVAE FREQUENTLY PUPATE IN A COCOON AND IN THE SOIL.

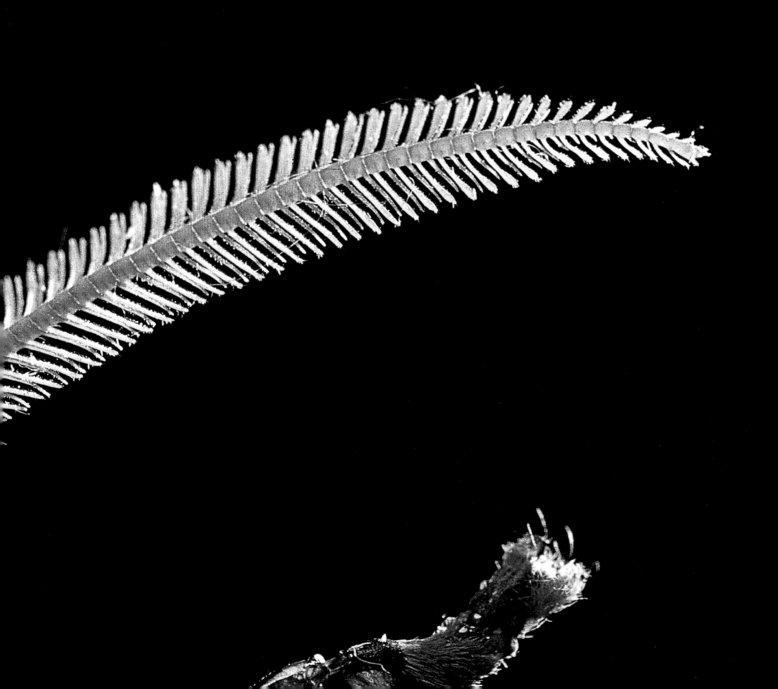

PREVIOUS DOUBLE-PAGE SPREAD

attacus atlas
"atlas" (x 12.3)

Distribution: tropical Asia
Host plants: very varied. In captivity: privet,
willow, fruit trees...

Arctiidae "tiger moths"

This cosmopolitan family of about 6,000 species of small- to medium-size moths is particularly prevalent in tropical regions. They are brightly colored, mainly in red, yellow, white, or black. The larvae have a positive mane of long hairs that they weave into their cocoon; they can also move at surprising speed. In the adult state, some species, if touched, give off drops of blood from the prothorax (the first segment of the thorax) that they can project a distance of up to 20cm (8in).

RIGHT

epicallia villica (x 6.2)
"cream-spot tiger"

These moths, because of their cumbersome body, fly heavily and in a straight line. Many play dead if they feel threatened. Another defense mechanism is their bitter taste that predators are alerted to by the moth's bright colors.

Distribution: Europe
Host plants: polyphagous (feeds off many different types of food)

OVERLEAF

egybolis vaillantina (x 16) & (x 17.7)

Some of these moths are not nighttime creatures at all, but fly during the day when they are even more brightly colored with a brilliant metallic sheen.

Distribution: tropical Africa
Host plants: not listed

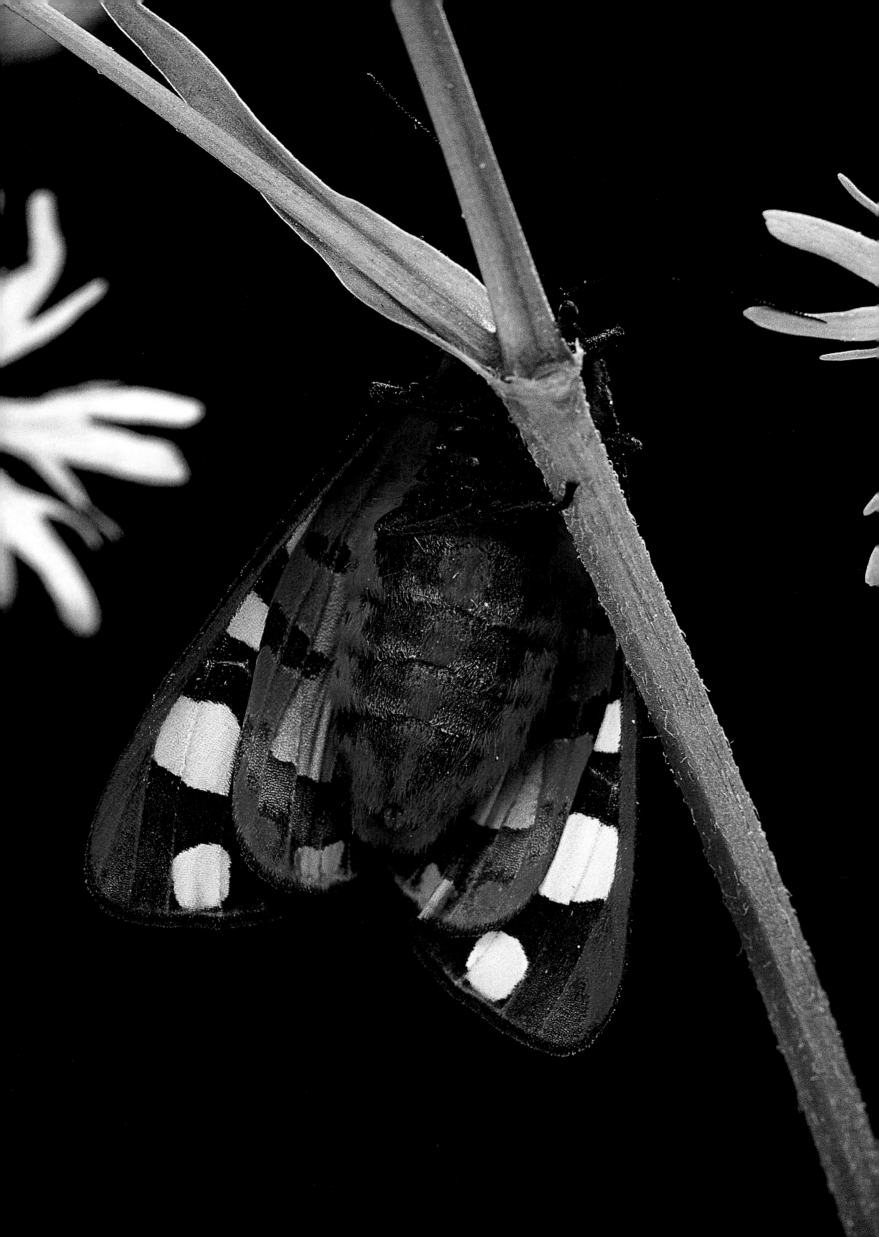

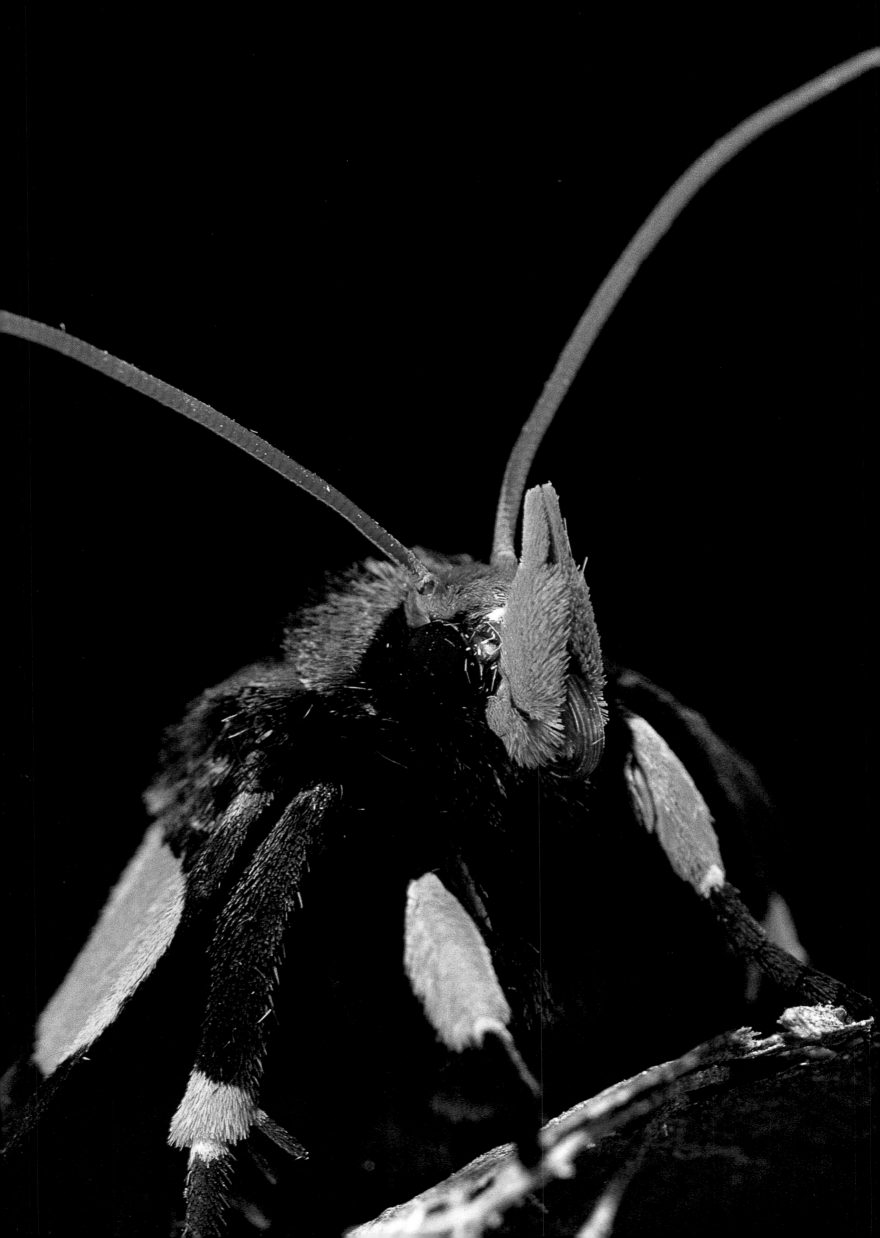

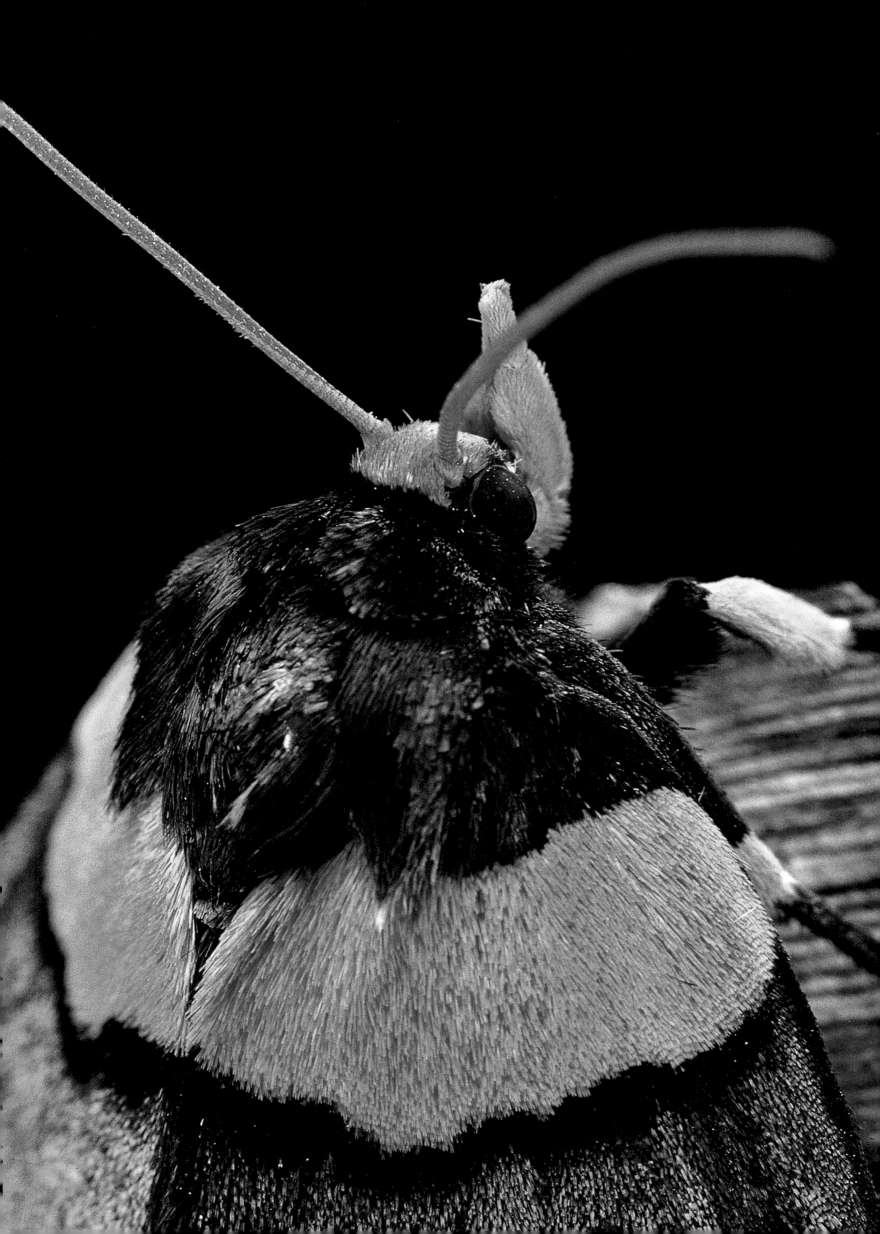

Attacidae

This family is famous for its giant moths, including some specimens with an impressive 30cm (12in) wingspan; they are particularly common in warm countries, and only seven species have been recorded in Europe. The larvae weave voluminous cocoons and are often domesticated and used to produce large quantities of a rather poor-grade silk. The adult moth cannot feed and only lives long enough to reproduce.

OPPOSITE, OVERLEAF, AND PAGES 120-121

actias selene
"moon" moth (x 5.6), (x 7.2), (x 2.6) & (x 8)

This moth is named after the moon *(selene)* because of its exquisitely soft diaphanous-green color. It belongs to the Attacidae group of moths that are notable for their hindwings extending into a long "tail." A related species is the Madagascan comet butterfly that can have a wingspan of up to 20 cm (8in).

Distribution: tropical Asia
Host plants: rhododendron, fruit trees

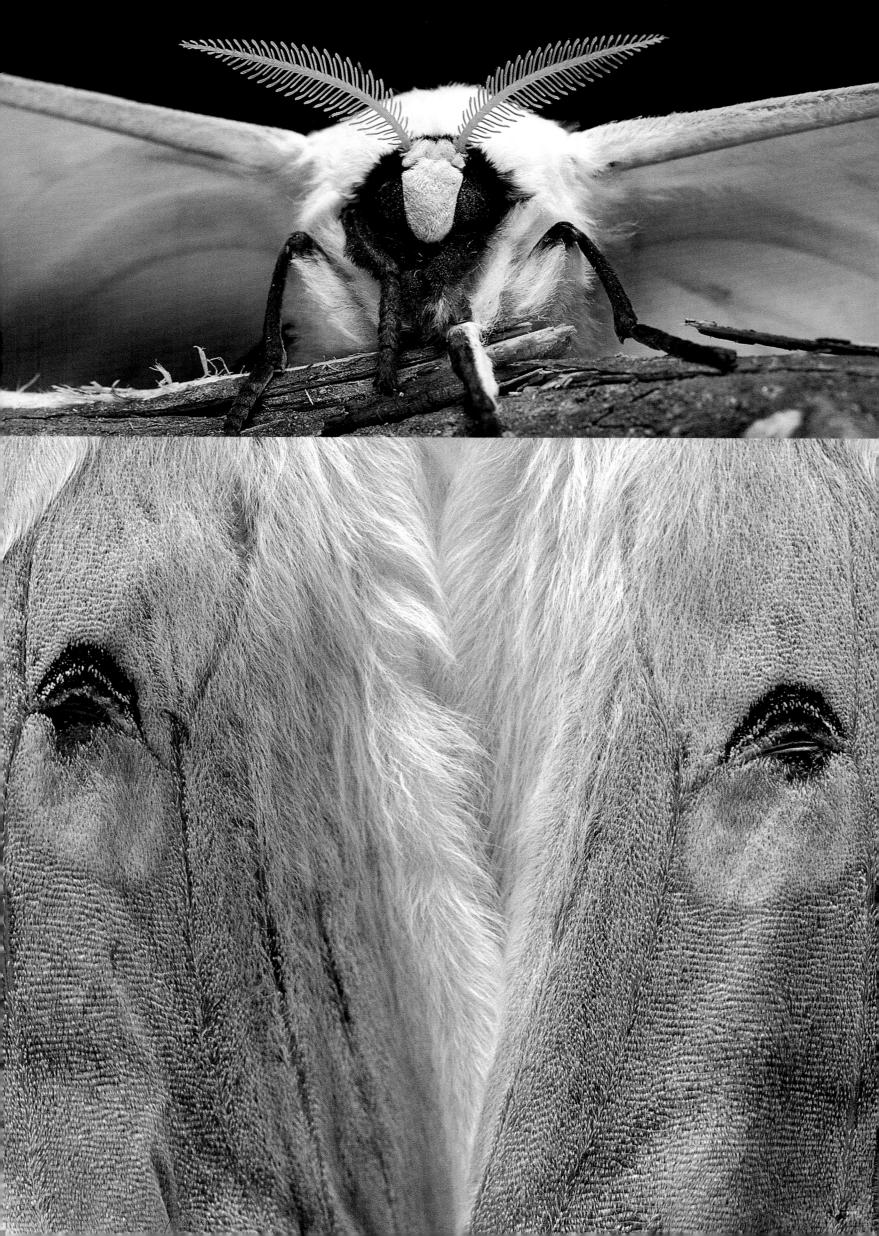

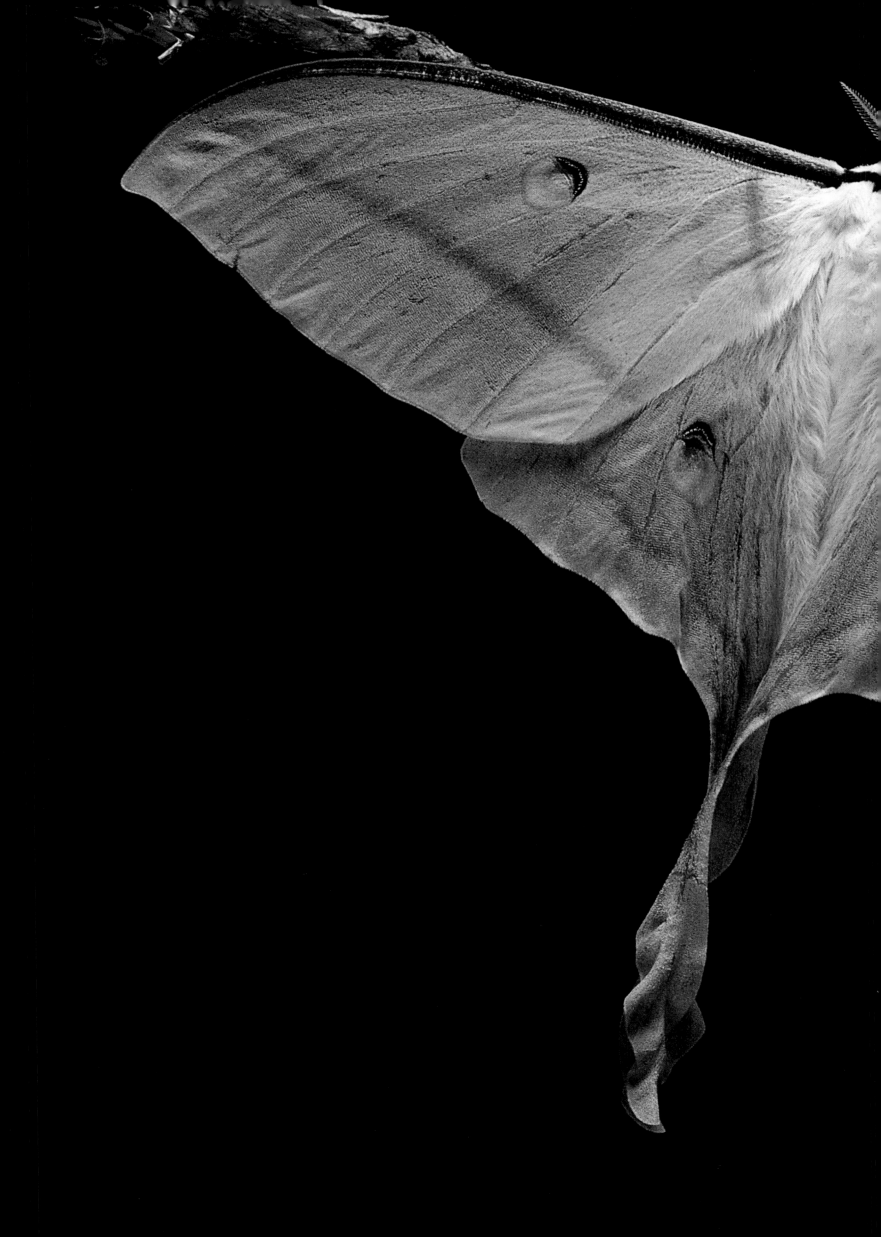

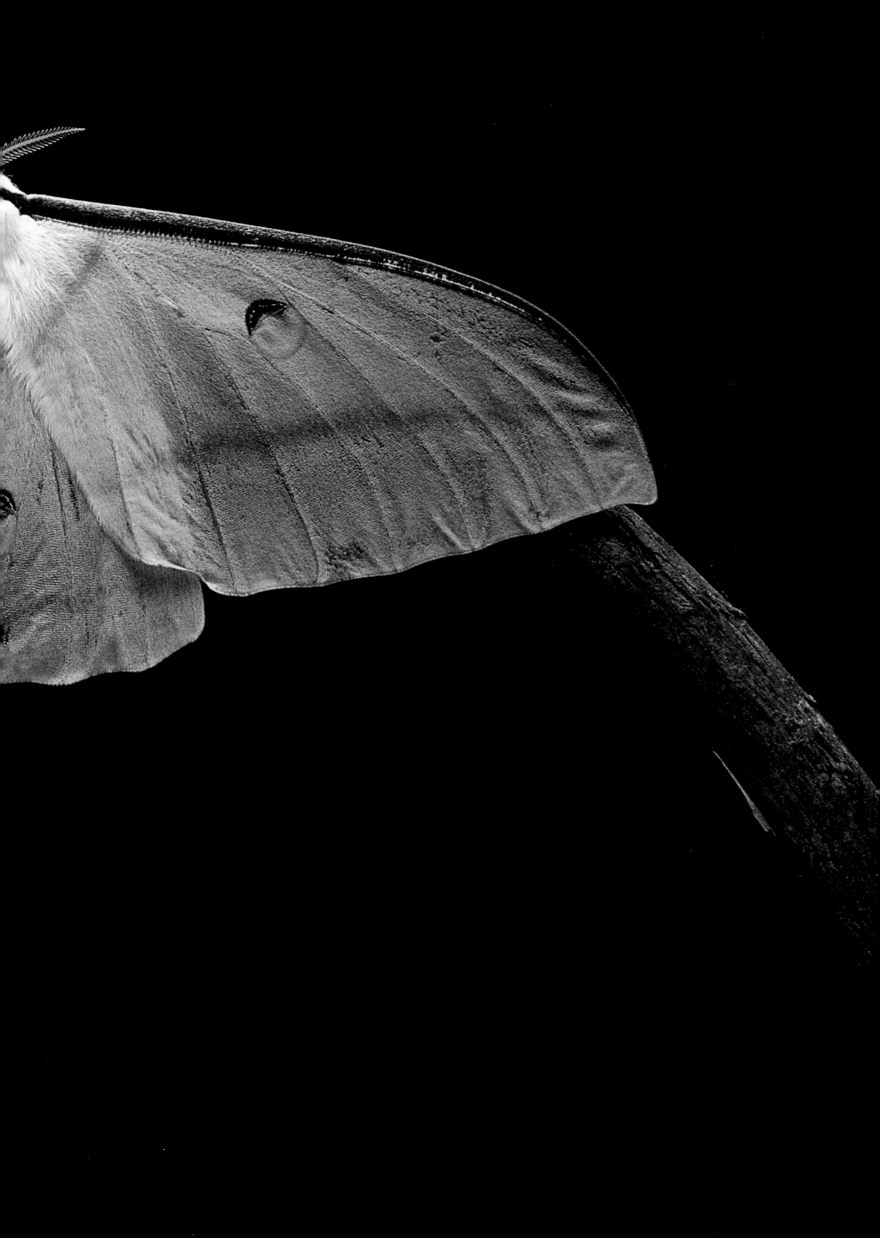

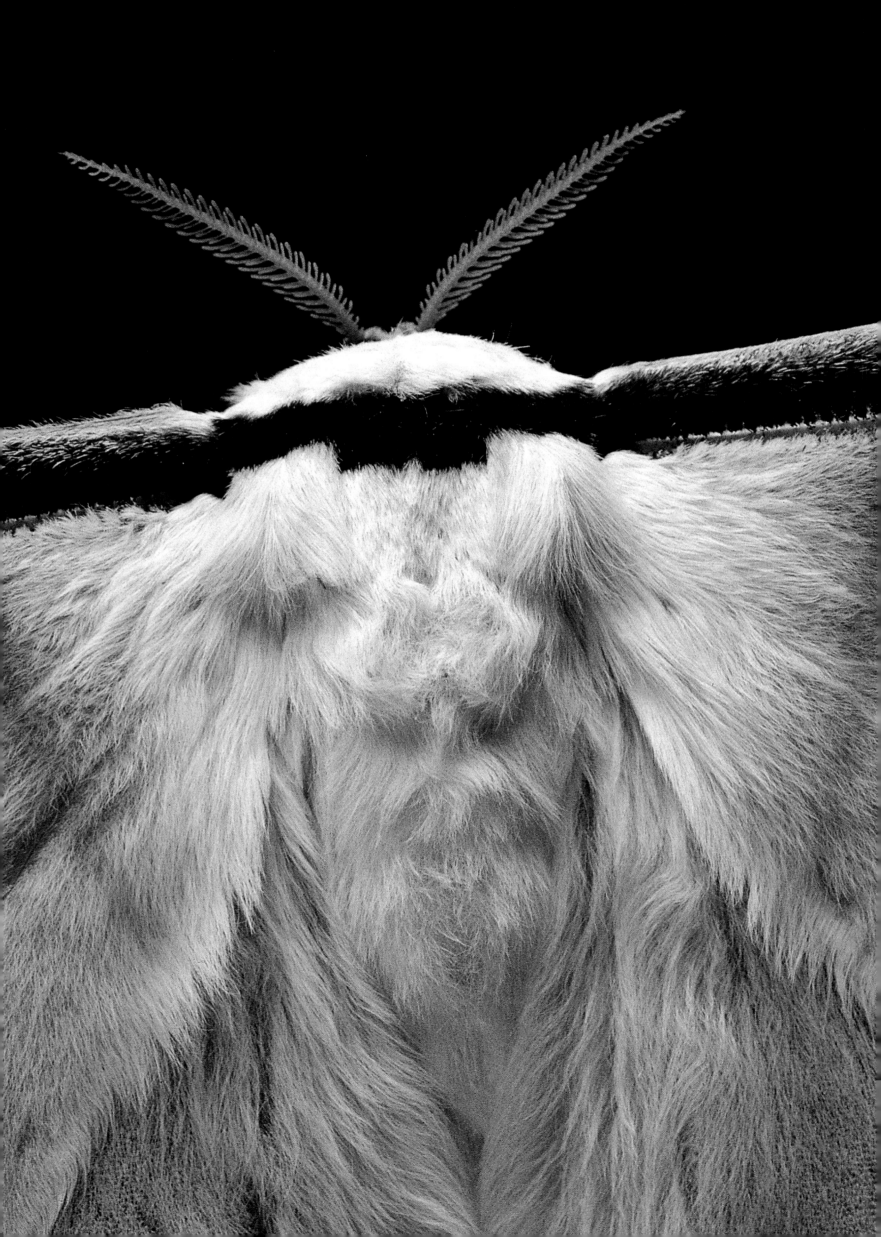

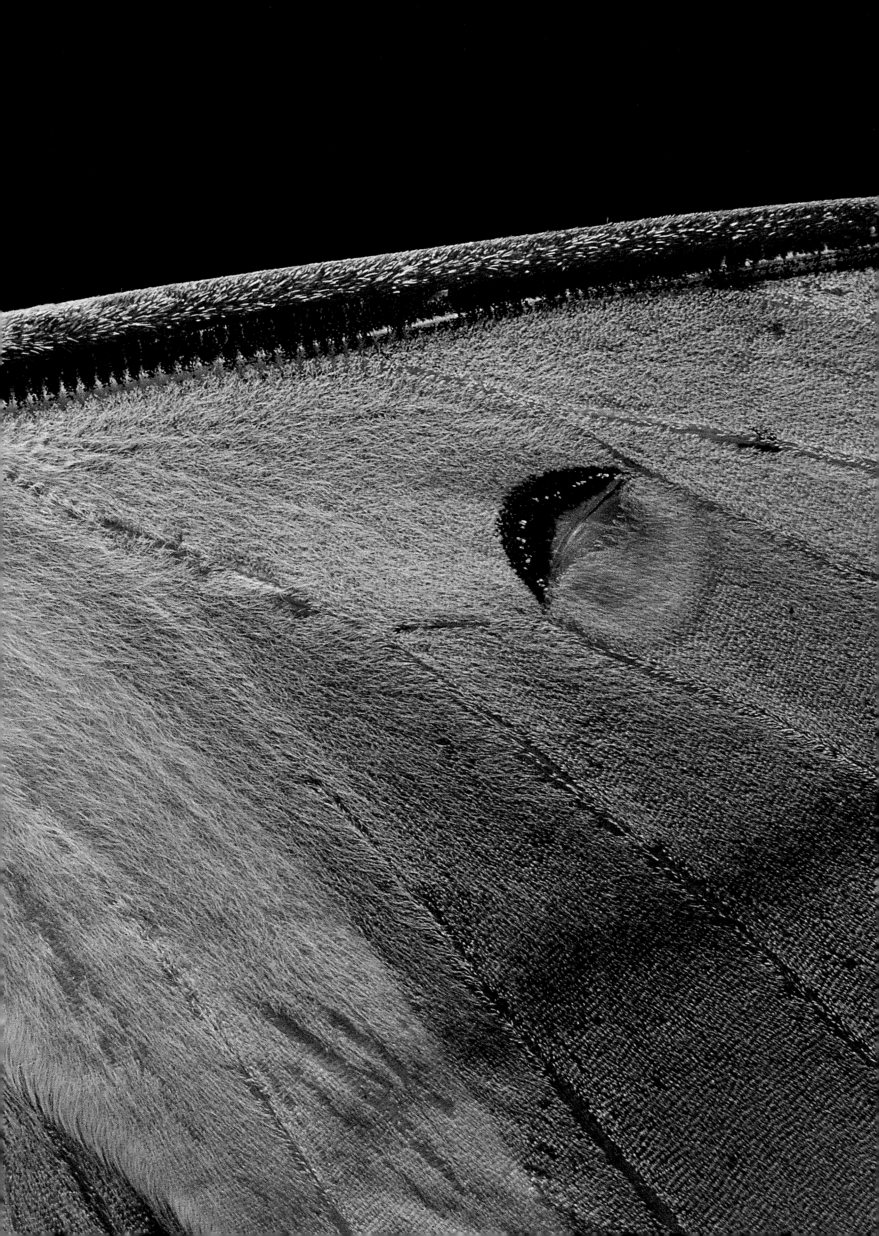

antherea pernyi (x 2) & (x 10.9)

Traditionally, the *Antherea* were domesticated and used to produce medium-quality silk for manufacture into relatively inexpensive fabrics. Originally from Asia, these moths are now found in Europe and the Balearic Islands in populations founded by moths that escaped from the former silk farms. The particular shape and pattern of the scales, which are very elongated and overlapping, make the wings look almost cuddly.

Distribution: China
Host plants: oak

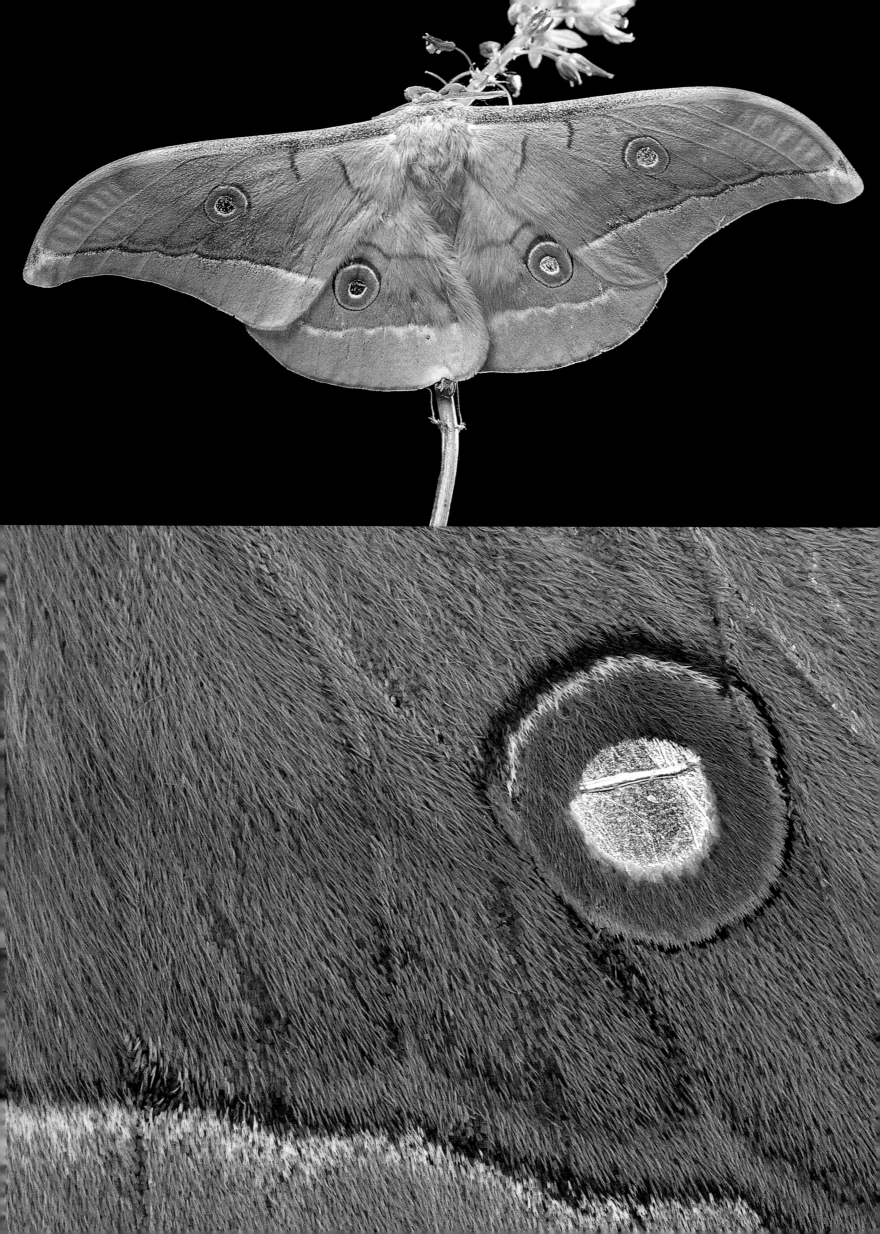

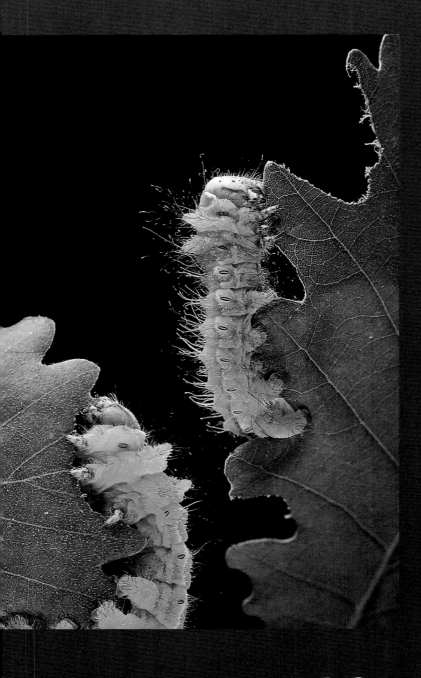

LEFT

antherea pernyi (x 1.9)

When you think how tough and thick oak leaves are, you can see why *Antherea* larvae have been equipped with a large head and powerful mandibles.

Distribution: China
Host plants: oak

RIGHT

automeris harrissorum (x 4.3)

Distribution: South America
Host plants: in captivity, privet and oak

OVERLEAF

attacus atlas
"atlas" (x 2.1)

The *Attacus* moth is named after Atlas, the colossus in Greek mythology who bore the Earth upon his shoulders. Like its legendary namesake but on a different scale, this moth is also a giant and ranks as one of the largest Lepidoptera in the world, with a wingspan of up to 30cm (12in).

Distribution: tropical Asia
Host plants: very varied. In captivity, privet, willow, fruit trees ...

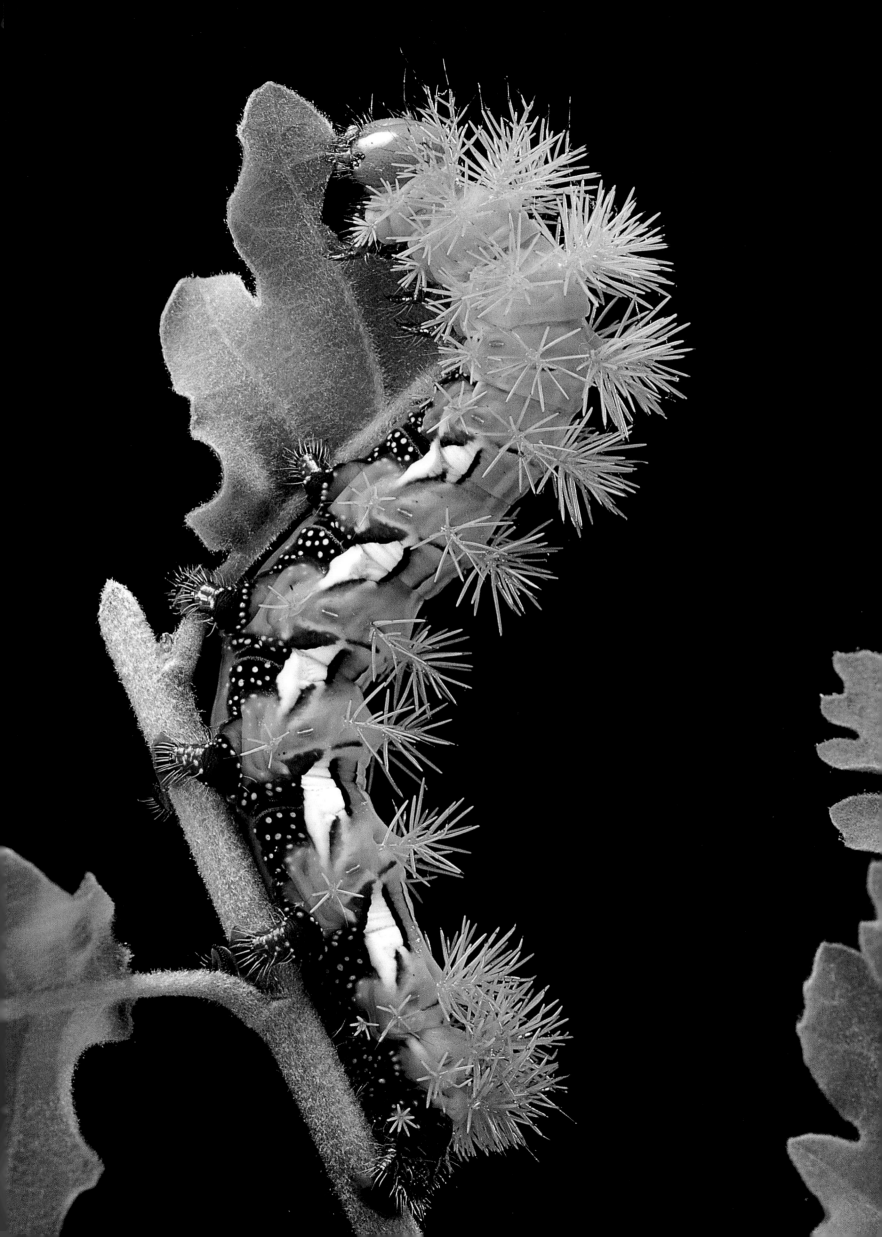

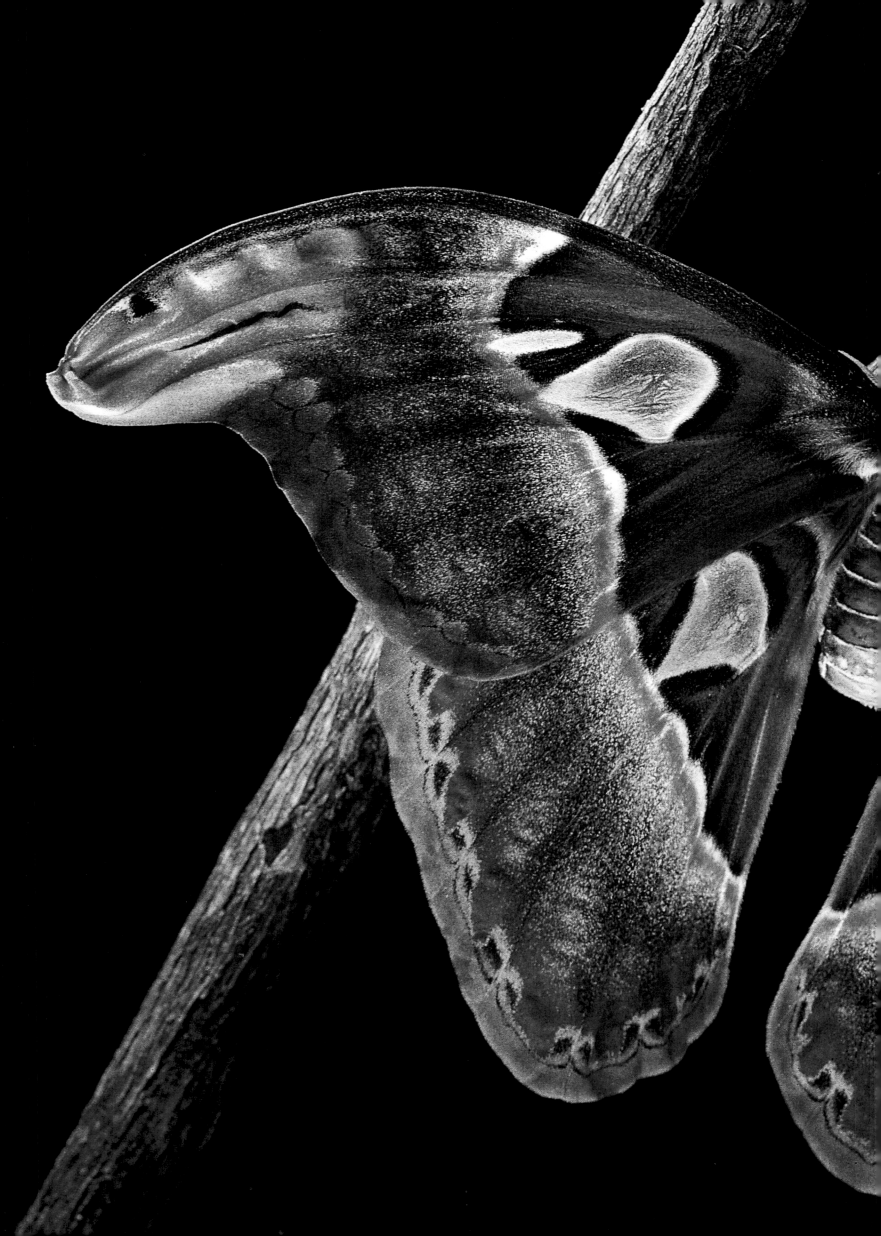

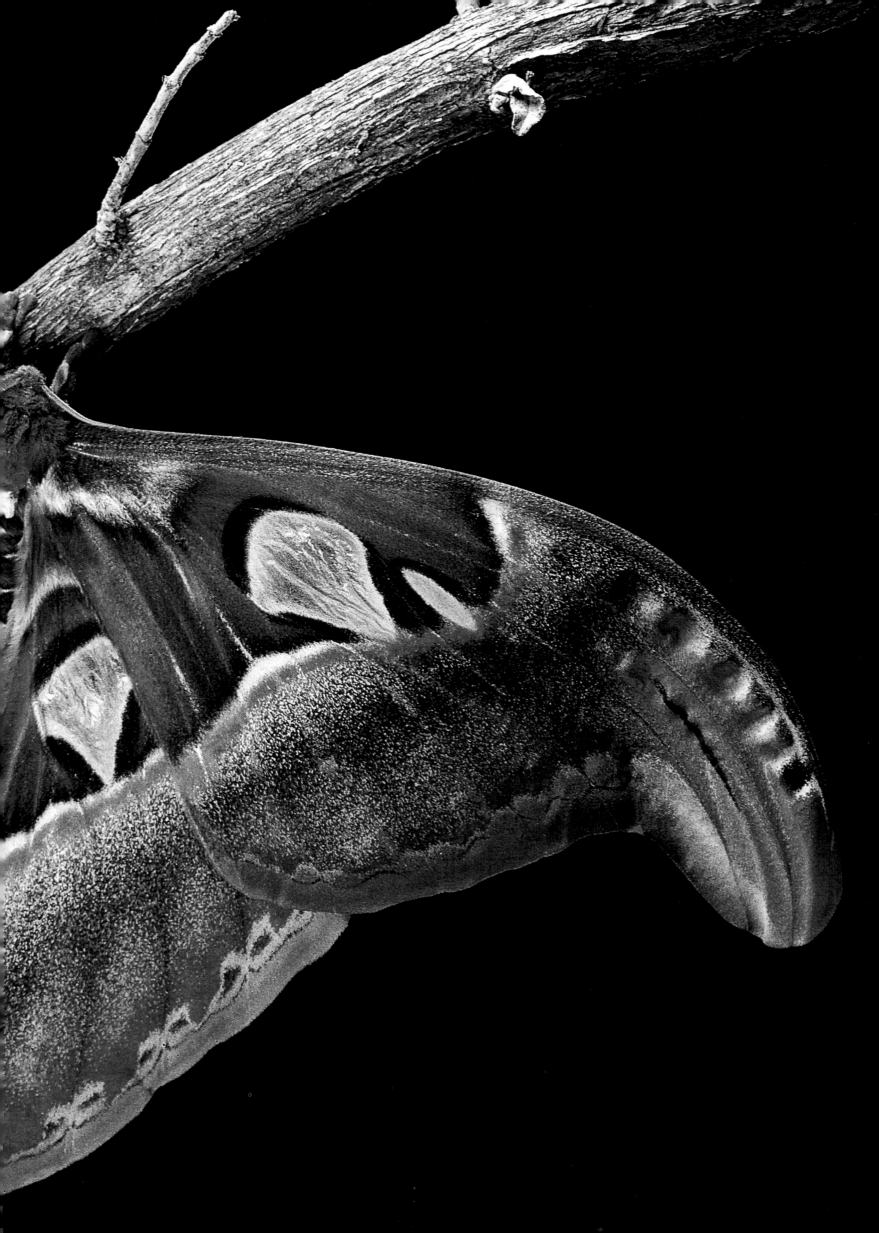

automeris harrissorum
(x 7.2)

This large group of exclusively American moths was originally destined for silk production. Unfortunately, however, despite the quality of the silk obtained, the larvae were extremely difficult to handle because of their stinging spines that, to make matters worse, they deliberately wove into the silk. This produced a hair-cloth-like fabric that caused the most appalling itching. Customers complained and production had to cease.

Distribution: tropical America
Host plants: in captivity, privet

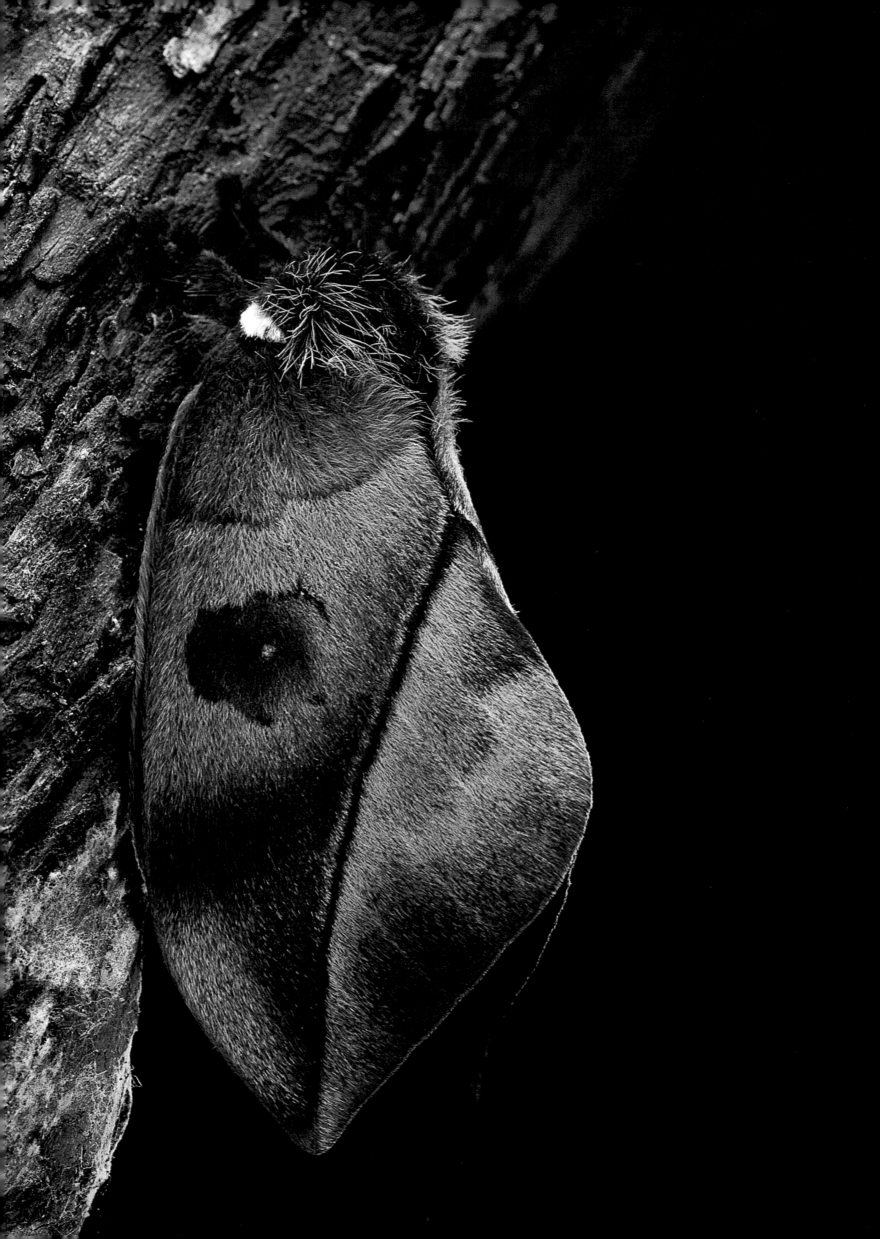

automeris liberia (x 9)

The most remarkable feature about this species is the fragmented pattern at the center of the ocelli.

Distribution: tropical America
Host plants: in captivity, privet

automeris harrissorum (x 2.2)

Distribution: tropical America
Host plants: in captivity, privet

automeris egeus (x 3.3), (x 3.5) & (x 3.3)

These larvae have an almost infallible defense mechanism that plainly makes them quite unsuitable for silk production. Their thorny spines are tipped with poison that causes a very painful sting. Imagine finding one of those in your silk shirt …

Distribution: tropical America
Host plants: in captivity, privet

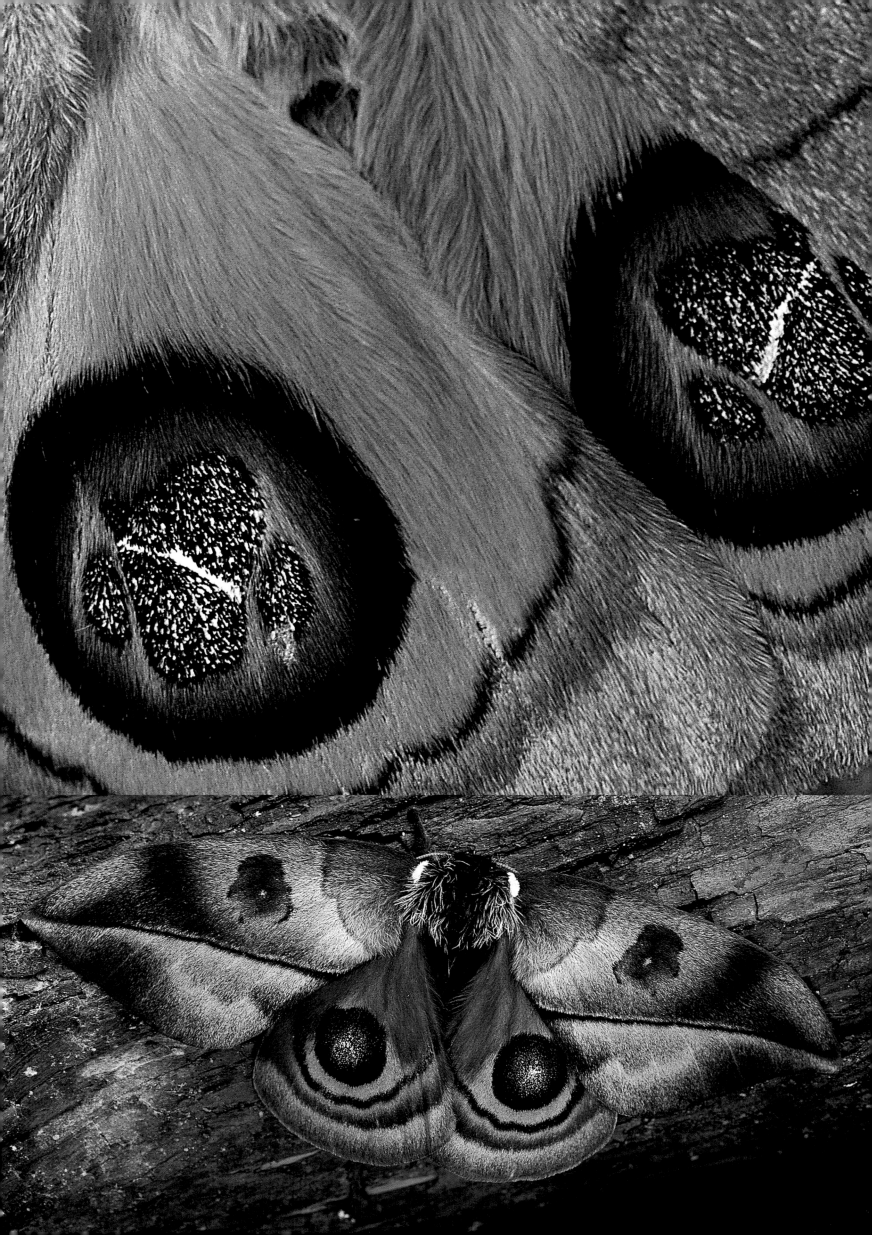

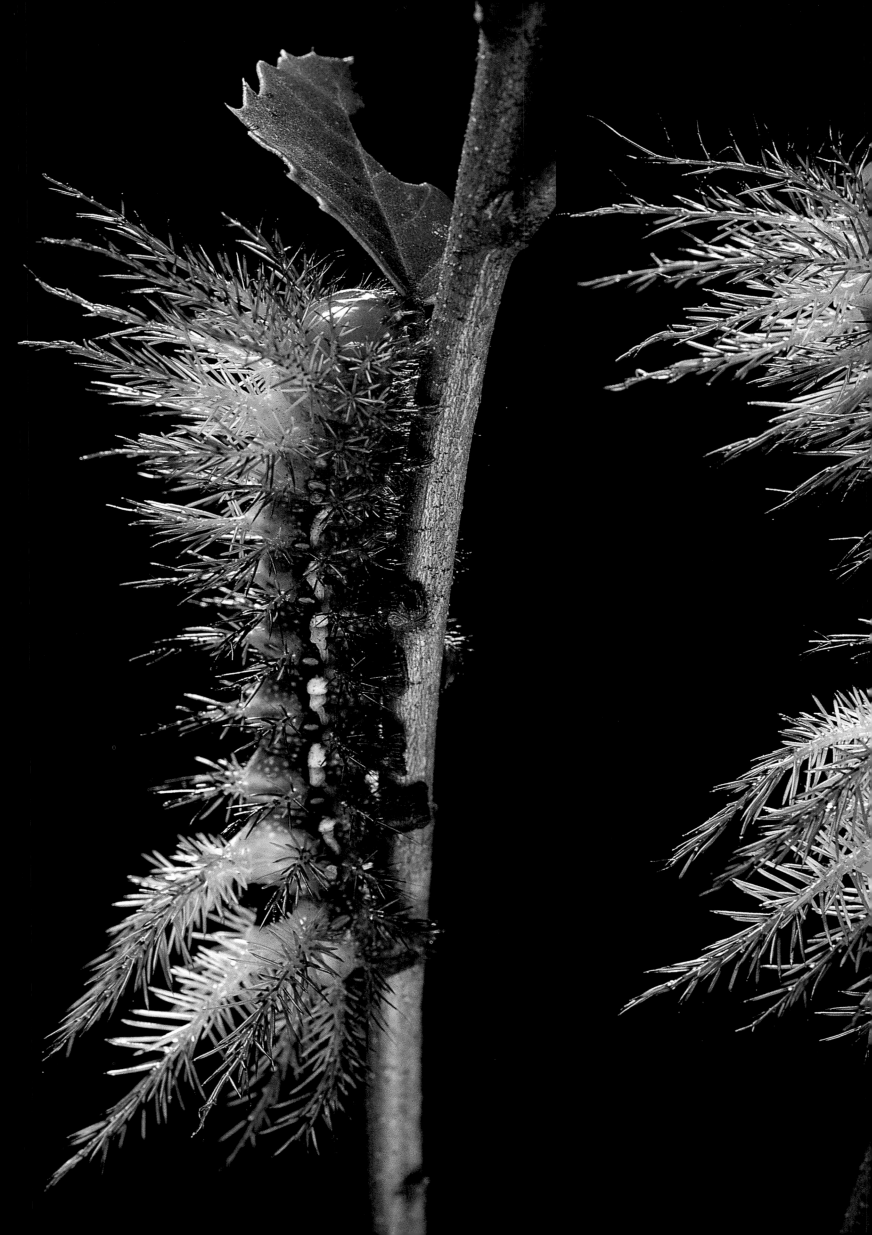

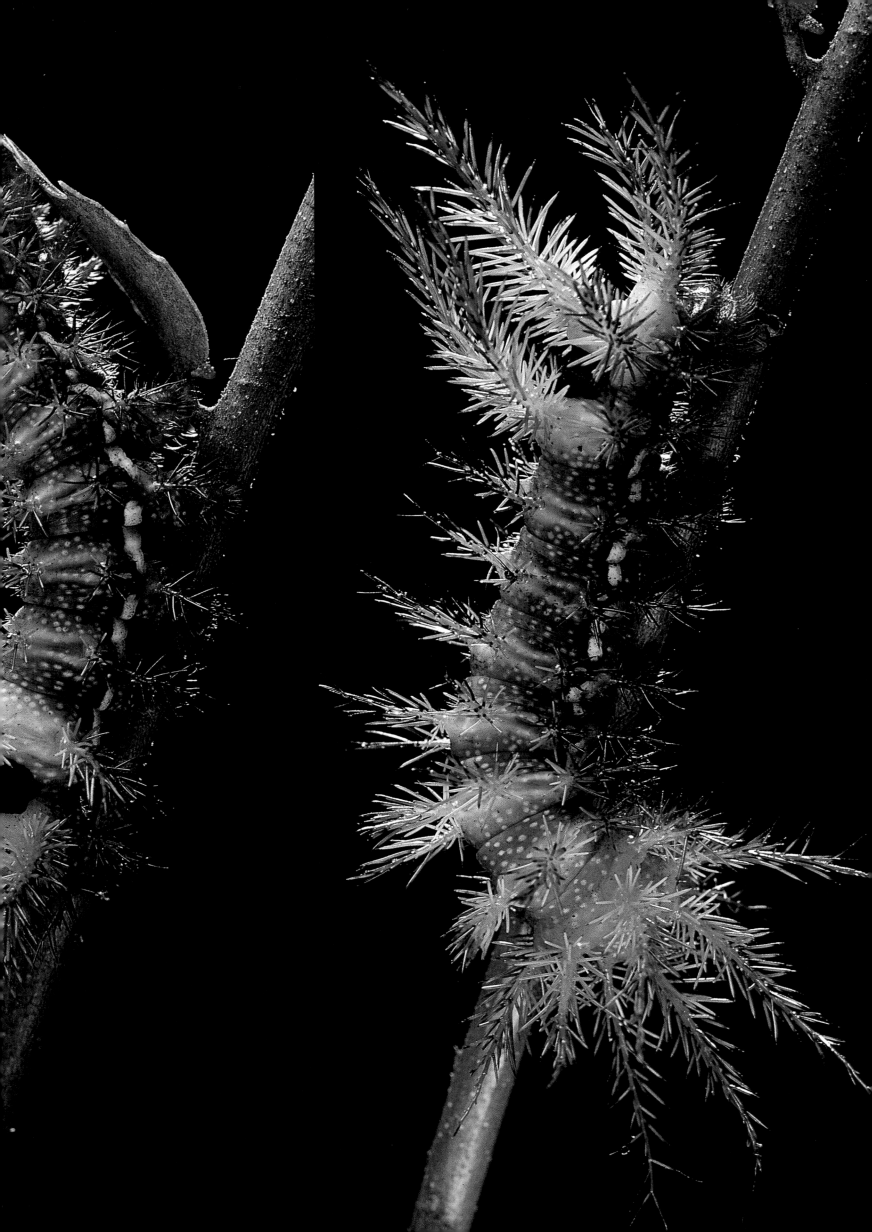

OPPOSITE AND RIGHT

rothschildia jacobae [x 1.7] & [x 1.7]

Distribution: tropical America
Host plants: in captivity, privet

OVERLEAF, LEFT

rothschildia hesperus [x 3.4]

Distribution: tropical America
Host plants: in captivity, privet

OVERLEAF, RIGHT

rothschildia lebeau [x 6]

Distribution: tropical America
Host plants: in captivity, privet

PAGES 138-139

samia cynthia ssp. ricini [x 4.4]

This moth, which came originally from Asia where it was used in silk production, is now found all over the world. In France, for instance, it is known to be quite at home in Paris, where for a century now it has lived happily in avenues lined with ailanthus trees ("tree of Heaven").

Distribution: tropical and temperate Asia
Host plants: ailanthus and privet

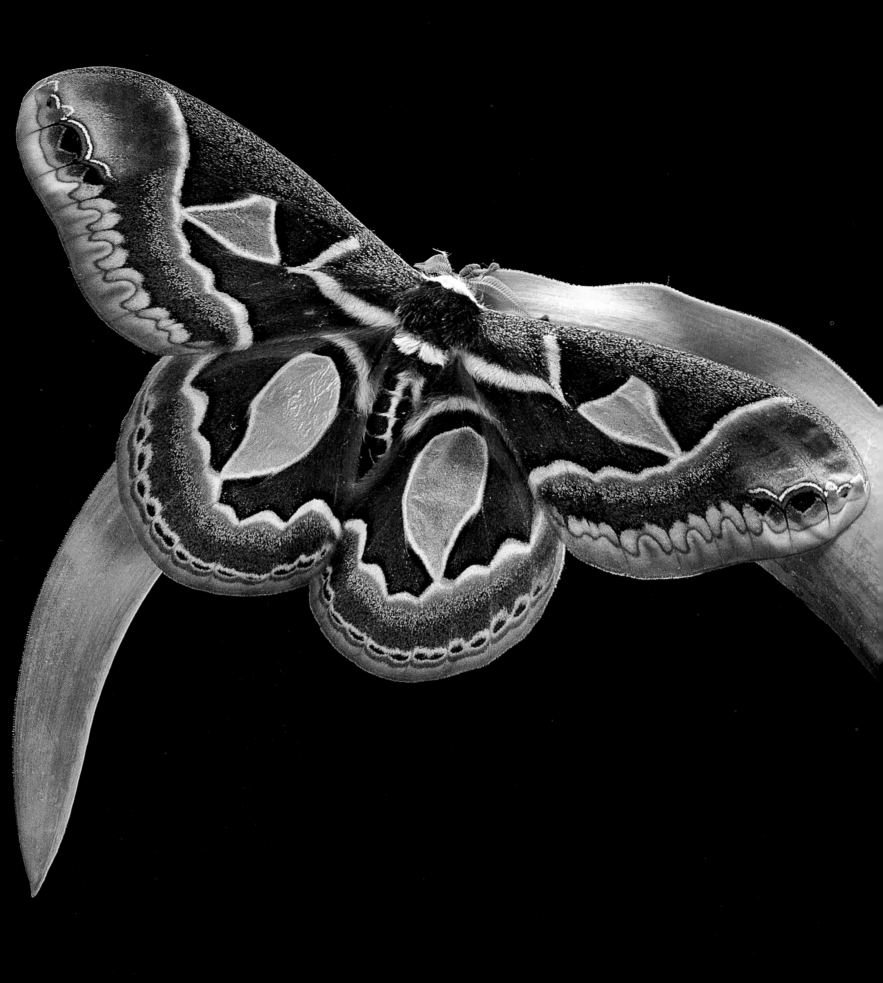

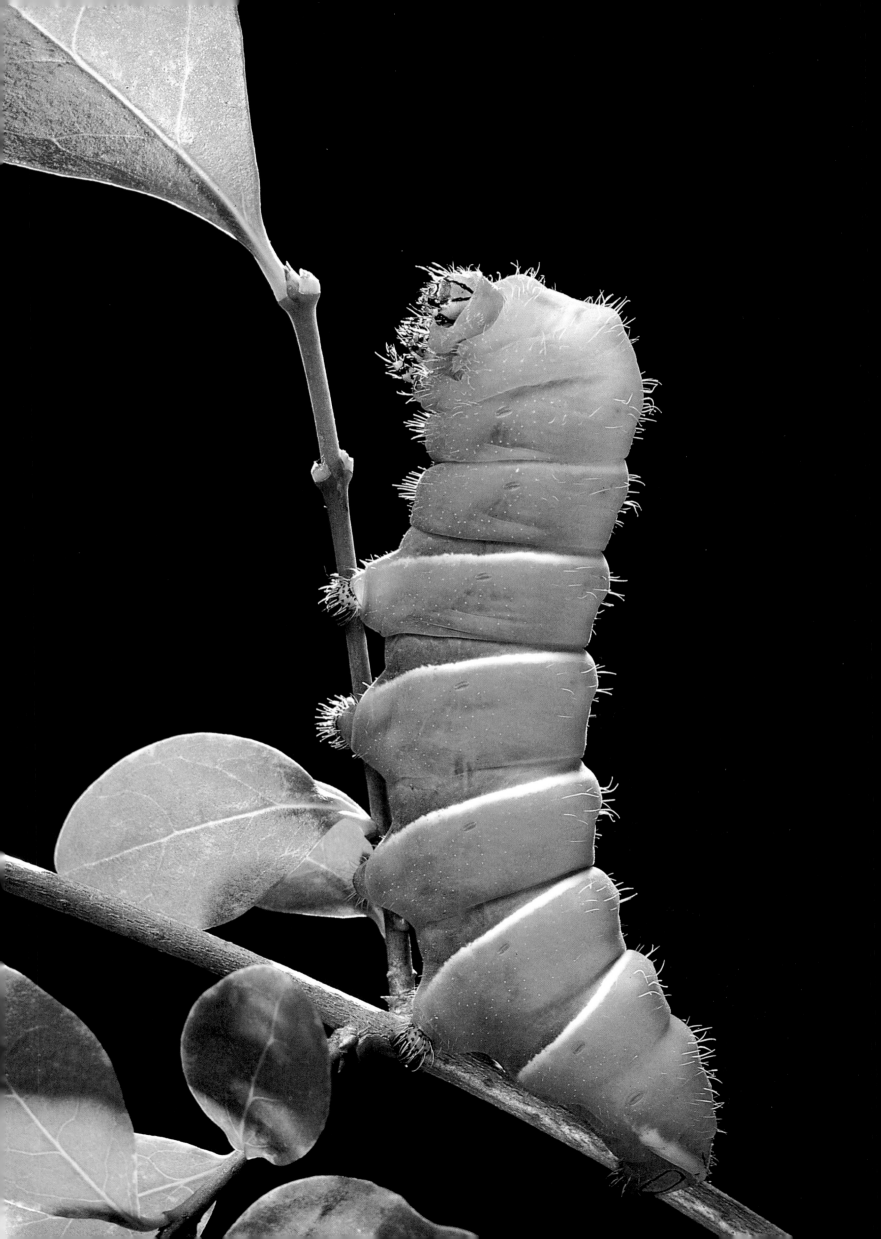

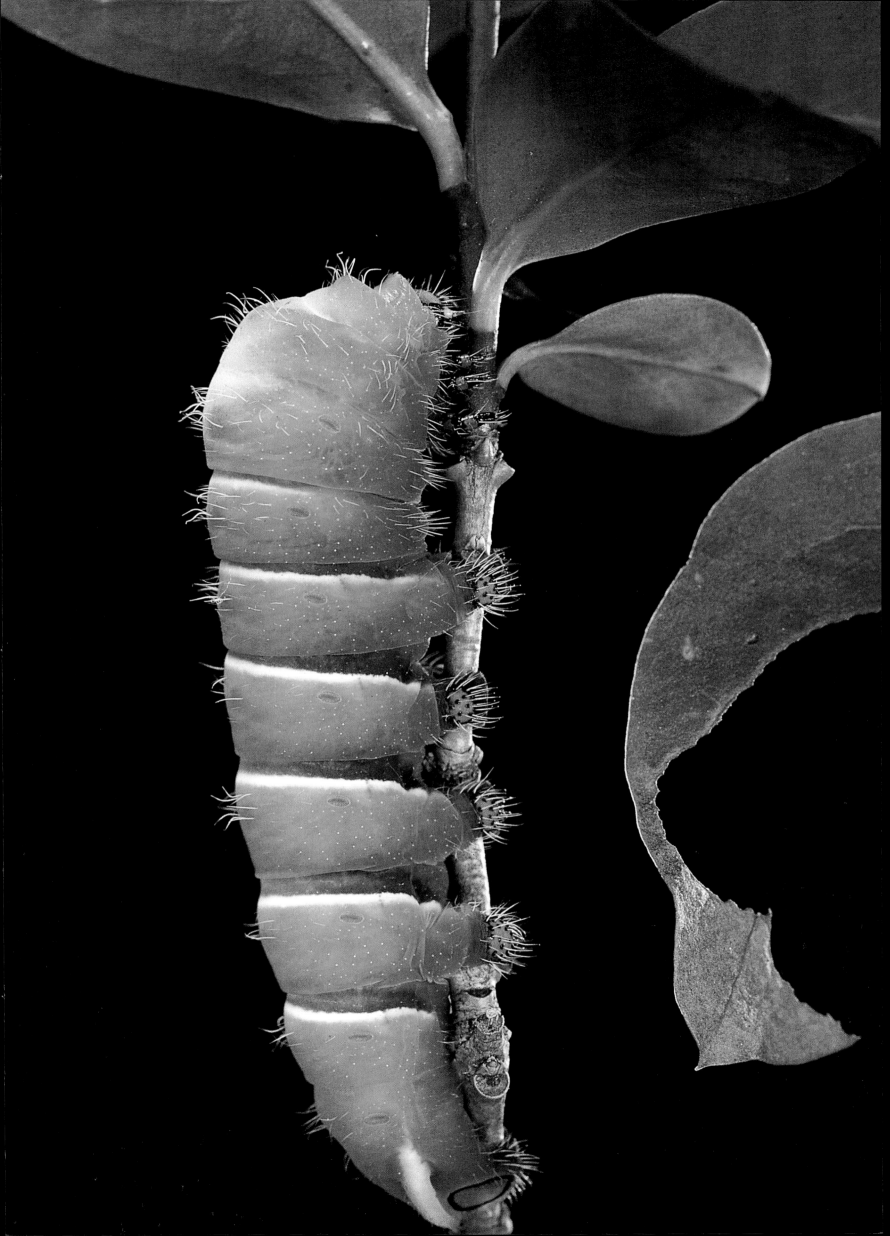

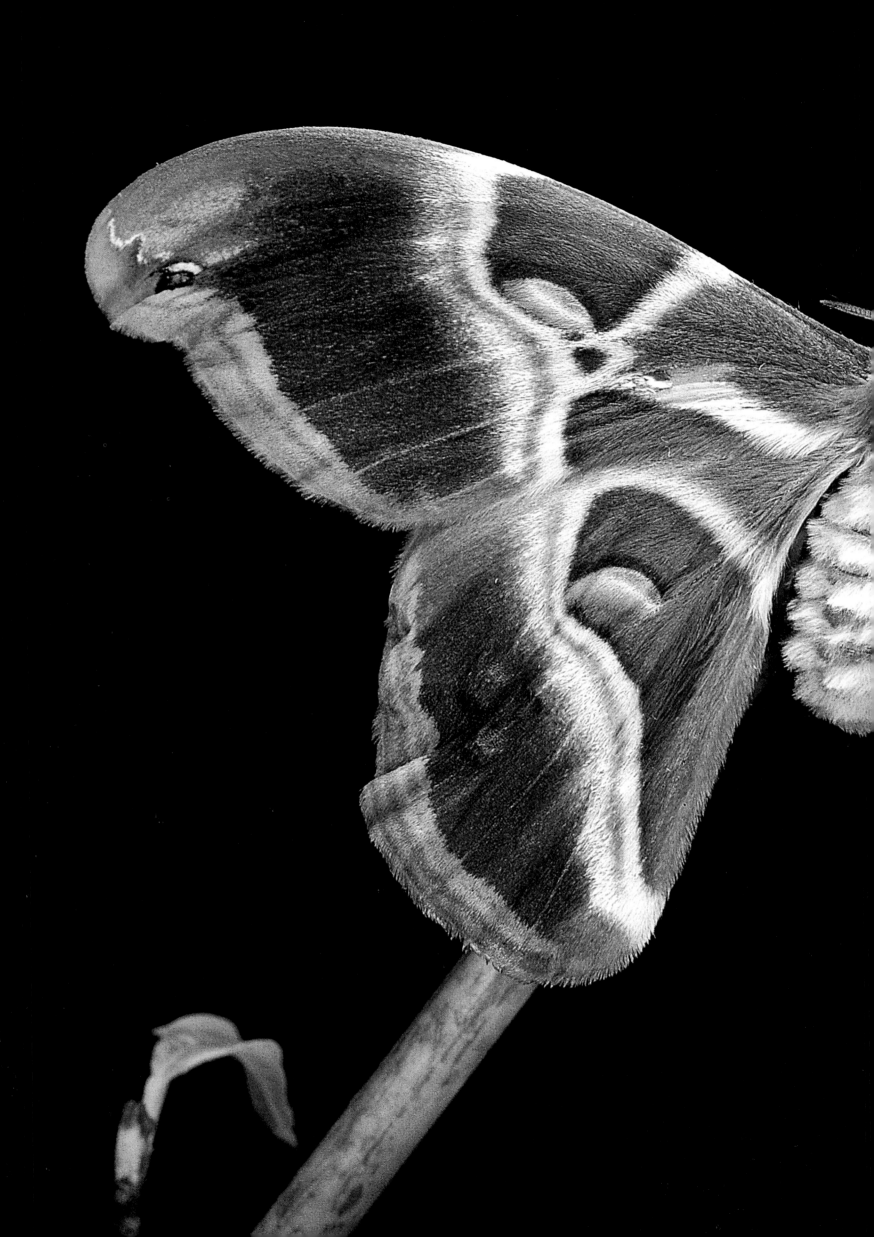

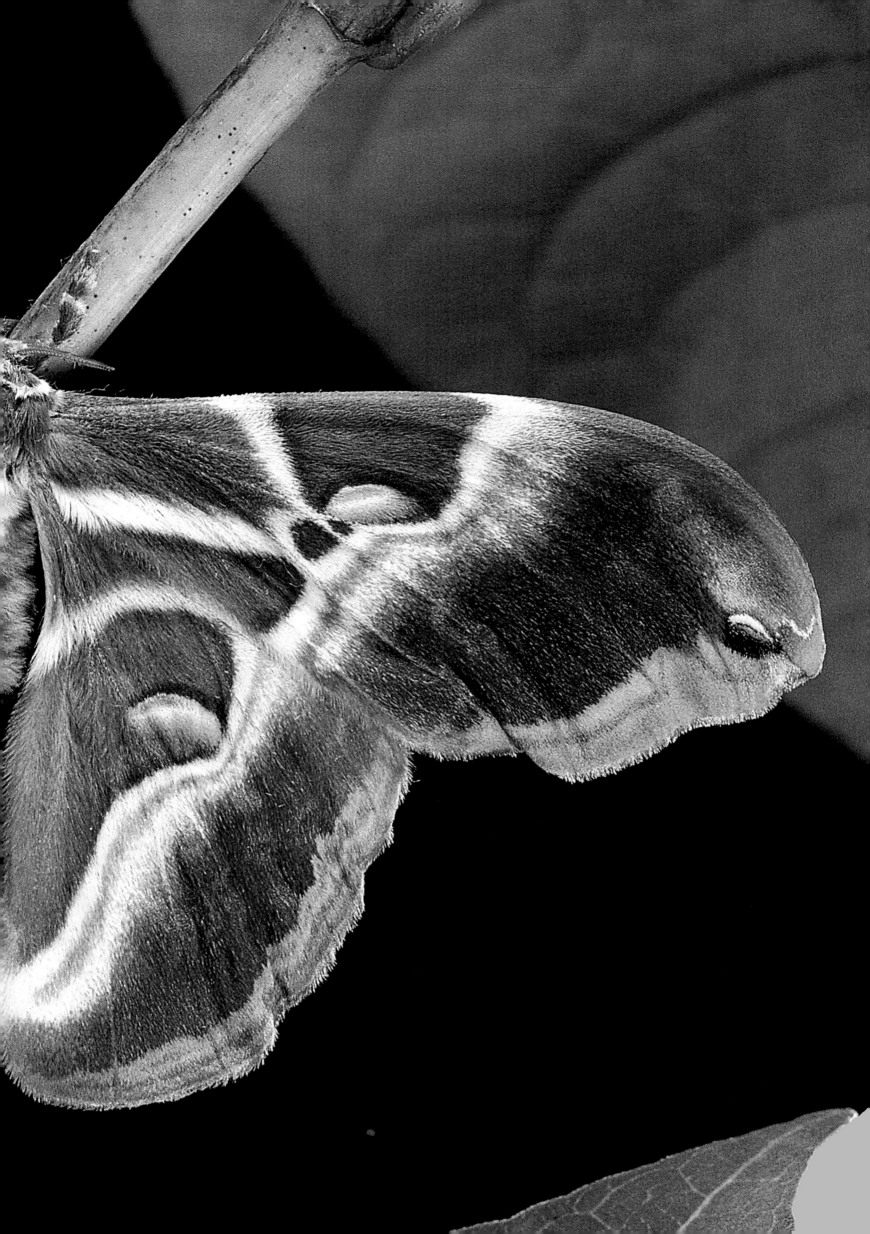

Bombycoidea

This family of moths is distributed worldwide, although numbers are dwindling, and the family now comprises no more than thirty medium-size species. The adult moths have no proboscis and only live for a few days.

● ● ● **bombyx mori**
silkworm (x 4.7), (x 3.9) & (x 6.2)

This moth is unrivaled when it comes to quality silk production, and is the only completely domesticated species. It is flightless and totally dependent on man for food and reproduction. When the larva is fully grown, its silk glands make up a quarter of its bodyweight, and it starts to build a complex network of silk on which to anchor the future cocoon. For two days, it rocks its head back and forth three hundred thousand times as it wraps itself in a cocoon made with a single thread more than half a mile long. When the larva has finished its work, it remains motionless and starts to pupate. A few weeks later, the moth is ready to emerge, but not without a little help from chemistry: it secretes an alkaline liquid from its mouth that softens the silk so that the moth can simply push its way out head first.

Distribution: originally from China, domesticated
Host plants: mulberry bush

PAGES 144-145

Endromidea

This is the smallest of all the families and consists of only a single species.

endromis versicolor
(x 12.3)

These moths hatch as soon as the snows melt, but survive for just a few days. The males are rapid diurnal fliers, and their sole purpose in life is to find a female. The females are nocturnal, and only take flight after mating to lay their eggs on the still leafless branches of birch trees.

Distribution: the cold regions of temperate Eurasia
Host plants: mainly birch trees.

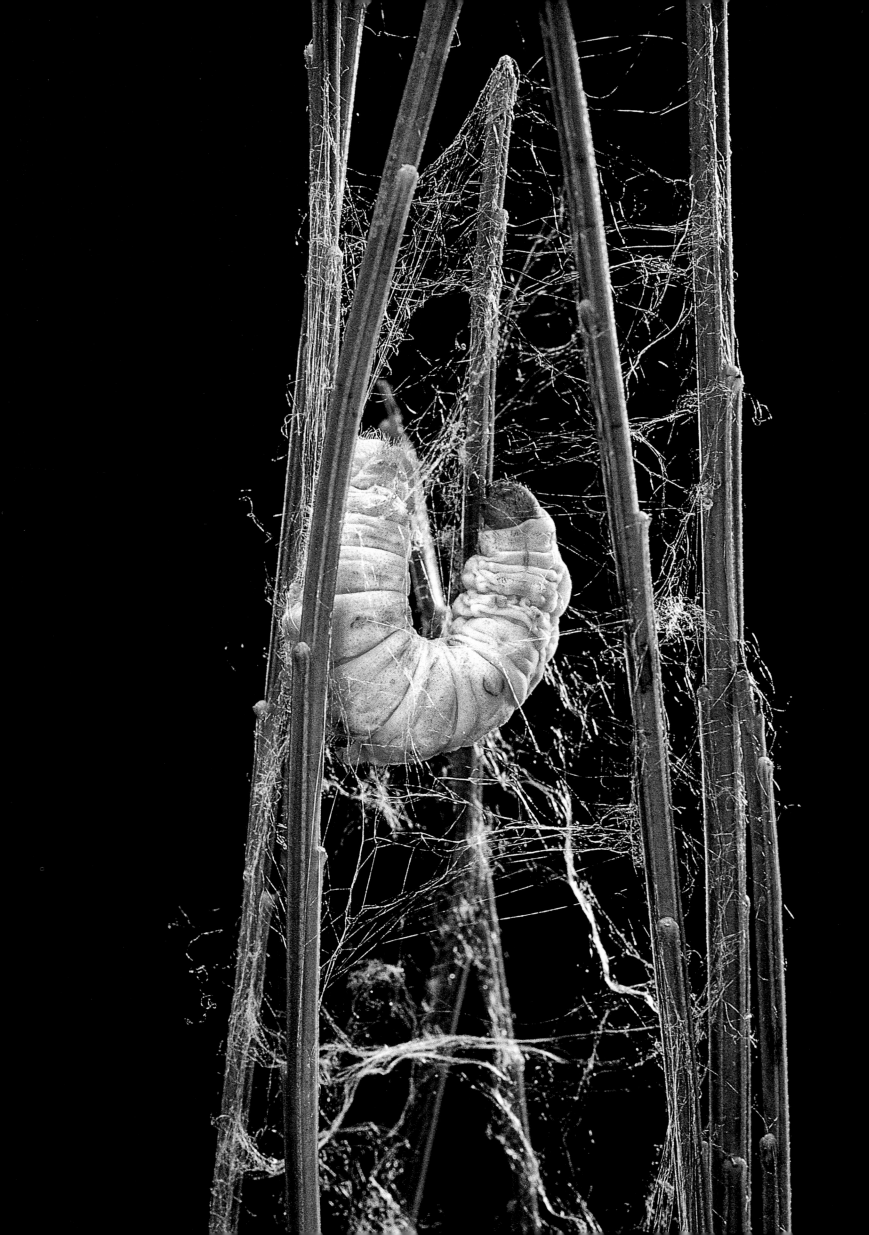

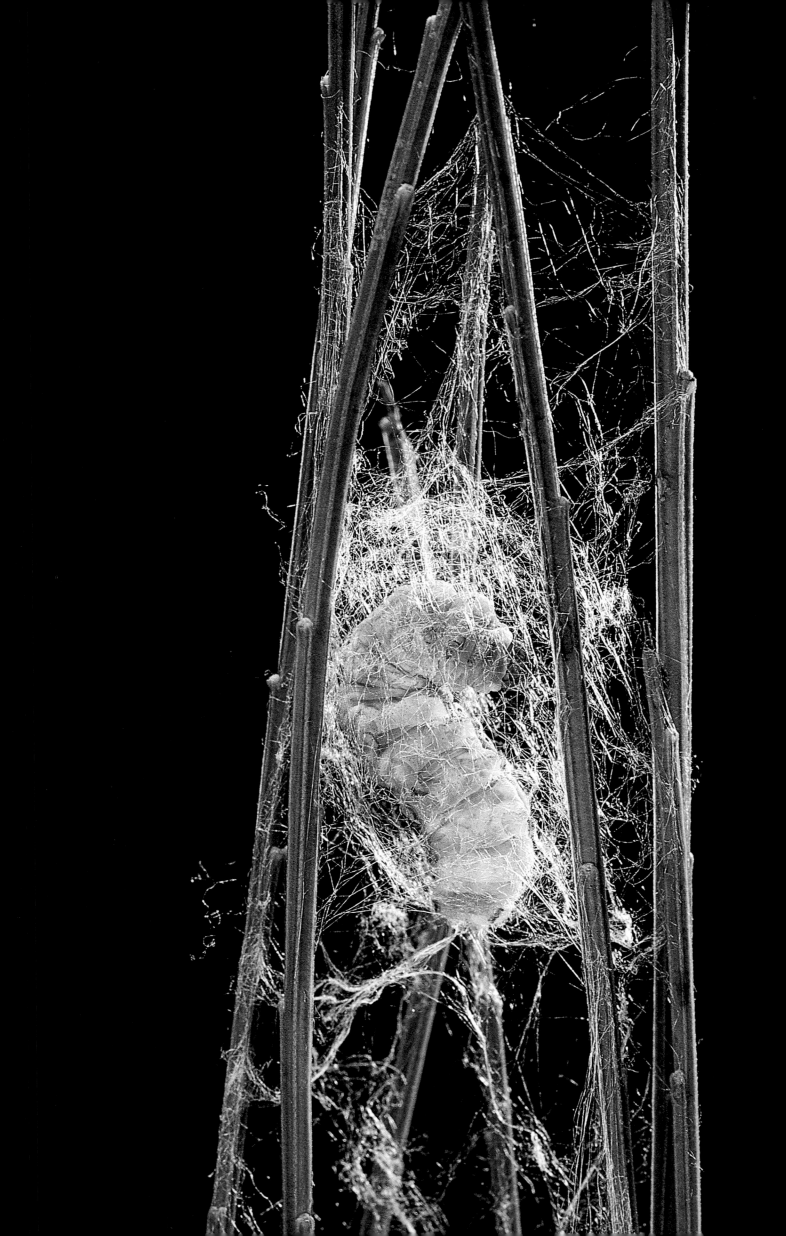

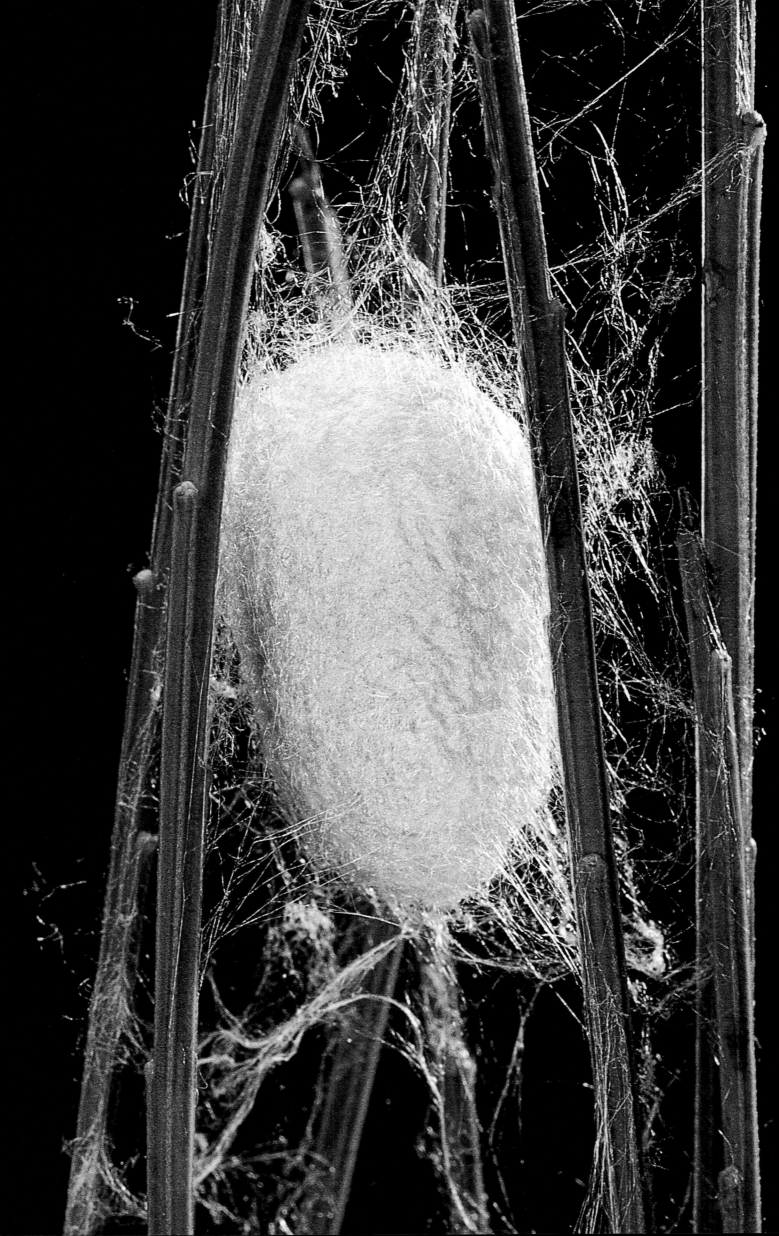

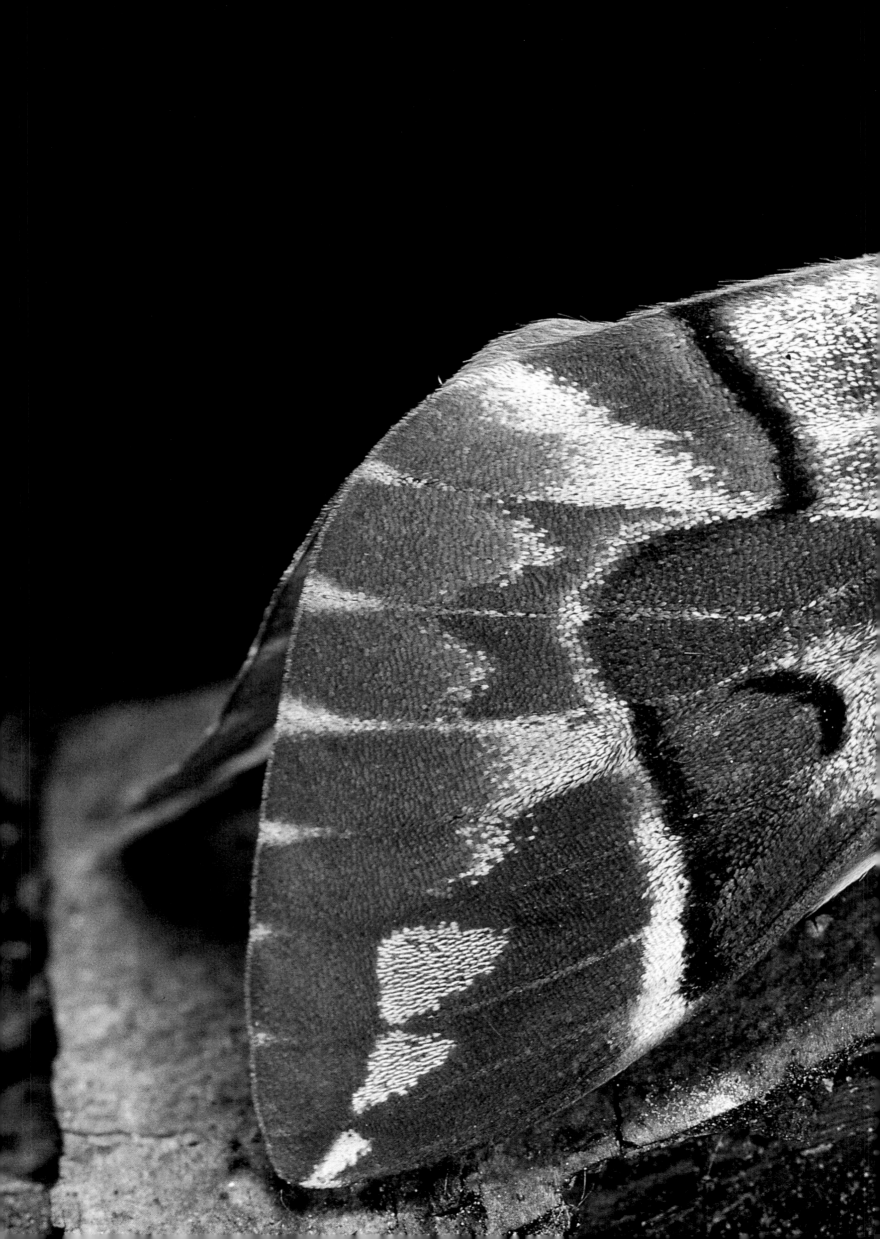

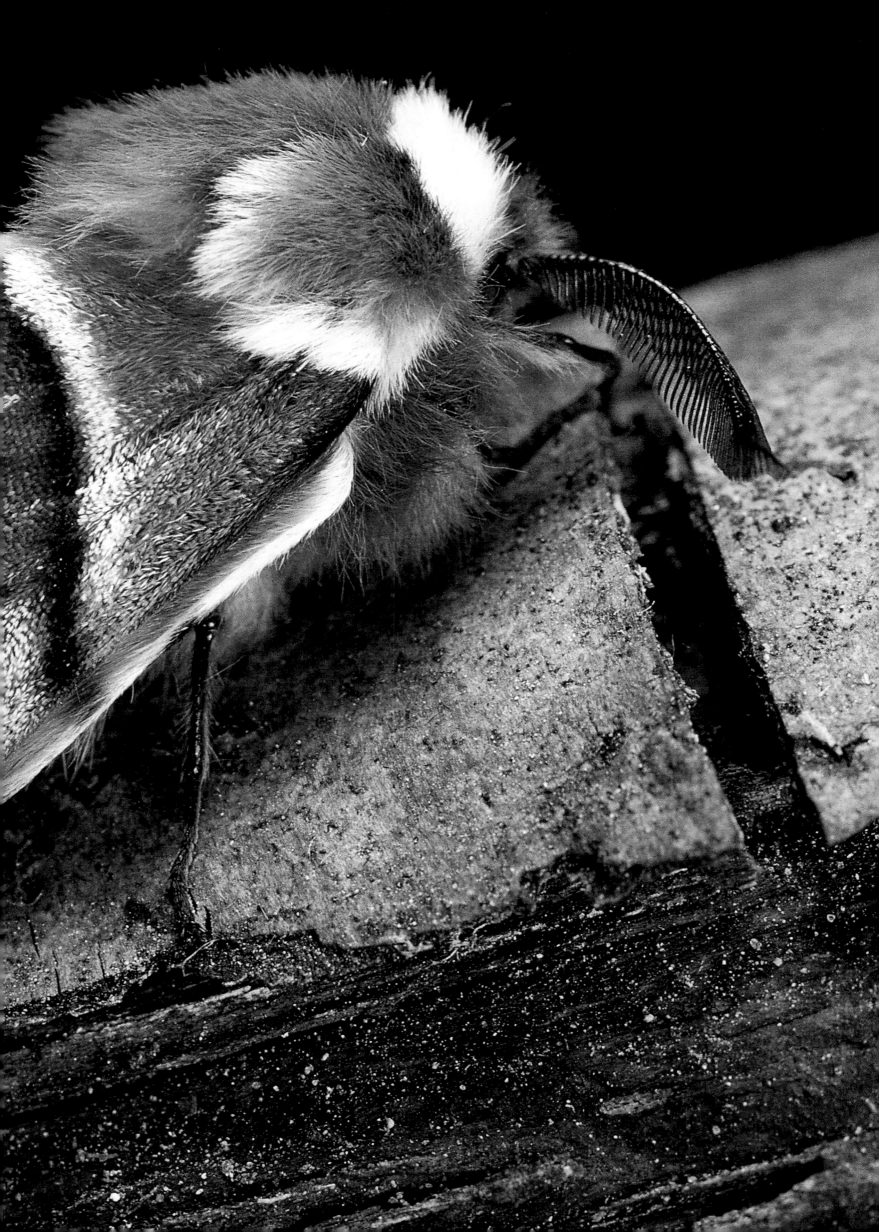

Geometridae
"measuring-worm moths"

This huge family of about 15,000 species is found all over the world. At rest, the moth's wings are pinned to its body, and this combined with very cryptic coloring helps to camouflage them. However, it is the larvae that are the most remarkable from this point of view: long and spindly, they look exactly like twigs. With legs only at each end of the body, the larva has a characteristic looping gait that has earned it the name "measuring worm" or "inchworm." This is also the name for the family as a whole.

OPPOSITE AND RIGHT

gnophos sp. (x 4.4) & (x 6.6)

Few larvae succeed in looking as much like vegetation as the "inchworm" that is perfectly twig-like in shape, color, and immobility. Only the silk thread attaching it to the twig gives it away.

Distribution: Europe
Host plants: plum and other fruit trees

PAGE 148

ennomos sp. (x 4)

Distribution: Europe
Host plants: plum and other fruit trees

PAGE 149

Lasiocampidae "tent caterpillar and lappet moths"

There are nearly 1,500 species of this moth that is found more or less worldwide. The medium-size imago has rather dark coloring. The hairy, sometimes stinging larvae often have lateral or dorsal appendages.

lasiocampa quercus "oak-eggar" (x 3.7)

The male imago that evolves from this larva is probably one of the world's fastest flying moths, so fast, in fact, that it often bumps into things.

Distribution: Eurasia
Host plants: many different shrubs

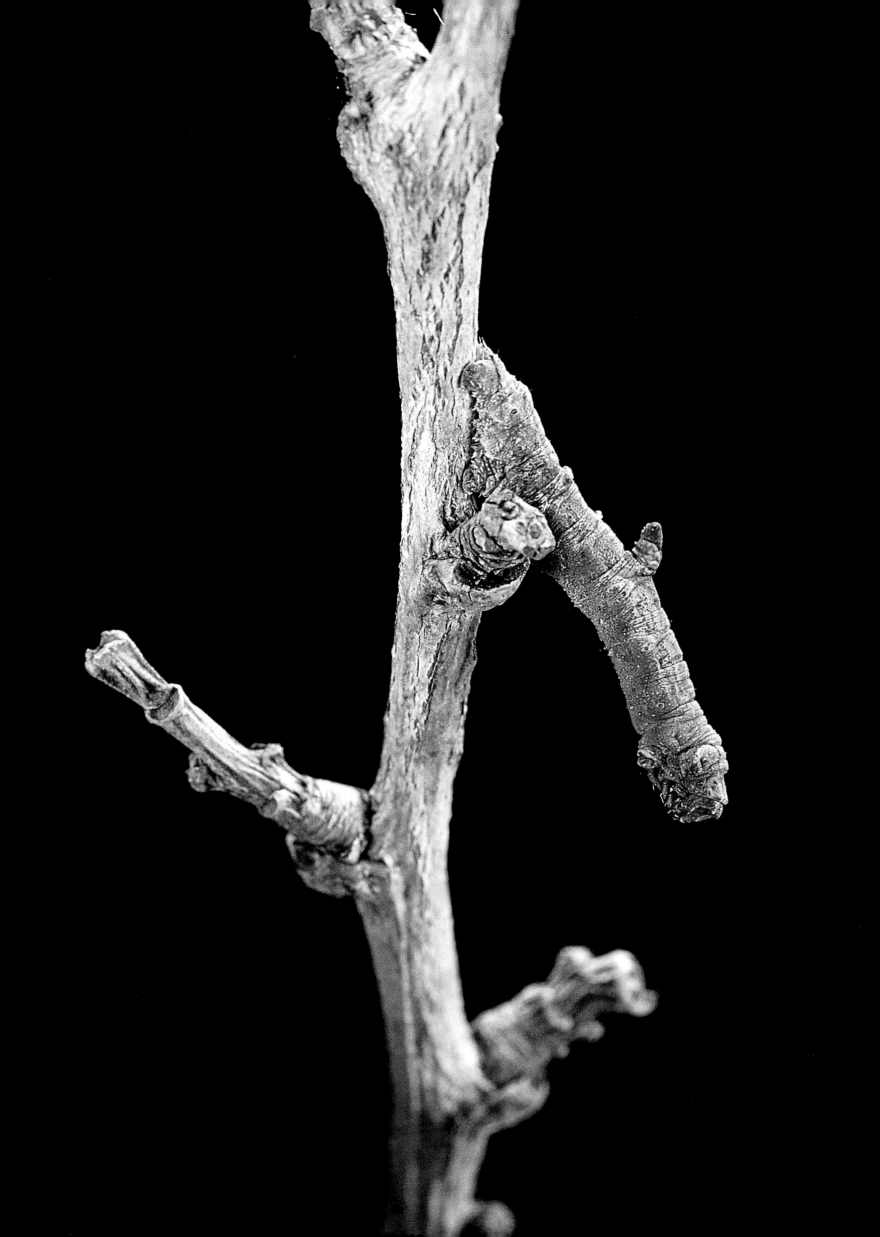

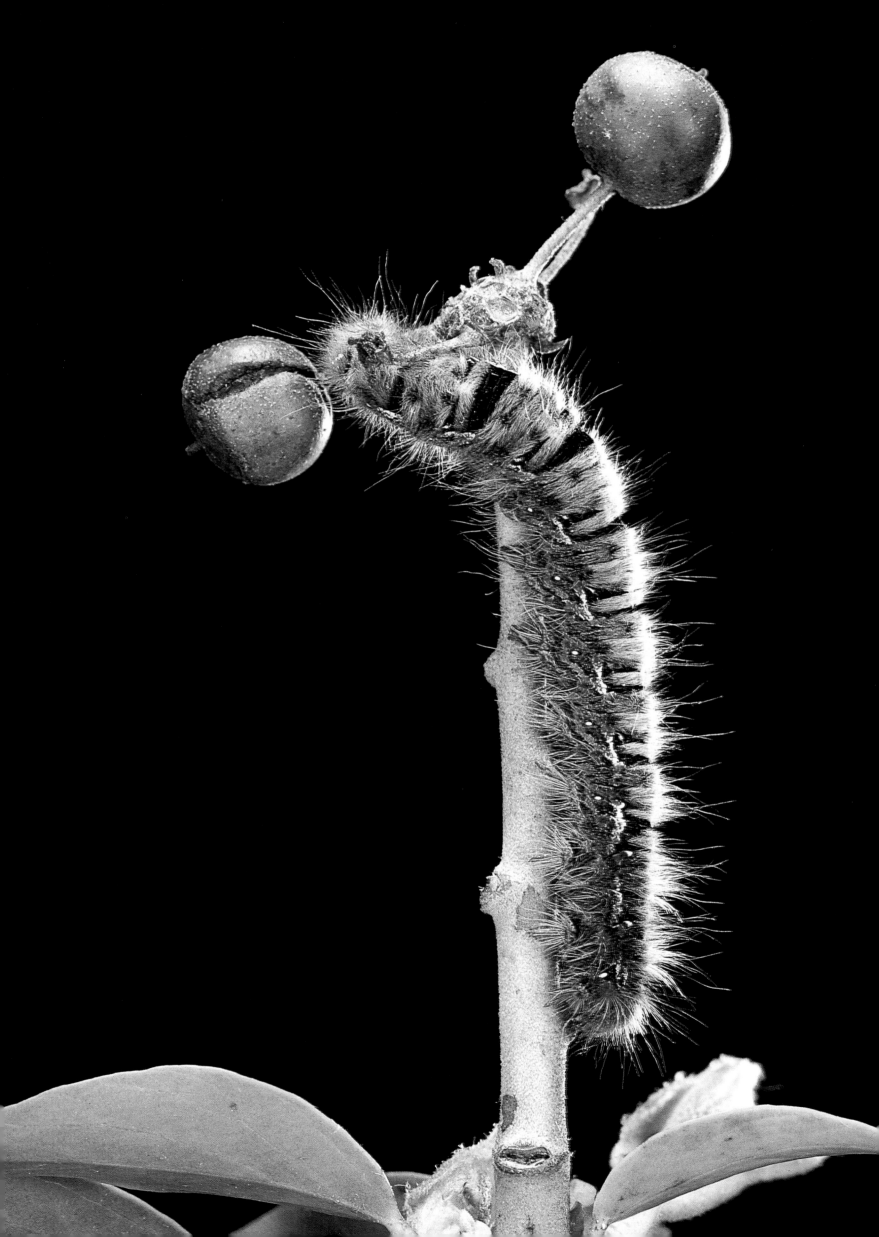

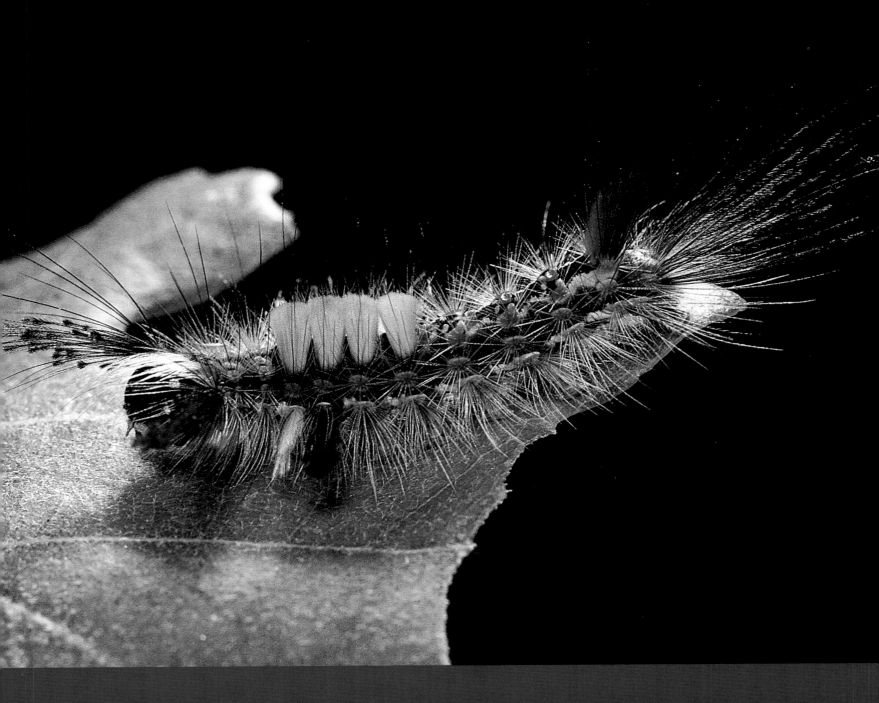

Lymantriidae

This family comprises 2,000 species, all heavy-bodied, especially the females. The larvae are usually brightly colored, often with stinging spines. Some species are very destructive to forests, and during population explosions can defoliate several thousand acres at a time.

orgyia antiqua [x 7.1] "the vapourer"

The female orgyia is characteristically apterous (wingless) and has little to look forward to. Her life consists of emerging from the cocoon, hanging on while she waits for a male, laying all her eggs at once, and dying right where she is.

Distribution: Europe
Host plants: many different leaves

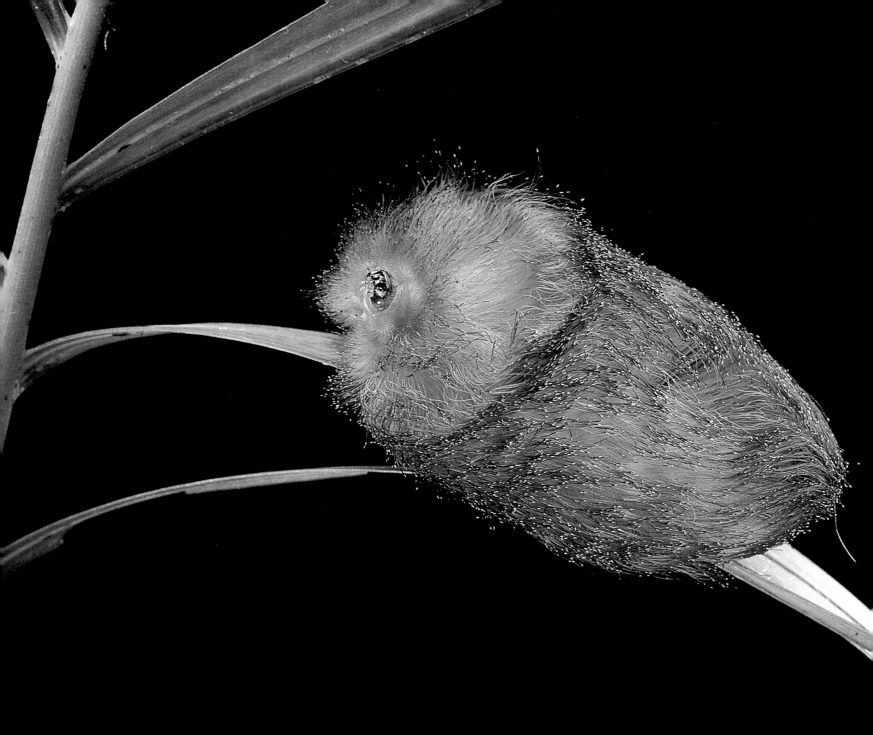

Megalopygidae "flannel moths" This small family of
about 300 species is almost exclusive to South America. The larvae are exceptionally hairy, some
with fiercely irritant setae. The adults are broad-winged and heavy-bodied with a furry appearance.

Megalopyge "southern flannel moth" (x 2)

Anyone who has ever had the misfortune to brush against the little lion
shown above will know that its abundant mane conceals cruelly stinging
spines. The hairs on this species can indeed be very urticating. In the
United States at the turn of the century, Megalopyge opercularis had
become so common in places that its hairs were all over the place. So much
so that state schools were declared unhealthy and forced to close down.

Distribution: America
Host plants: palms

Noctuoidea "owlet moths"

This is the largest family of Lepidoptera with more than 25,000 species more commonly known by their familiar name of "owlet moths." They have slender antennae and well-developed proboscises. The hindwings are often cryptically colored with a complex pattern. The larvae are nearly always hairless and often polyphagous. They are well known to gardeners because of the irresistible attraction some of them have for succulent garden vegetables.

phlogophora meticulosa [x 7.3]
"angle-shade"

Moths of this species are a common sight and find their way everywhere, including town gardens. As the Latin name "meticulosa" suggests, these are by no means primitive moths, and are distinguished by the elegant position of their wings. The moth is able to fold its wings in this way by sending a wave of muscle tension down the length of the wing. When the moth takes off, the muscles relax, releasing the fold that would otherwise destabilize flight.

Distribution: Eurasia
Host plants: polyphagous

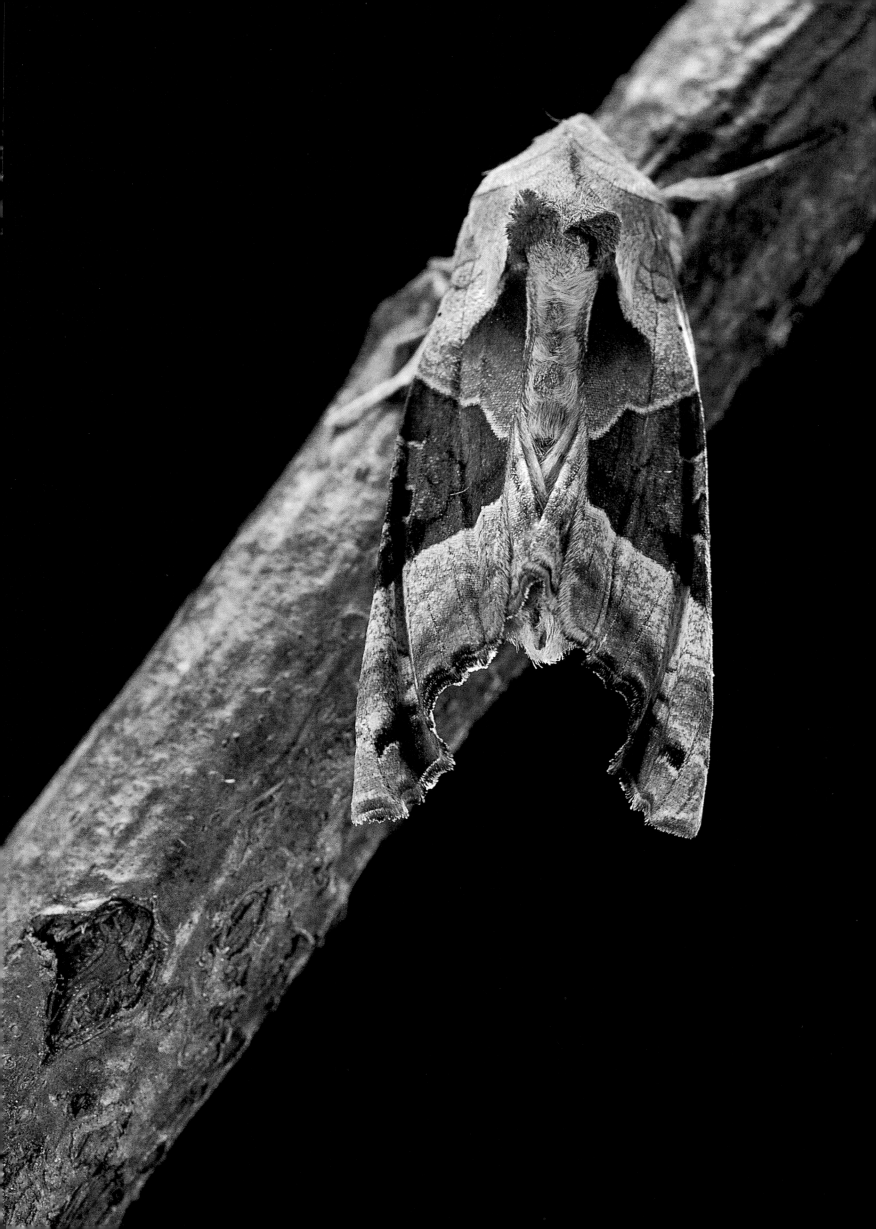

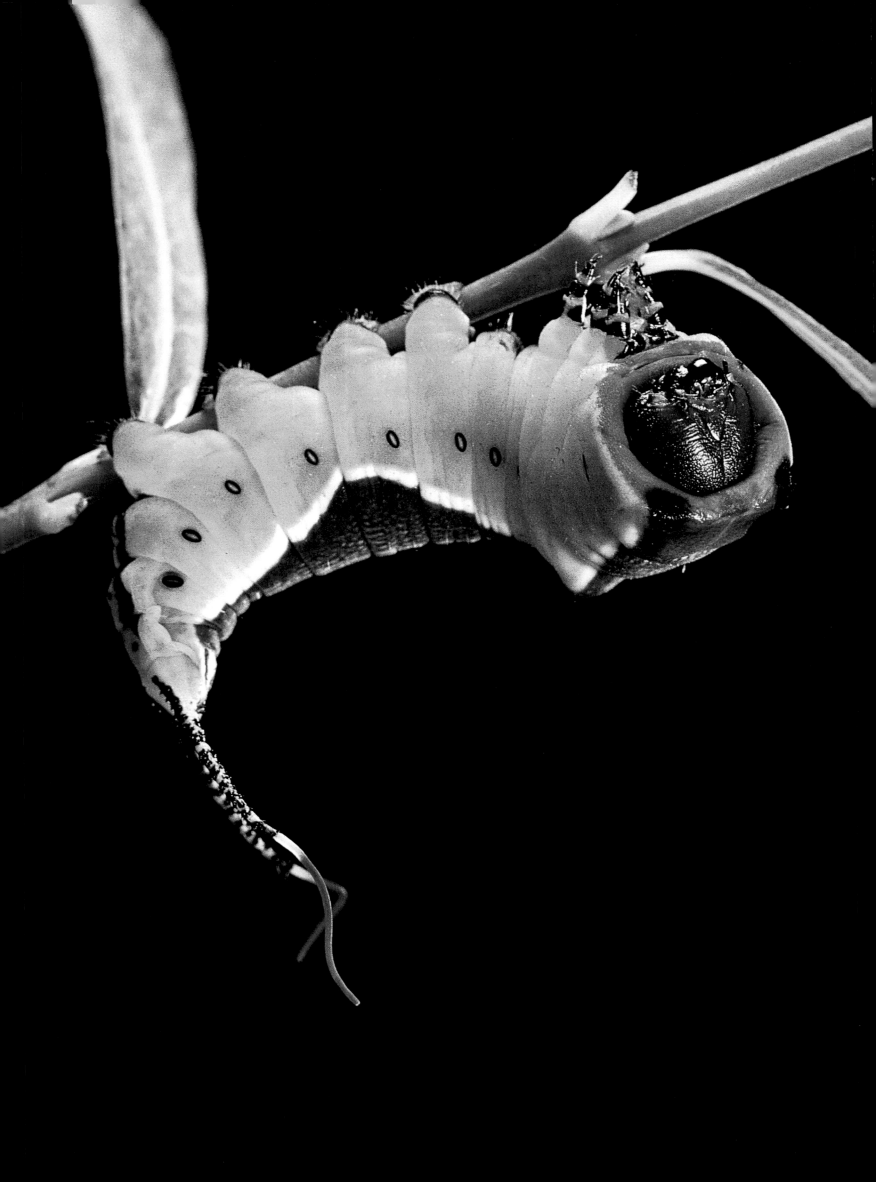

Notodontidae "prominents"

Few larvae are as flamboyant as these. What they lack in hairs they make up for in a wide variety of appendages, tubers, lumps, and bumps—to such an extent that some of them cease to resemble larvae at all. The moths are fairly sturdy, medium-size, and cryptically colored. There are about 2,500 species in all, mainly in warm regions.

OPPOSITE AND OVERLEAF

cerura vinula [x 6.6] & [x 4.4]
"puss moth"

The last pair of legs on this larva has become hollow tubes containing two red filaments that the larva waves around at the least sign of trouble. The cocoon is hard as stone and is an aggregate of wood particles and silk.

Distribution: temperate Eurasia
Host plants: willow, poplar

PAGE 157

phalera bucephala [x 10]
"buff-tip moth"

Distribution: Eurasia
Host plants: oak, beech

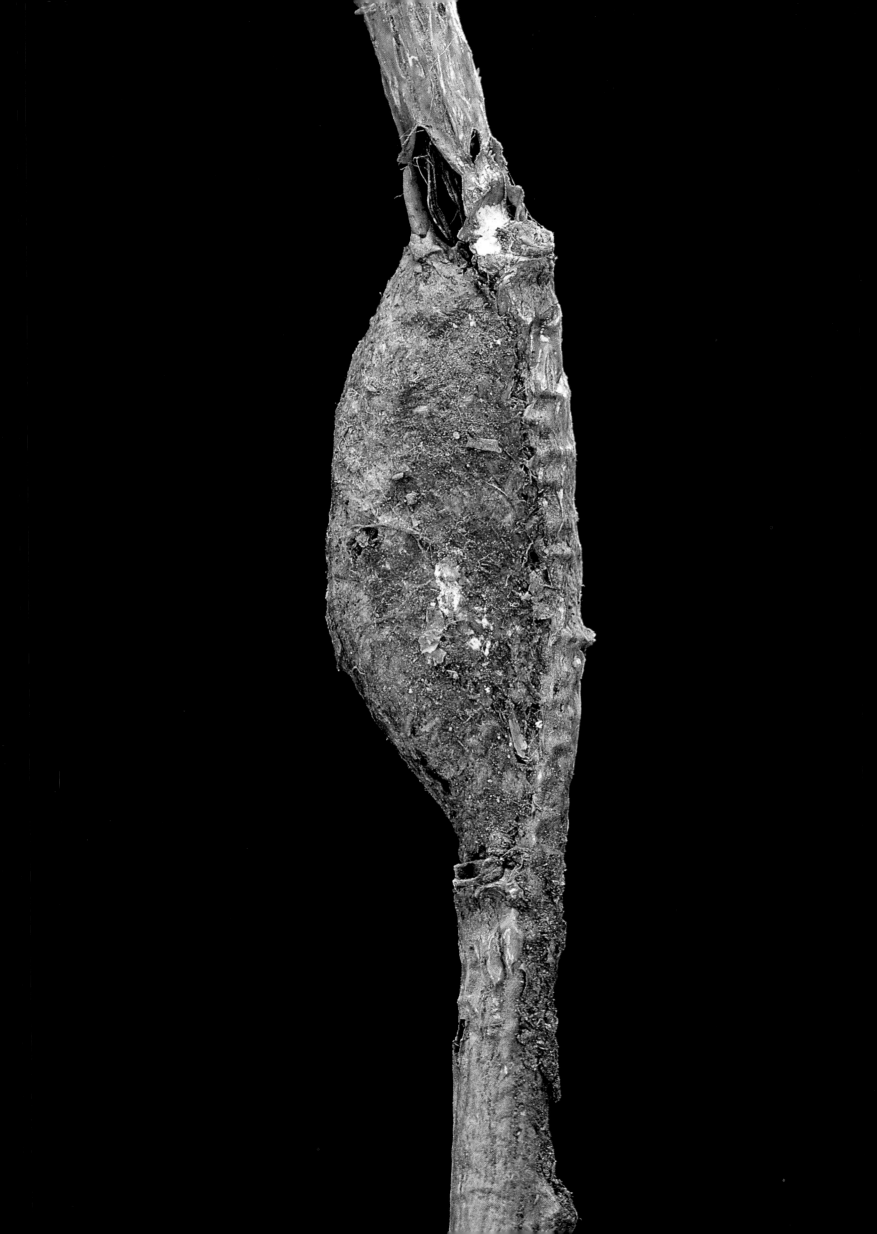

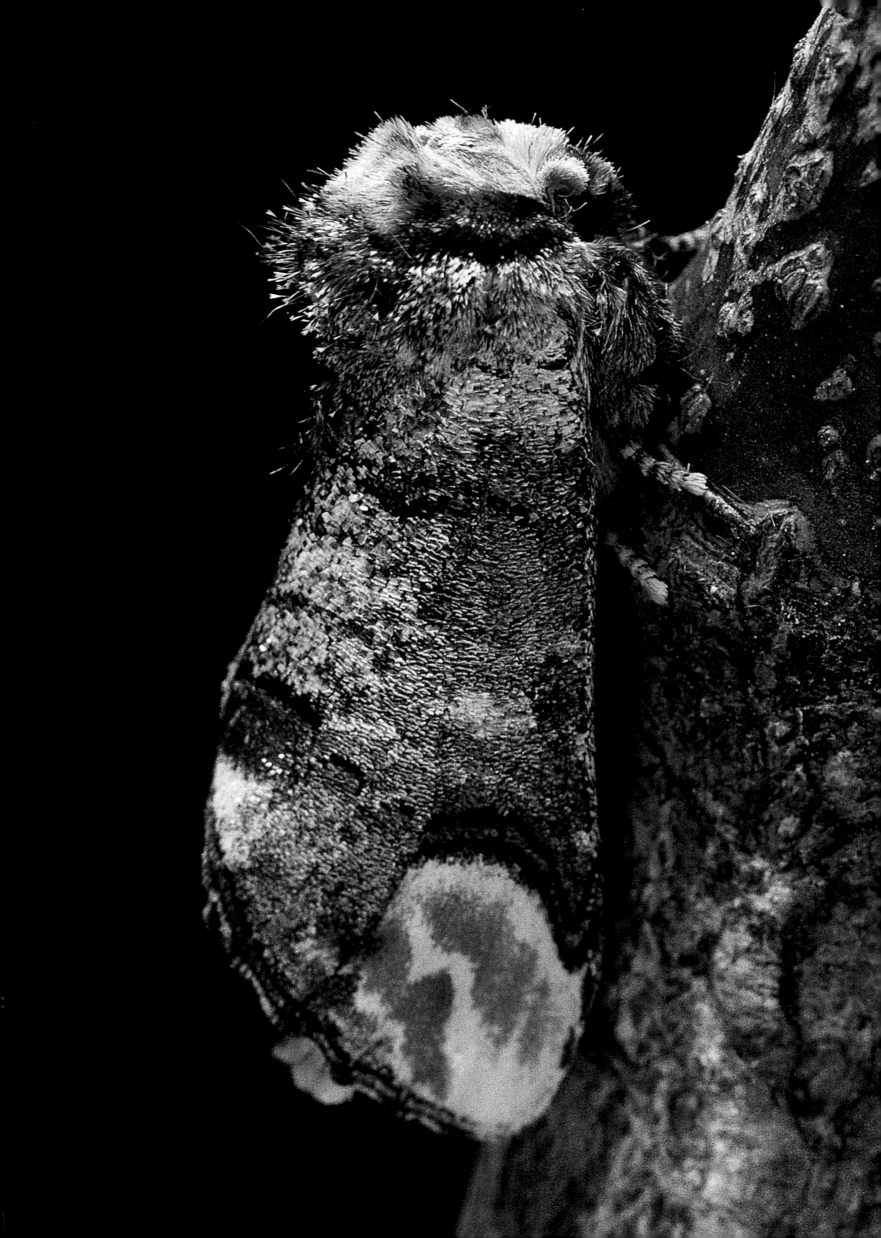

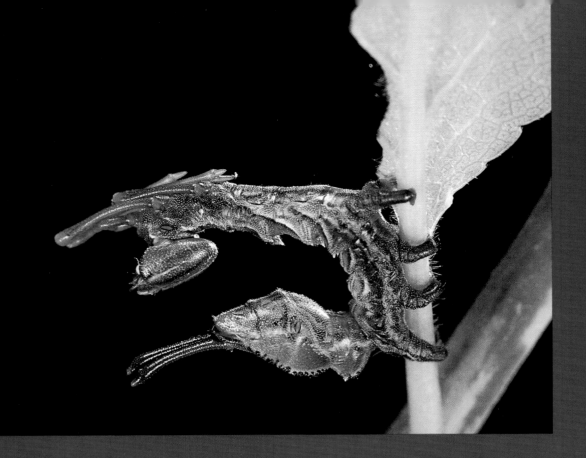

ABOVE AND RIGHT

stauropus fagi (x 5.7) & (x 11.25)
"the lobster"

With its raised hindquarters, a head quite separate from its body, and its folded front legs, there is something quite definitely lobster-like about this larva. It is also referred to as "ant-like."

Distribution: temperate Eurasia
Host plants: oak, beech

Sphingoidae "hawk" or "sphinx moths"

There are more than 1,000 species in this family that could be mistaken for no other. All the members have a thick, tapering body and narrow, robust wings, making them powerful fliers and famous migrants. They can travel over several thousand miles without even stopping to gather nectar. An exceptionally long proboscis (nearly 30 cm/12in)) allows hawk moths to explore the deepest corollas and satisfy their huge appetite. The larvae also have a family look, with hairless bodies that come to a tip in a bold (but harmless) horn. Some are as long as a pencil and about as thick as a finger, making them the largest larvae in the world.

OVERLEAF

hyles lineata (x 3.2) & (x 7.7)

Population explosions of sphinx larvae are rare but when they do occur they cause damage to vine foliage.

Distribution: almost worldwide
Host plants: virtually polyphagous

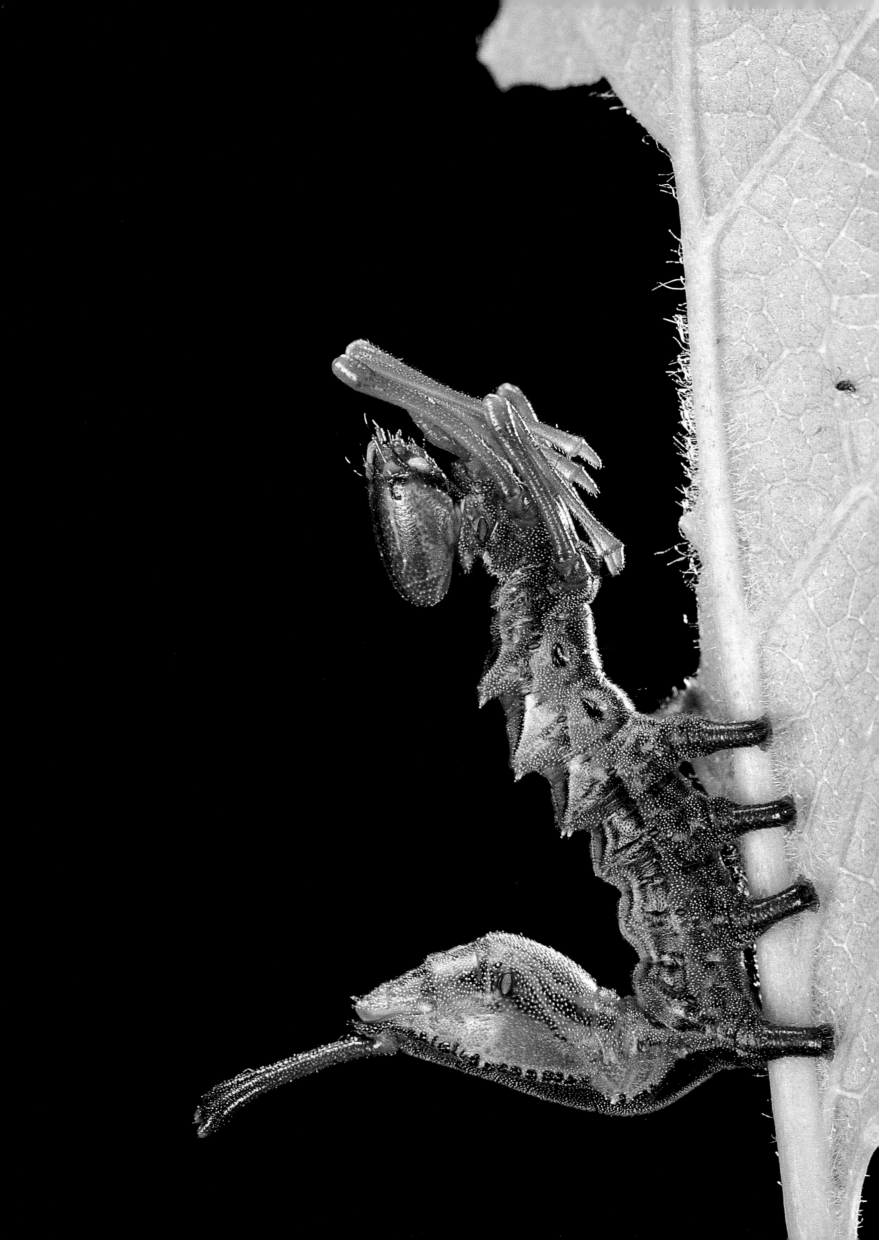

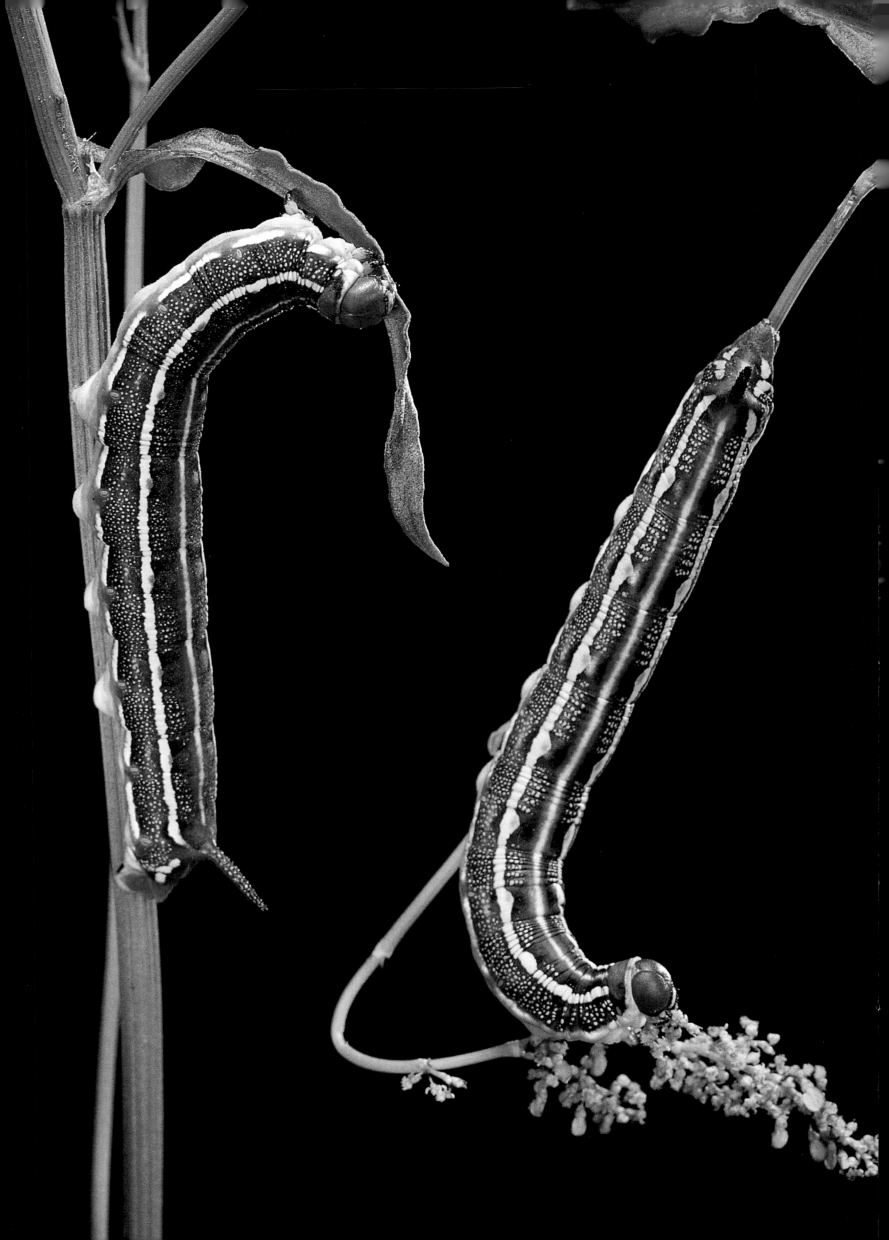

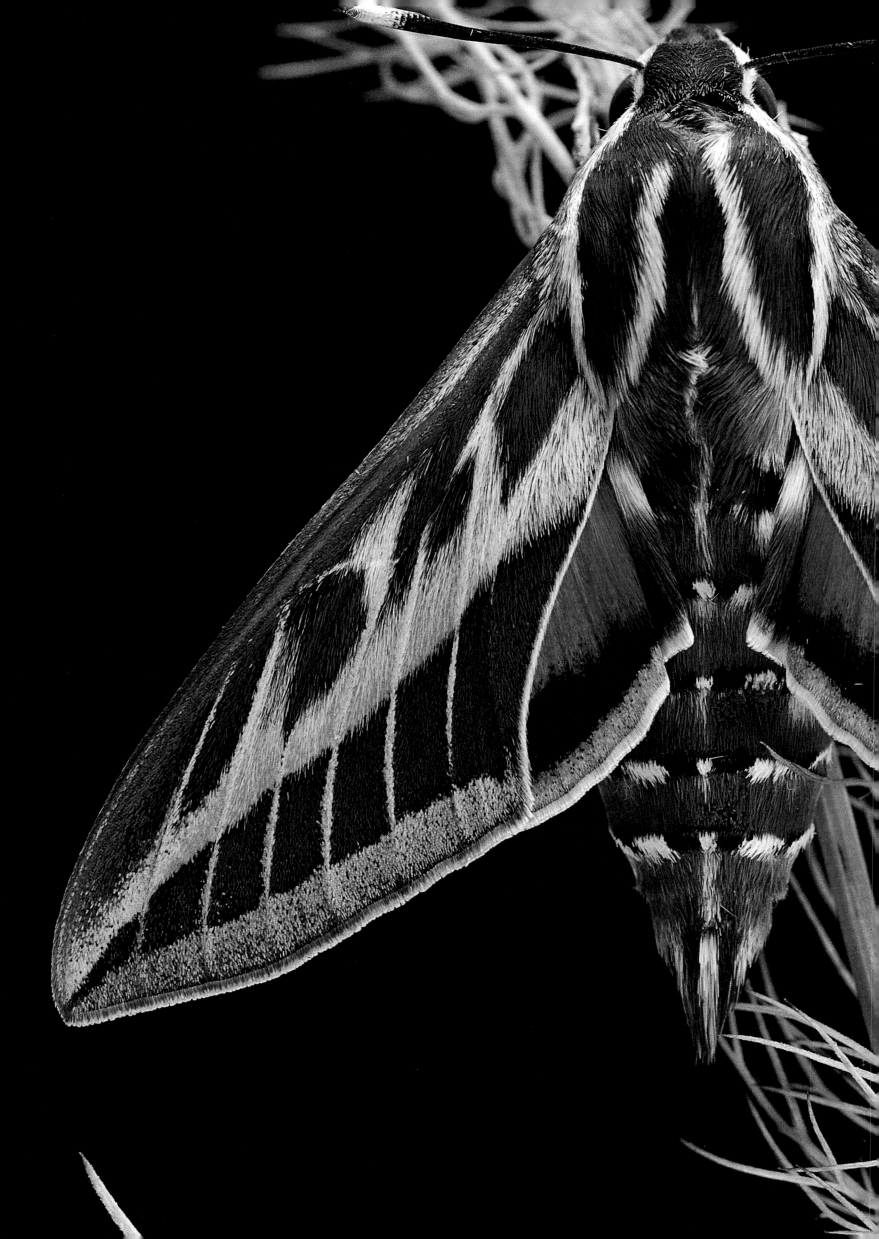

acherontia atropos ^(x 1.5)
"death's-head hawk moth"

Distribution: tropical Africa, migrates to Europe

Host plants: mainly Solanaceae but very polyphagous

agrius convolvuli ^(x 1)
"convolvulus hawk moth"

Distribution: tropical Africa, migrates to Europe

Host plants: bindweed

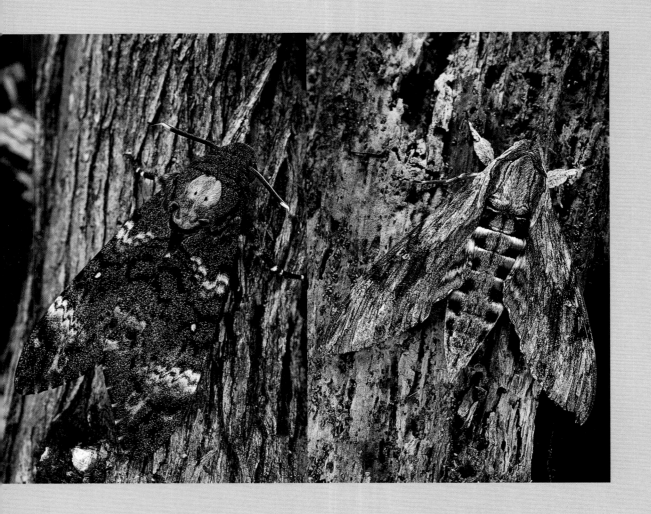

sphinx ligustri ^(x 15.7)
"privet hawk moth"

The strange appendage on this pupa is the future proboscis.

Distribution: Europe

Host plants: privet

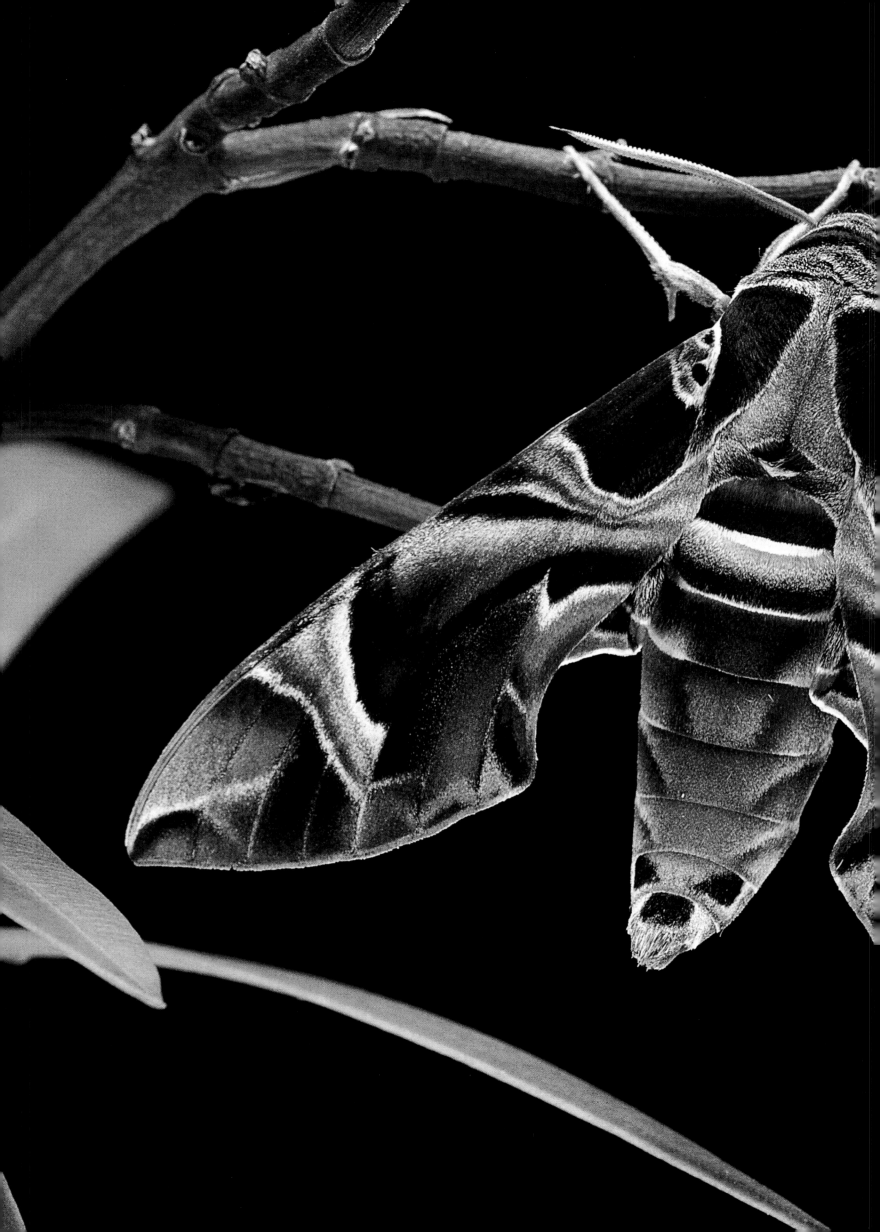

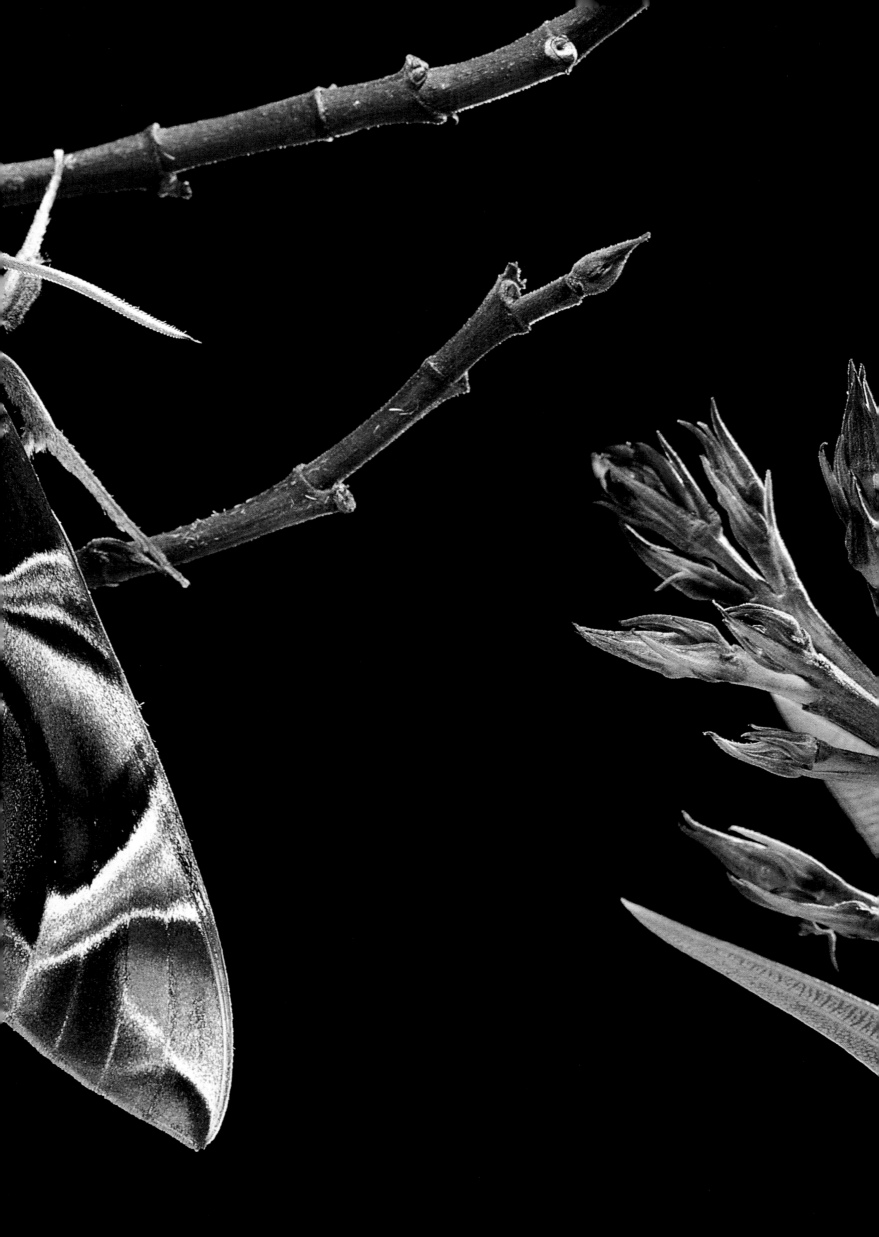

PREVIOUS DOUBLE PAGE SPREAD

daphnis nerii (x 3.6)
"oleander hawk moth"

Distribution: tropical Africa, migrates to Europe

Host plants: various Apocynaceae

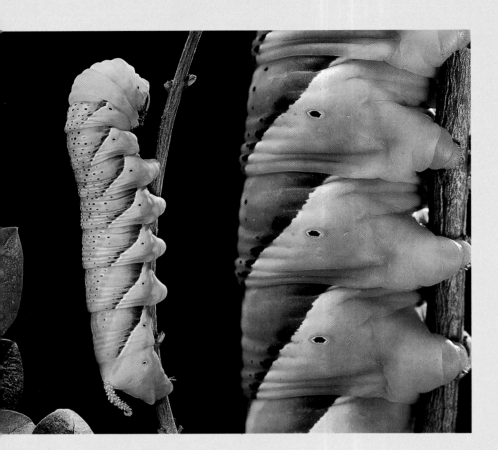

ABOVE

acherontia atropos (x 1) & (x 3.2)
"death's-head hawk moth"

For centuries, the sight of this moth was
considered a bad omen because of the strange
design on its thorax (see p. 162), and because it
is one of the rare moths to let out a chirrup
when threatened. This chirrup, or whistle, can
be clearly heard several yards away. Finally, to
add to its attractions, it is also a honey thief,
thanks to a thick coating of fine soft hairs that
protects it from bee stings and allows it to break
into hives.

RIGHT

deilephila porcellus (x 5.2)
"small-elephant hawk moth"

Distribution: Europe

Host plants: vines and various Onagraceae

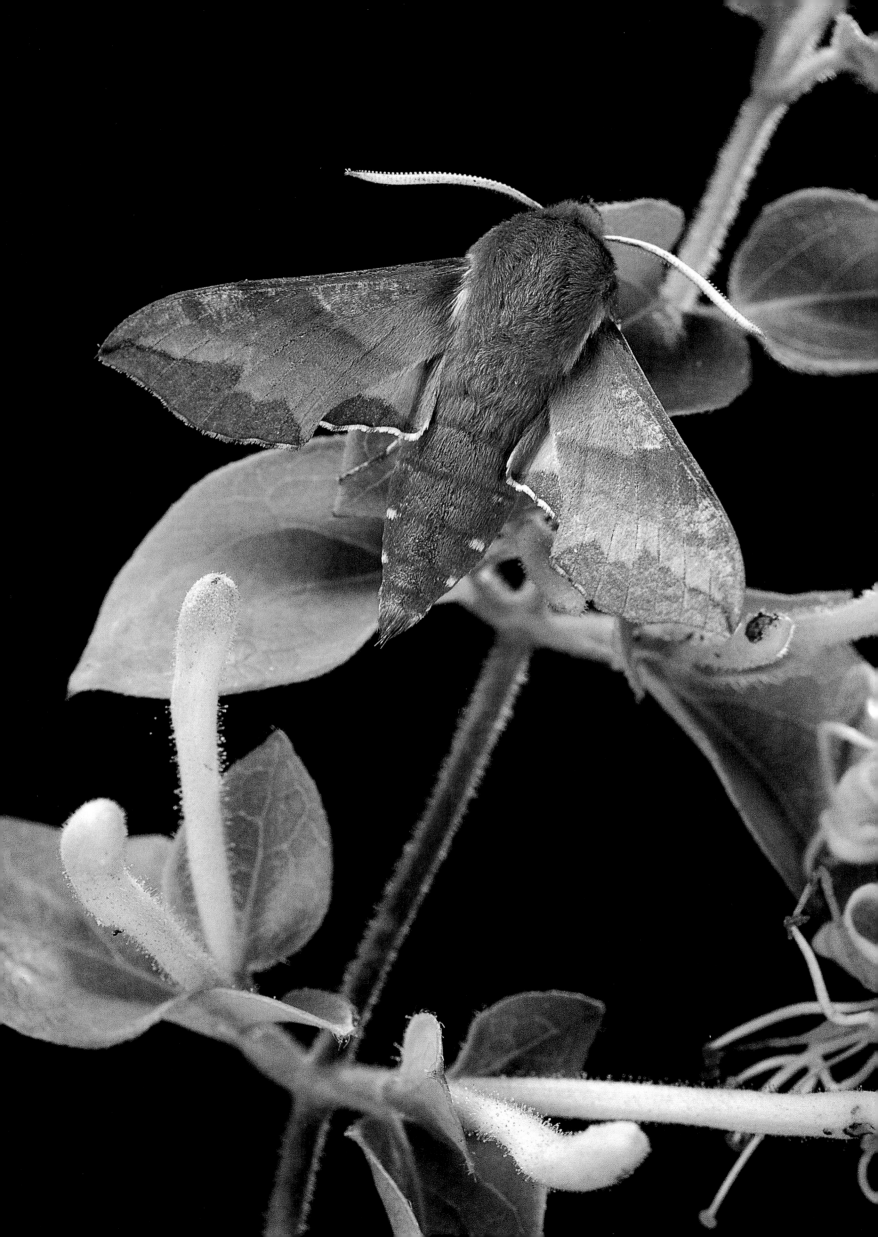

mimas tiliae (x 3.4)
"lime hawk moth"

The two specimens shown at the right are in the traditional mating position. The female above can be identified by her swollen abdomen filled with eggs.

Distribution: Europe
Host plant: lime blossom

● ● ○

OVERLEAF

siproeta steneles (x 5)

Family: Nymphalidae
Distribution: central America
Host plants: Ruellia and other Acanthaceae

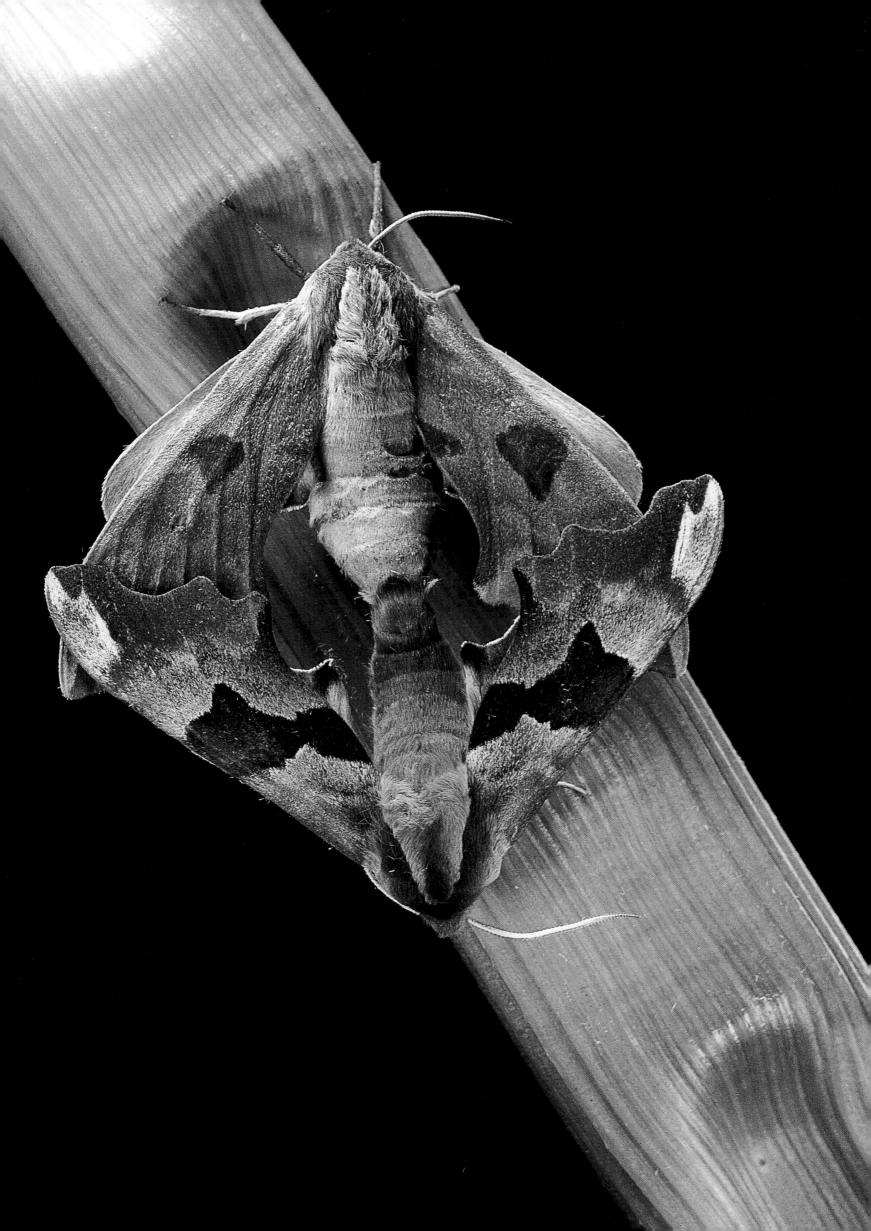

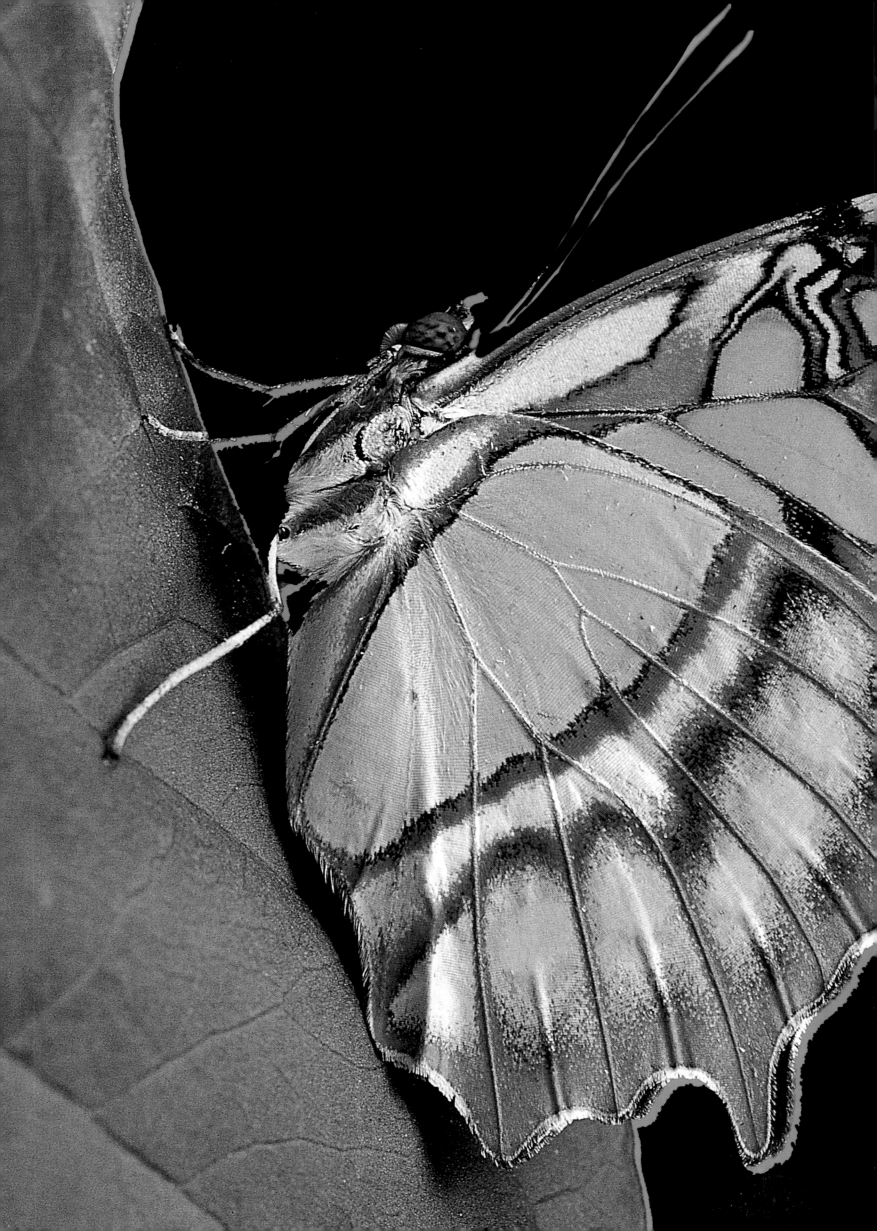

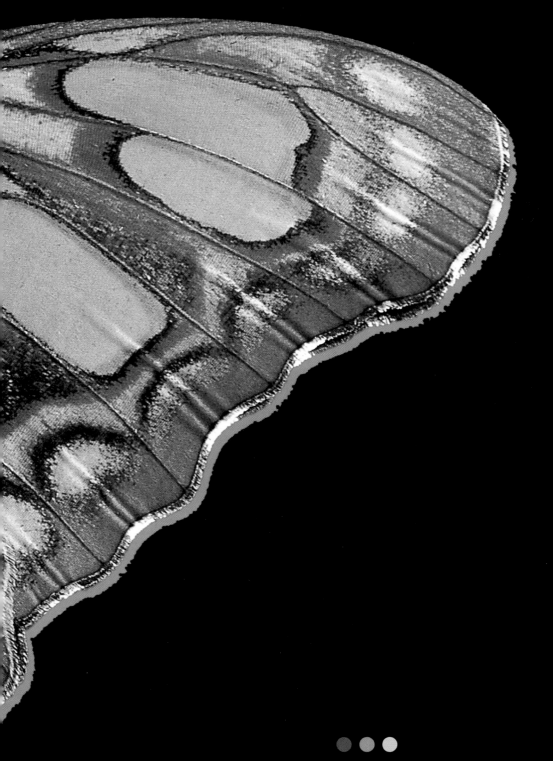

The last flight

"Butterflies are but flowers that blew away one sunny day, when Nature was feeling at her most inventive and most fertile."

George Sand

Butterflies (Note: from left to right, across the double-page spread)

acraea insularis (x 1.2)
Family: Acraeidae
Distribution: São Tomé
Host plant: *Urera* (Urticaceae)

caligo memnon (x 0.6)
with wings closed
Family: Brassolidae
Distribution: South America
Host plant: banana tree and related plants

caligo memnon (x 0,5)
with wings open
Family: Brassolidae
Distribution: South America
Host plant: banana tree and related plants

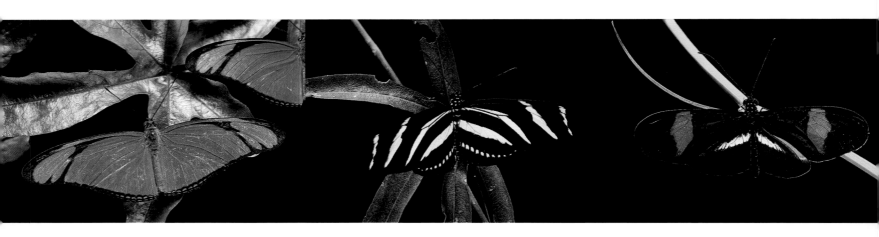

dryas julia (x 0.6)
"flame of flambeau"
Family: Heliconidae
Distribution: tropical America
Host plant: passiflora

heliconius charitonia (x 0.7)
"zebra"
Family: Heliconidae
Distribution: central America
Host plant: passiflora

heliconius erato (x 1)
Family: Heliconidae
Distribution: tropical America
Host plant: passiflora

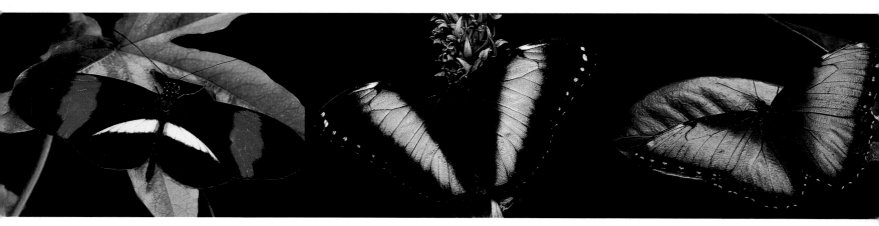

heliconius melpomene (x 1)
"postman"
Family: Heliconidae
Distribution: tropical America
Host plant: passiflora

morpho helenor (x 0.6)
Family: Morphidae
Distribution: South America
Host plant: *Pterocarpus* et and other Leguminosae

morpho peleides (x 0.6)
"blue morpho"
Family: Morphidae
Distribution: South America
Host plant: *Pterocarpus* et and other Leguminosae

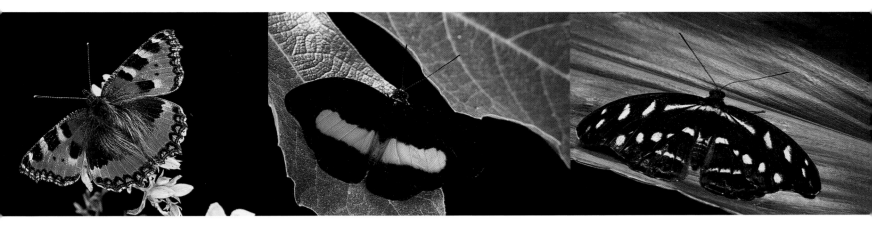

aglais urticae (x 1)
"small tortoiseshell"
Family: Nymphalidae
Distribution: temperate Eurasia
Host plant: nettle

catonephele acontius (x 1) male
Family: Nymphalidae
Distribution: tropical America
Host plant: *Alcornea* (Euphorbiaceae)

catonephele acontius (x 1,1) female
Family: Nymphalidae
Distribution: tropical America
Host plant: Alchornea (Euphorbiaceae)

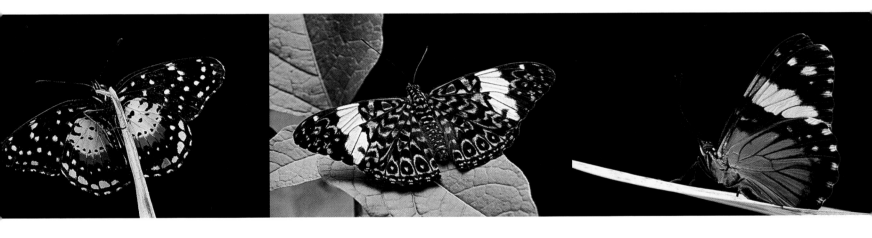

chlosyne janais (x 1.5)
Family: Nymphalidae
Distribution: central America
Host plant: Odontonema (Acanthaceae)

hamadryas amphinome (x 1) "cracker"
with wings open
Family: Nymphalidae
Distribution: tropical America
Host plant: *Dalechampia* (Euphorbiaceae)

hamadryas amphinome (x 1,2) "cracker"
with wings closed
Family: Nymphalidae
Distribution: tropical America
Host plant: Dalechampia (Euphorbiaceae)

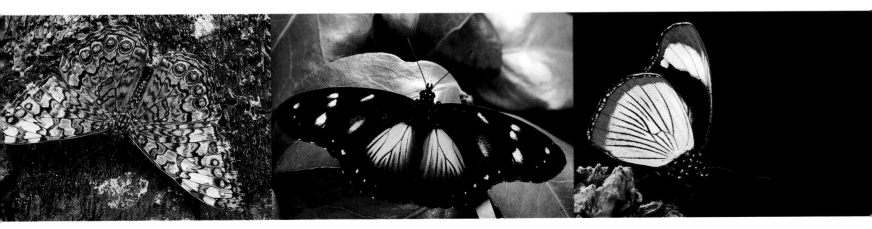

hamadryas februa (x 1.1)
Family: Nymphalidae
Distribution: central America
Host plant: *Dalechampia* (Euphorbiaceae)

hypolimnas dubius (x 0.7)
Family: Nymphalidae
Distribution: tropical Africa
Host plant: *Urera* (Uticaceae)

hypolimnas usambara (x 0.9)
Family: Nymphalidae
Distribution: tropical Africa
Host plant: *Urera* (Uticaceae)

butterflies (continued from left to right, across the double-page spread)

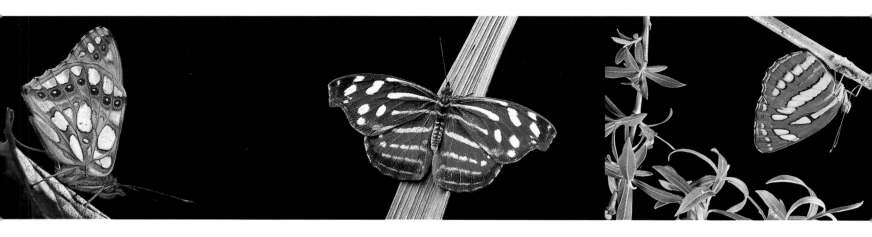

issoria lathonia (x 1.7)
Queen of Spain fritillary
Family: **Nymphalidae**
Distribution: **Europe**
Host plant: **pansies, violets**

myscelia cyaniris (x 1)
Family: **Nymphalidae**
Distribution: **tropical America**
Host plant: *Tragia* **(Euphorbiaceae)**

neptis hylas (x 1)
Family: **Nymphalidae**
Distribution: **tropical Asia**
Host plant: **very polyphagous**

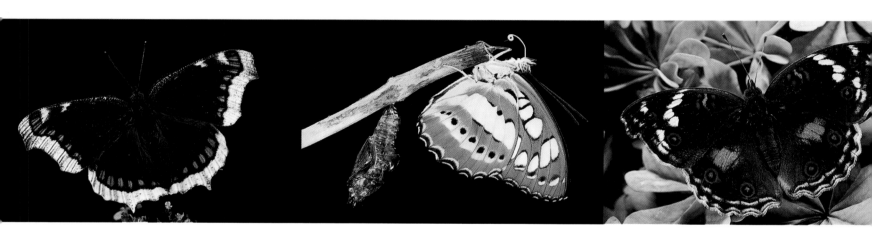

nymphalis antiopa (x 0.75)
camberwell beauty
Family: **Nymphalidae**
Distribution: **temperate Eurasia**
Host plant: **willow, birch**

pantoporia perius (x 1.4)
Family: **Nymphalidae**
Distribution: **tropical Asia**
Host plant: **Mimosaceae**

junonia oenone (x 1.5)
Family: **Nymphalidae**
Distribution: **tropical Africa**
Host plant: **various Acanthaceae**

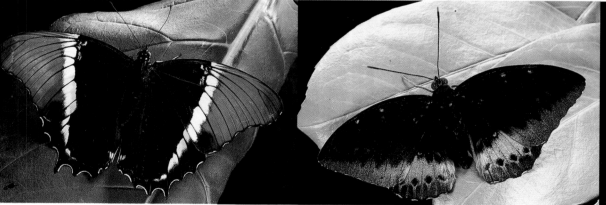

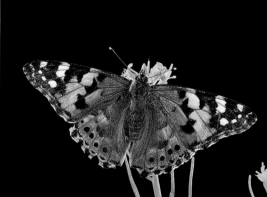

siproeta epaphus (x 0.7)
brown bamboo page"
Family: **Nymphalidae**
Distribution: **central America**
Host plant: *Ruellia* **and other Acanthaceae**

lexias dirtea (x 0.5)
Family: **Nymphalidae**
Distribution: **tropical Asia**
Host plant: *Garcinia* **(Guttiferaceae)**

vanessa cardui (x 0.8)
painted lady
Family: **Nymphalidae**
Distribution: **practically worldwide**
Host plant: **very varied**

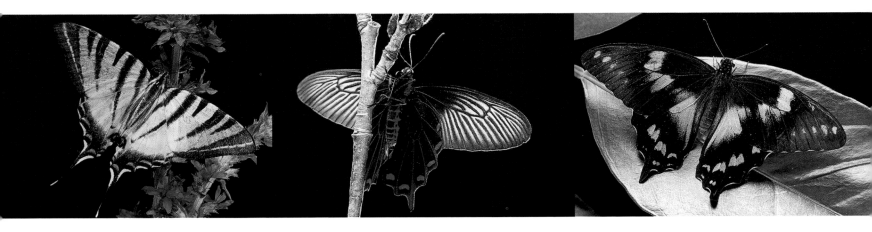

iphiclides podalirius (x 0.6)
scarce swallowtail
Family: Papilionidae
Distribution: Europe
Host plant: plum-tree and close relatives

pachliopta sp. (x 0.75)
Family: Papilionidae
Distribution: tropical Asia
Host plant: Aristolochiae

papilio epiphorbas (x 0.8)
Family: Papilionidae
Distribution: Madagascar
Host plant: Rutaceae

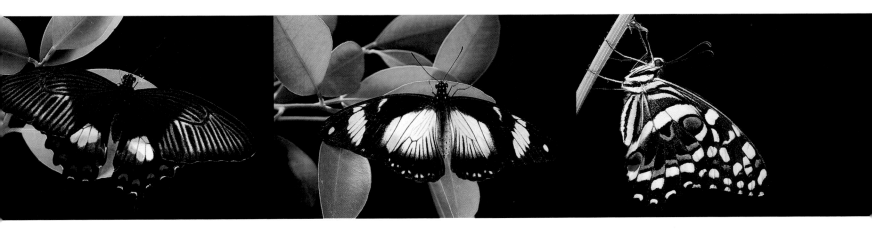

papilio polytes (x 0.75) femelle
Family: Papilionidae
Distribution: tropical Asia
Host plant: Citrus

papilio dardanus (x 0.75) female
Family: Papilionidae
Distribution: tropical Africa
Host plant: Rutaceae

papilio demodocus (x 1)
Family: Papilionidae
Distribution: tropical Africa
Host plant: Rutaceae

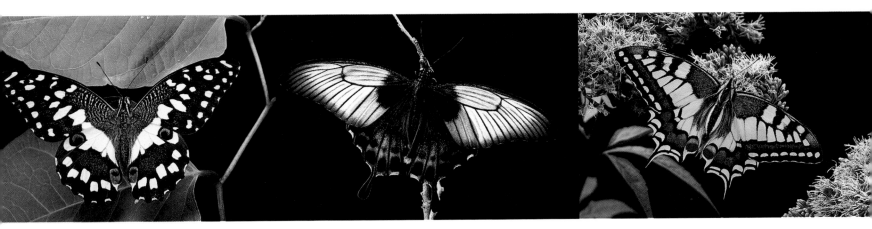

papilio demoleus (x 0.7)
Family: Papilionidae
Distribution: tropical Asia
Host plant: *Citrus*

papilio lowi (x 0.5) female
Family: Papilionidae
Distribution: tropical Asia
Host plant: *Citrus*

papilio machaon (x 0.6)
Family: Papilionidae
Distribution: northern hemisphere
Host plant: many Apiaceae

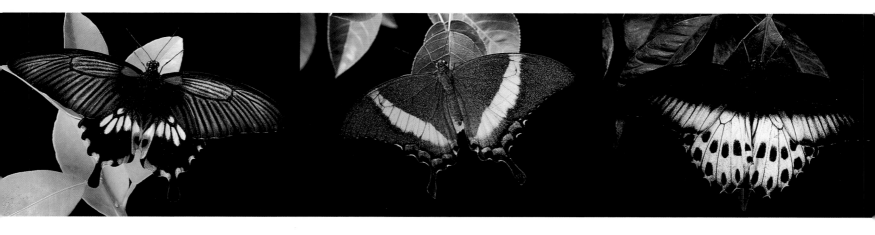

papilio memnon (x 0.6) female
Family: Papilionidae
Distribution: tropical Asia
Host plant: *Citrus*

papilio palinurus (x 0.6)
Family: Papilionidae
Distribution: tropical Asia
Host plant: *Citrus*

papilio polymnestor (x 1.25) male
Family: Papilionidae
Distribution: India
Host plant: *Citrus*

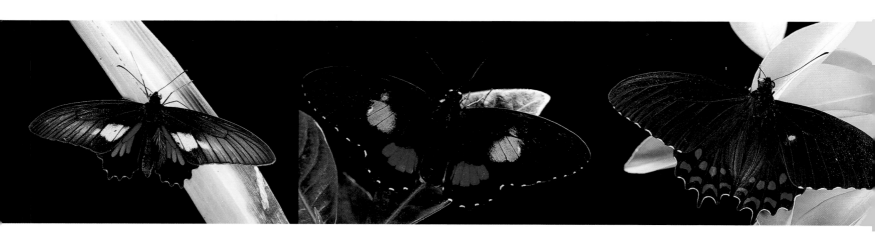

parides neophilus (x 0.75) male
Family: Papilionidae
Distribution: central America
Host plant: Aristolochiae

parides iphidamas (x 1)
Family: Papilionidae
Distribution: central America
Host plant: Aristolochiae

parides photinus (x 0.8)
Family: Papilionidae
Distribution: central America
Host plant: Aristolochiae

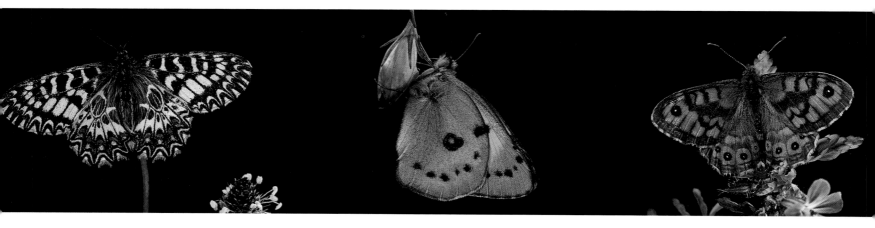

zerynthia polyxena (x 1.1)
southern festoon
Family: Papilionidae
Distribution: Europe
Host plant: Aristolochiae

colias australis (x 1.5)
Family: Pieridae
Distribution: Europe
Host plant: *Coronilla varia* (Leguminosae)

lasiommata megera (x 1)
the wall
Family: Satyridae
Distribution: Europe
Host plant: gramineae

Moths

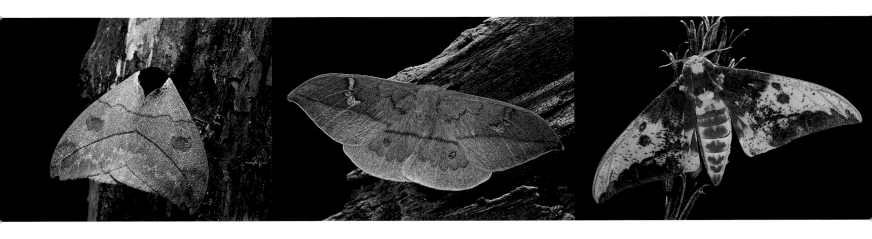

automeris liberia (x 0.25)
Family: Attacidae
Distribution: tropical America
Host plant: privet, in captivity

cricula andrei (x 0.75)
Family: Attacidae
Distribution: temperate Asia
Host plant: fruit trees (Rosaceae)

eacles imperialis (x 0.7)
Family: Attacidae
Distribution: temperate America
Host plant: polyphagous on many trees

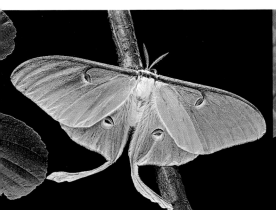

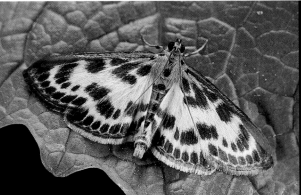

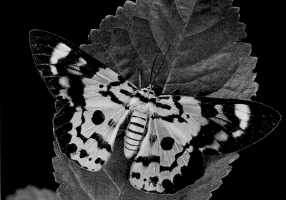

actias luna (x 0.6)
Family: Attacidae
Distribution: north America
Host plant: walnut tree

eurrhypara hortulata (x 2.5)
small magpie
Family: Crambidae
Distribution: Europe
Host plant: nettle

disphania sp. (x 0.8)
Family: Geometridae
Distribution: tropical Asia
Host plant: not classified

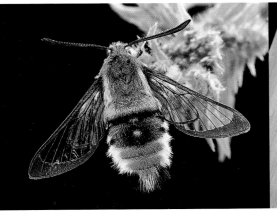

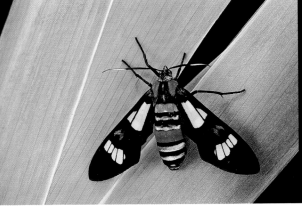

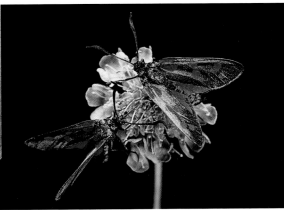

hemaris tityus (x 1.75)
narrow-bordered bee-hawk moth
Family: Sphingidae
Distribution: Europe
Host plant: honeysuckle, scabious

euchromia foletti (x 1.25)
Family: Ctenuchidae
Distribution: Madagascar
Host plant: ficus

zygaena filipendulae (x 1.5)
six-spot burnet
Family: Zygenidae
Distribution: Europe
Host plant: clover, Vicia (esp. V. Sativa)

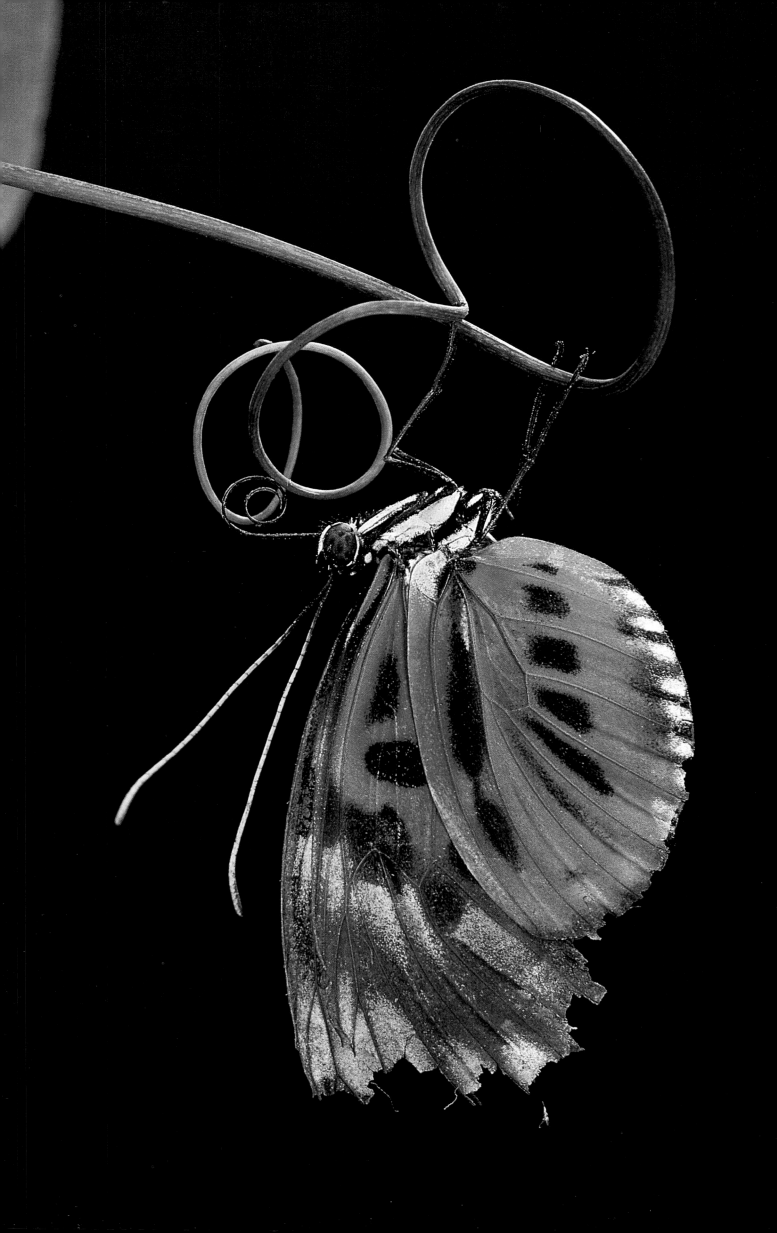

conclusion

As with all living beings, Lepidoptera cannot escape the marks of time, but their deterioration is particularly rapid. At four months old this female is already a centenarian, yet it has taken her this long to fulfil her reproductive task. Like most *Heliconius* she only lays a few eggs a week, and to make up for this poor performance, must live an exceptionally long active life. She has lived to see the birth of her own children and her grandchildren, which is a rare privilege indeed for a butterfly. Now she can disappear, having completed her task and accomplished what Nature asked of her: to pass on the torch to her descendants.

LEFT
Heliconius numata (x 4.1),

Heliconiidae.
Distribution: tropical America
Host plants: passiflora

index

Acknowledgments

This book would not have been possible without the help and advice of certain people, especially those who sent us butterflies, moths, larvae, and pupae that we could not have obtained otherwise. First, may I thank Professor Henri Descimon for his kindness and patience in answering my questions through all these years. My thanks also to specialist moth breeders Rodolphe Rougerie and Lucas Baliteau for providing us with extremely photogenic specimens. We are also grateful to David Rignon and Laurence Fabro in Guyana, breeders of several very rare and beautiful species, who gave us a great deal of information on the biology of South American butterflies. Finally, a special mention for Pascal Bernard who was responsible for much of the breeding that was necessary to obtain photographs of the most interesting stages of Lepidoptera development.

JEAN-PIERRE VESCO

The translator wishes to thank the London Butterfly House, Syon Park, Middlesex, and the Wildlife Charity Butterfly Conservation, Wareham, Dorset, for their invaluable help with some of the more technical aspects of this translation.

VIKING STUDIO
Published by the Penguin Group
Penguin Putnam Inc., 375 Hudson Street,
New York, New York 10014, U.S.A.

Penguin Books Ltd, 27 Wrights Lane,
London W8 5TZ, England

Penguin Books Australia Ltd, Ringwood,
Victoria, Australia

Penguin Books Canada Ltd, 10 Alcorn Avenue,
Toronto, Ontario, Canada M4V 3B2

Penguin Books (N.Z.) Ltd, 182-90 Wairau Road,
Auckland 10, New Zealand

Penguin Books Ltd, Registered Offices:
Harmondsworth, Middlesex, England

First published in the United States by Viking Studio,
a member of Penguin Putnam Inc.

First printing, November 2001

10 9 8 7 6 5 4 3 2 1

Original edition published under the title *Papillons*
Copyright © 2000, Editions du Chêne-Hachette livre

English-language text translated from the French
by Florence Brutton
Copyright © 2001, Editions du Chêne-Hachette livre

CIP data available

Creative director: Paul Starosta
Editor: Cécile Aoustin-Demars
Design: Sabine Houplain
Layout: Karin Crona
Photoengraving: Chromostyle, Tours, France

Printed in France

ISBN: 0-670-03046-5